STRONG IS THE NEW PRETTY

A Celebration of Girls Being Themselves

KATE T. PARKER

Workman Publishing • New York

Library of Congress Cataloging-in-Publication Data is available.

ISBN 978-0-7611-8913-8 (PB)
ISBN 978-1-5235-0068-0 (HC)

Design by Lisa Hollander

Photo on page 1 by Kathleen Taylor

Workman books are available at special discounts when purchased in
bulk for premiums and sales promotions as well as for fund-raising or
educational use. Special editions or book excerpts can also be created
to specification. For details, contact the Special Sales Director at the
address below, or send an email to specialmarkets@workman.com.

Workman Publishing Co., Inc.
225 Varick Street
New York, NY 10014-4381
workman.com

WORKMAN is a registered trademark of Workman Publishing Co., Inc.

Printed in China
First printing January 2017

For all the fearless, strong, and amazing girls who inspired the following pages.
Special thanks to my two beautiful, strong girls,
Ella and Alice, who make me laugh every day. I love you.

CONTENTS

INTRODUCTION

When I was seven, my hair was long and thick and nearly reached my waist. Most days it was in a messy ponytail (not much has changed). At that same time in my life, my main goals were to first, be exactly like my two older brothers and second, kick butt on the soccer field just like they did.

It wasn't lost on me that most boys didn't need to spend time painfully getting their knots brushed out or putting in ponytails—and *their* hair didn't get in their face while they played sports. I began to realize that the hair had to go. It was a time suck. I had games to play and goals to score.

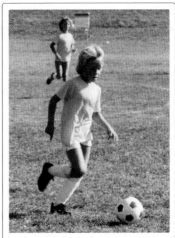

The author, age 8

I didn't want just a trim. Nope, "go big or go home" was my attitude. I wanted it to look like my brothers' hair. Chop it all, please. Not exactly what you saw every day on suburban New Jersey girls circa 1983. However, my parents both fully supported me. The results were exactly what I wanted, and I didn't care what other people were going to think. I loved my new hair so damn much.

The day after I had my hair cut, I walked proudly into second grade. My new look was the bomb. Not one single part of me thought it "didn't look good" or "girls should have long hair" or it "wasn't feminine." You know why? It never occurred to me that girls had to do this, or be that, or look a certain way. I had never been told that girls shouldn't play sports, or be loud, or question everything, or get their hair cut exactly like their big brothers'. I loved that my parents allowed me to be whoever I really was. I still love them for that.

And now, as a mother of two young daughters, I try to do the same for my girls. My husband and I encourage loudness, silliness, fearlessness, confidence,

strength, and individuality. We let them wear their hair however they want. (The goal is brushed.) My husband and I aim to celebrate who they are, just as they are. This photo series started as a personal project. I work as a professional photographer, but I'm also a mom (the mom with the giant camera and bag of lenses at most events). And it's not uncommon for me to be photographing my girls and their friends—constantly—when they're riding their bikes, at soccer practice, or exploring tide pools while on vacation. The more I shot, the more I began to notice that the strongest images, the ones that resonated most with me, were the ones in which the girls were being 100 percent themselves. When they were messy and funny and stubborn and joyful and in your face, I kept shooting. I didn't ask them to smile or go put on a pretty dress. I wanted to capture these girls as they were, and how they were was amazing. I wanted to continue capturing them in just that way—not just for my sake, but for theirs, too.

As a body of work emerged, I kept at it with more intention. I wanted to show my girls that beauty isn't about being a certain size, or having your hair done (or even brushed, in their cases), or wearing a fancy outfit. I wanted to combat the messages the media sends to women every day. I wanted my girls to know that being themselves is beautiful, and that being beautiful is about being strong.

STRONG IS THE NEW PRETTY was born.

As the project began to receive more attention, I knew I had the opportunity to expand it, to show strength in all its varied forms. I began traveling to meet young women from all over the country, from Florida to Colorado to New York to Texas to Hawaii and lots of places in between. In fact, there are almost 200 girls represented here, from all over North America. More important, they represent a vast number of human stories, ranging from small moments of achievement to persistent struggles against adversity, from lifting oneself up to lending a helping hand or offering a hug. Though my personal experience with identifying and owning my own strength as a girl was through athletics, there is strength in the quiet moments, too—strength in the intellect, in nurturing your curiosity and being able to ask questions, in being creative and kind, in bold displays of anger and joy, and in quiet determination.

Every girl I met is amazing. I feel honored to share their stories and images—and their strength—with you: the look on Alice's face after she conquered the big hill on her bike, the wisdom Grace shared about her recent battle with cancer,

Aris's proud smile when she achieved her goal of becoming a pilot at just 16, Carlie's grit on the football field. It's my goal with these images to inspire girls and women to be their best selves, to challenge and test their limits. We all are constantly bombarded with societal messages about how women and girls should act or look or be, and processing them in a healthy way can be hard even for a 40-year-old mother of two who knows better. I worry about what my girls and their friends are exposed to and how their opinions of their bodies and selves are being shaped by the internet and TV and magazines. I want these images to combat those negative voices that tell us we're not good enough or thin enough or whatever enough. Because we are far more than enough! I wanted these girls to be able to hear their own voices through these images, and to inspire them to use them and continue to use them. *Loudly*.

When I was seven, being myself meant wrestling with my brothers; it meant bugging my sister (I was the youngest, obviously), sporting a bowl cut and soccer jersey, and listening to Blondie on my record player. For my own girls, it means being a singing, dancing, trampoline expert and a soccer-playing skater dude. The truth is, strong means many things and is revealed in many ways. My hope is that you'll see that on the following pages. These young women are the definition of strength and beauty, in all its varied forms.

"Let the wind whistle in your hair and whisper to yourself: 'I can do anything.'"

SHONDA RHIMES

CONFIDENT
IS STRONG

In the workforce, women earn an estimated average of just seventy-nine cents for every dollar their male counterparts make. In sports broadcasting, female athletic competitions represent 5 percent of the allotted airtime. And in film and television, female protagonists make up only 12 percent of cinematic roles. Tell that to Kekai, with the determined stare (page 27), or Caroline, with her unwavering poise as she balances on pointe (page 15). These girls are intelligent and clever, talented and strong—and they know it. They are confident. And they offer hope, too—hope that the inequity will disappear as this generation of girls grows into adulthood.

The confidence that they display in these photos will push them through the times when they feel hesitant or unsure or nervous. Confidence will push them, period. The challenge is in holding on to this power, this confidence, so they can help fuel the change that the world needs.

Do them a favor and remind these girls of their strength. Remind *each other* of your strength. Often. Write it down if you need to: the ways in which you are smart, the ways in which you are qualified, the ways in which you are strong. Put them on your wall, say them out loud—internalize them. *Believe* them. Don't let your daughter, your niece, your sister, your cousin waste any precious time wishing she looked like anyone else—she looks and acts and sings and walks and talks and works and plays like *herself*.

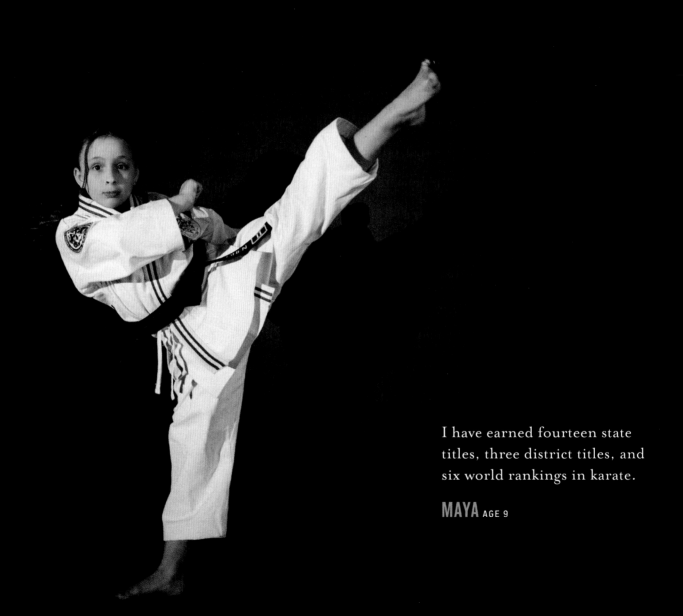

I have earned fourteen state titles, three district titles, and six world rankings in karate.

MAYA AGE 9

Don't let anybody make you feel like you are not wanted or don't belong.
You can do anything.

VALERIA AGE 11

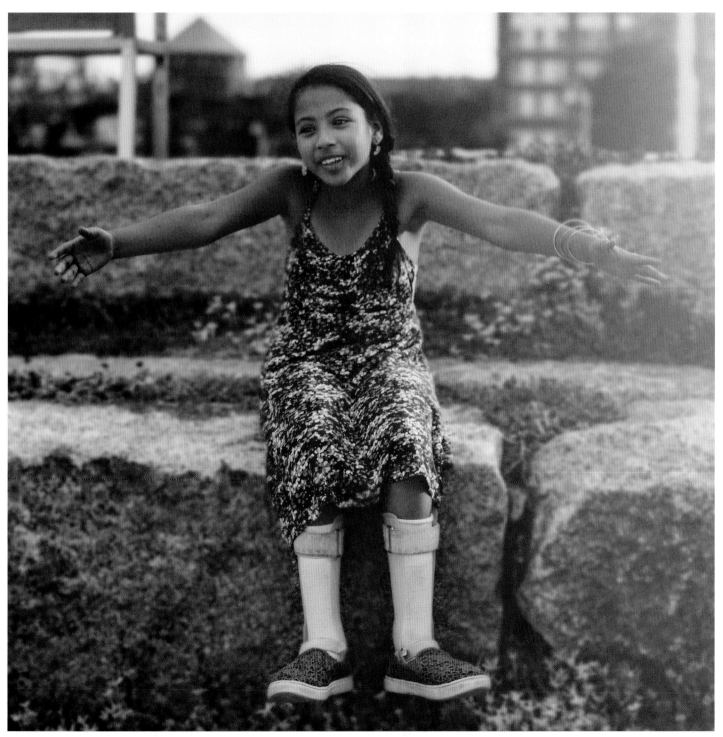

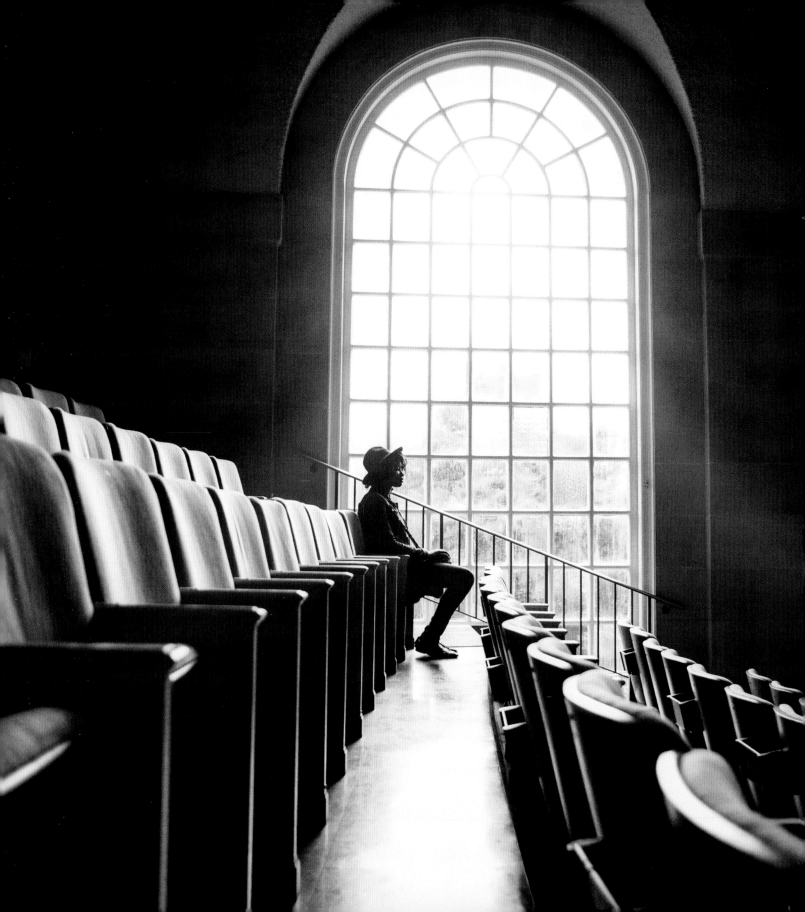

Strong is someone who takes the hardships life throws at them and never gives up. When my parents died from cancer months apart from each other, I worked really hard in school so that I could make them proud.

FAITH AGE 18

True beauty is a result of the persistence, resilience, and confidence that comes with being a strong woman.

SOPHIE AGE 17

I taught myself
how to bake
and decorate.

LINDSEY E. AGE 11

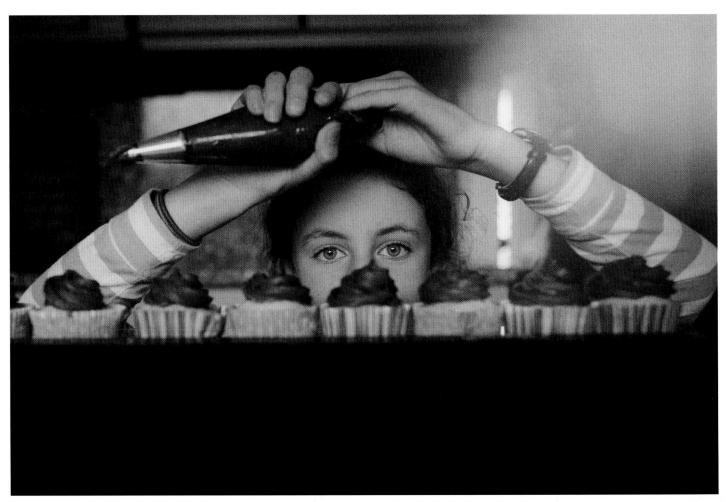

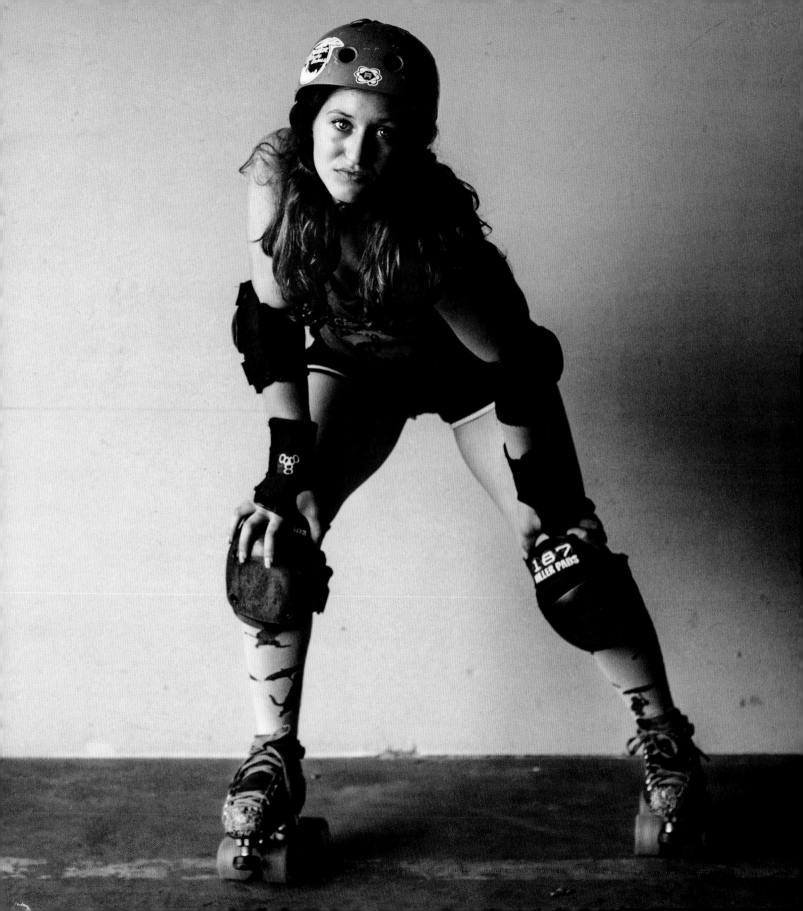

When I first started to surf, I got made fun of all the time. For years, I was the only girl. Every little thing that I did differently, the boys would laugh. Pretty soon, though, I started to show them up, and after that, they never made fun of me again. I plan to be a champion in two sports—surf and skate—that have always been predominantly "guys only" worlds.

JORDYN AGE 17

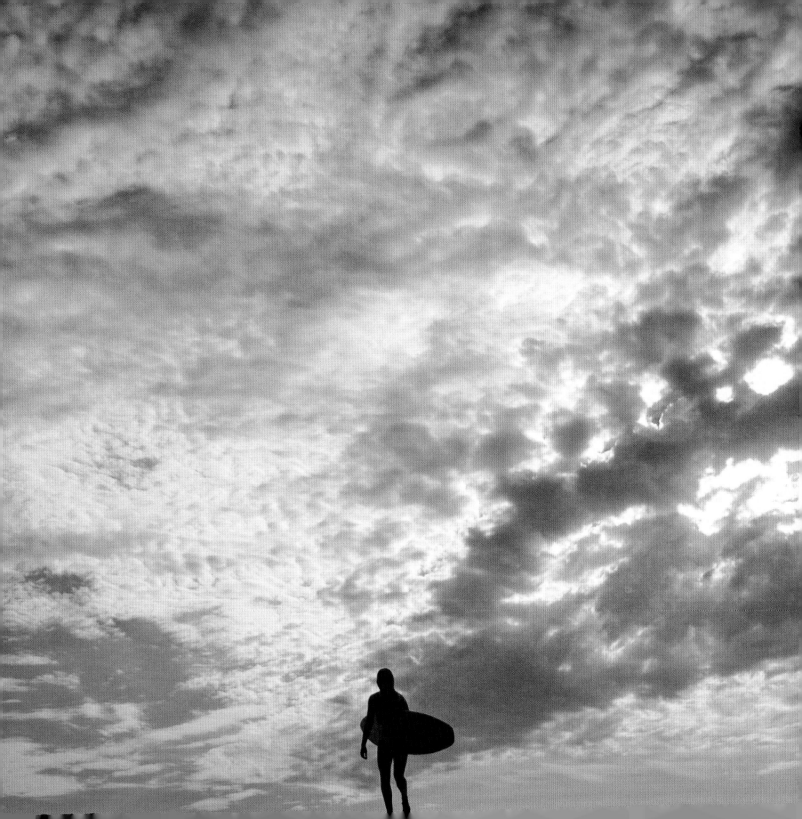

I believe in myself
even when the world is
spinning around me.

LINDSEY B. AGE 16

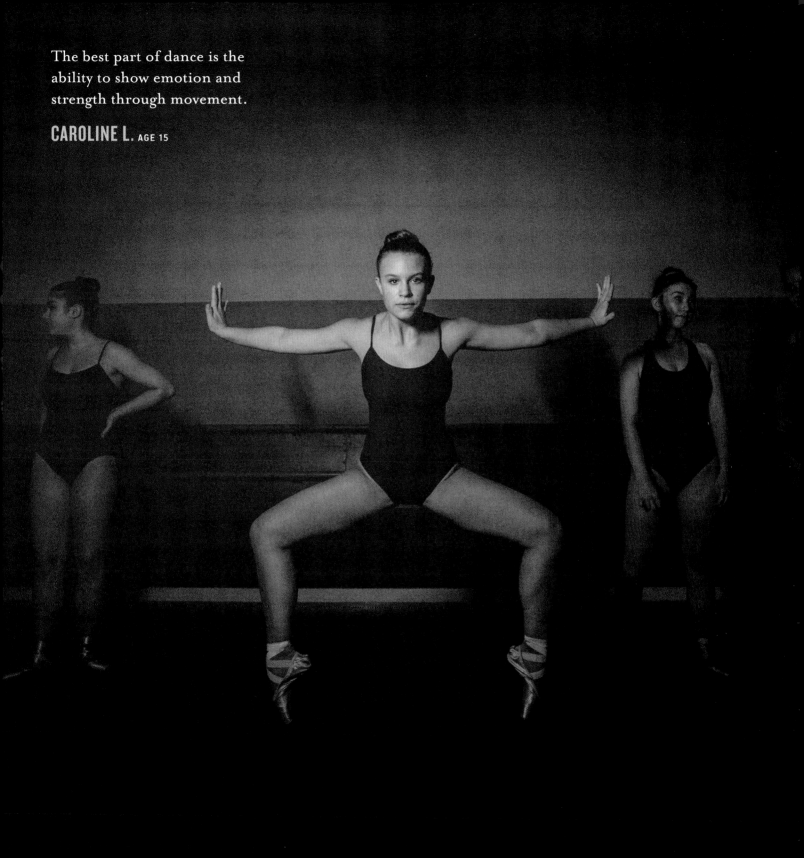

The best part of dance is the ability to show emotion and strength through movement.

CAROLINE L. AGE 15

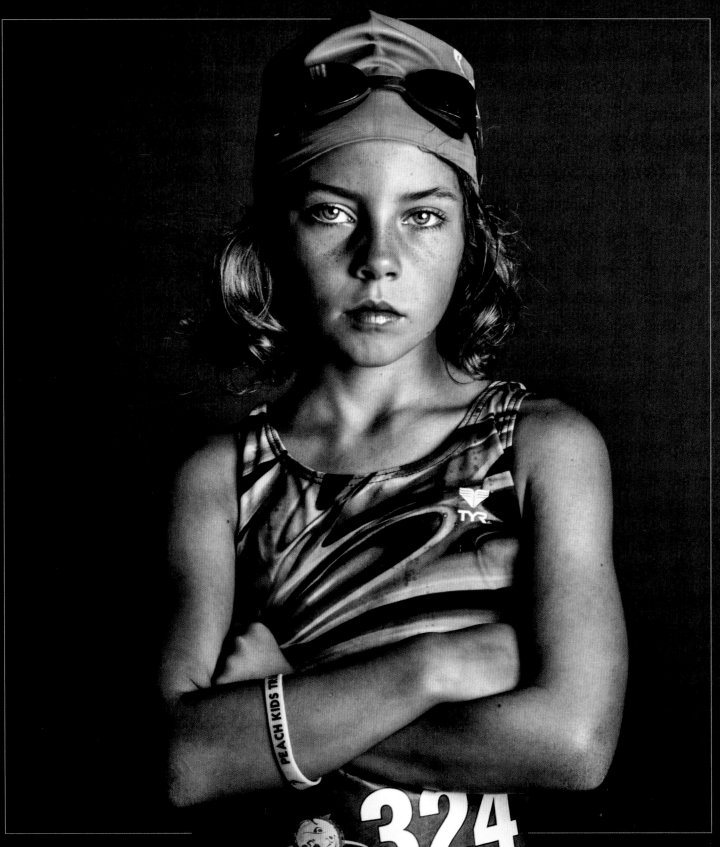

I was really scared for my
first triathlon. My mom
took this shot of me the night
before and told me that even
though I was afraid to race, to try
to *look* tough and fearless. I did,
and when my mom showed me
this shot, it made me believe
I could be as tough as I look.

ELLA AGE 9

I think girls everywhere
should focus way more on
who they are inside and way less
on what they look like outside.
I've found a lot of strength in
just not caring. Lake-water hair?
Don't care.

HALEY H. AGE 10

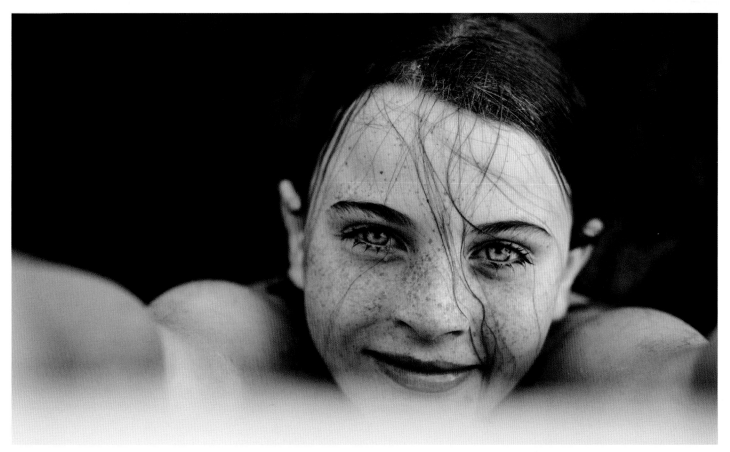

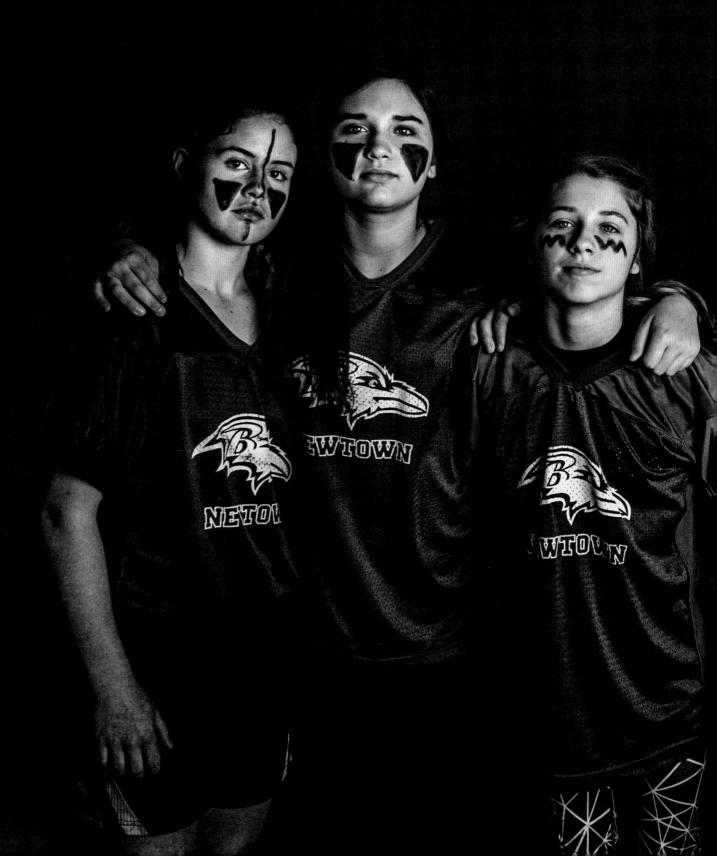

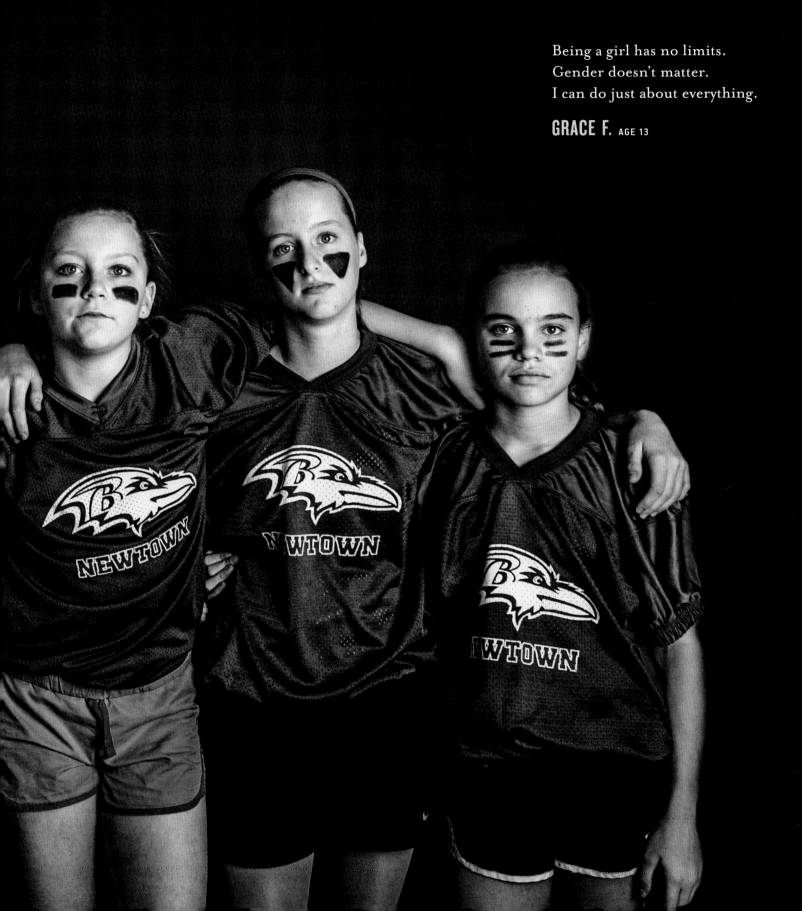

Being a girl has no limits.
Gender doesn't matter.
I can do just about everything.

GRACE F. AGE 13

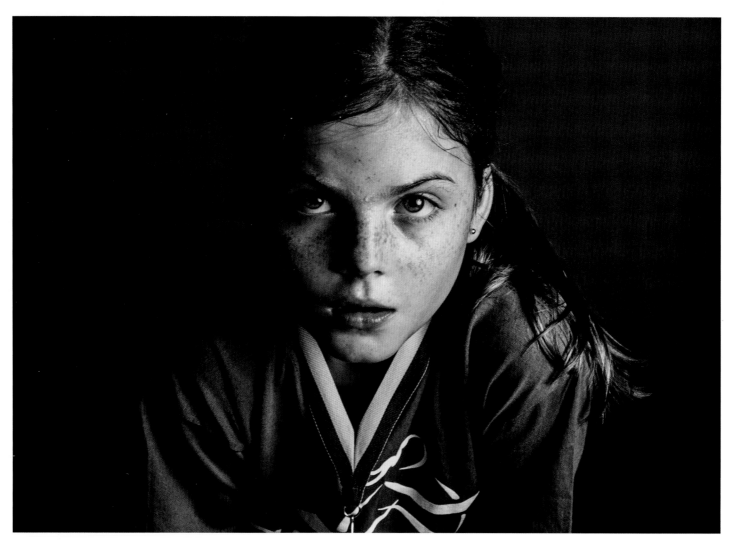

When I play soccer, I feel unstoppable.
When you have the ball, you just want to keep it
so you can score, but sometimes it is better to
pass the ball even if you don't want to.

CAROLINE C. AGE 10

I am blessed with gifts and talents
and can't wait to show the world.

ZARI AGE 11

STRONG IS BUILDING PEOPLE UP, NOT TEARING EACH OTHER DOWN.

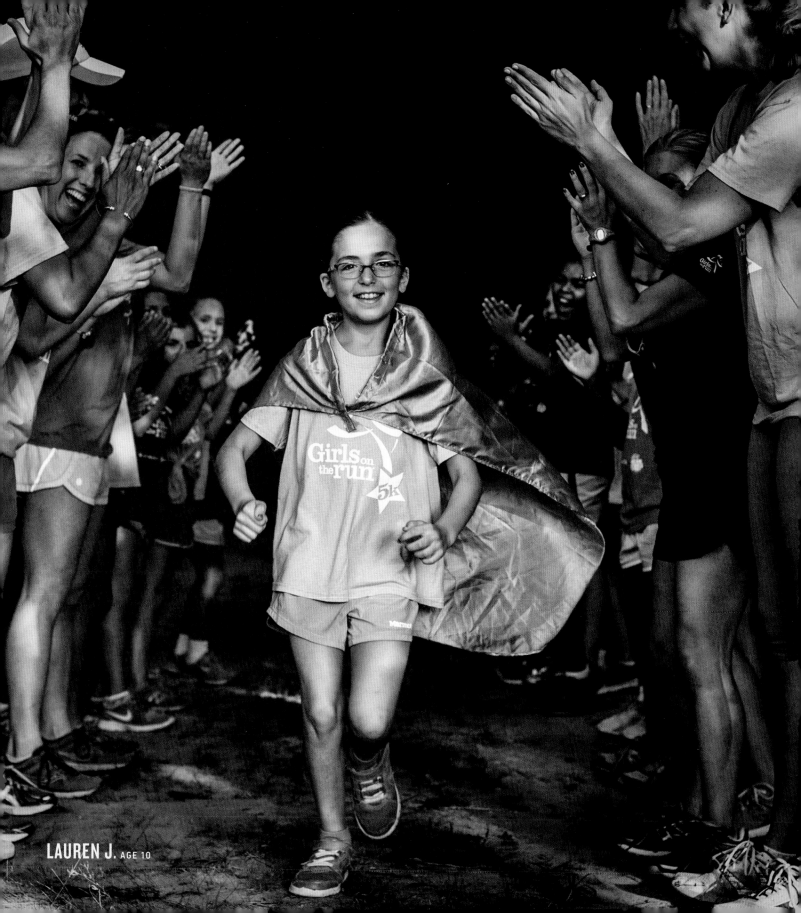

LAUREN J. AGE 10

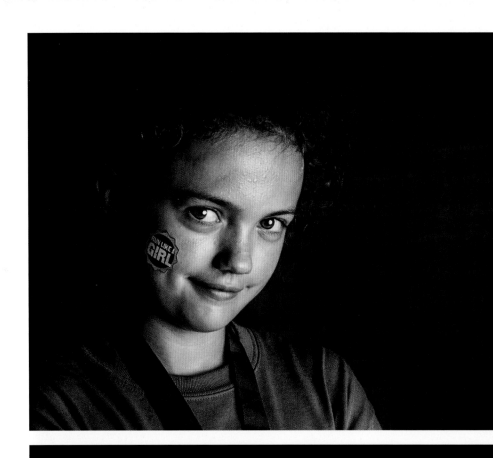

For me, being a girl means being part of a group of smart, excellent people. When people think of girls, they generally think of makeup, heels, and perfume—but girls aren't all that. Girls are intelligent, ambitious, strong people, and I'm proud to be one.

ZOHE AGE 10

I am fearless.

MAGGIE AGE 9

Being a girl is strength in itself. Many don't know, or choose to overlook, the battles that girls go through every day to achieve what they deserve, whether it be education, work, or simply respect.

SARAH A. AGE 18

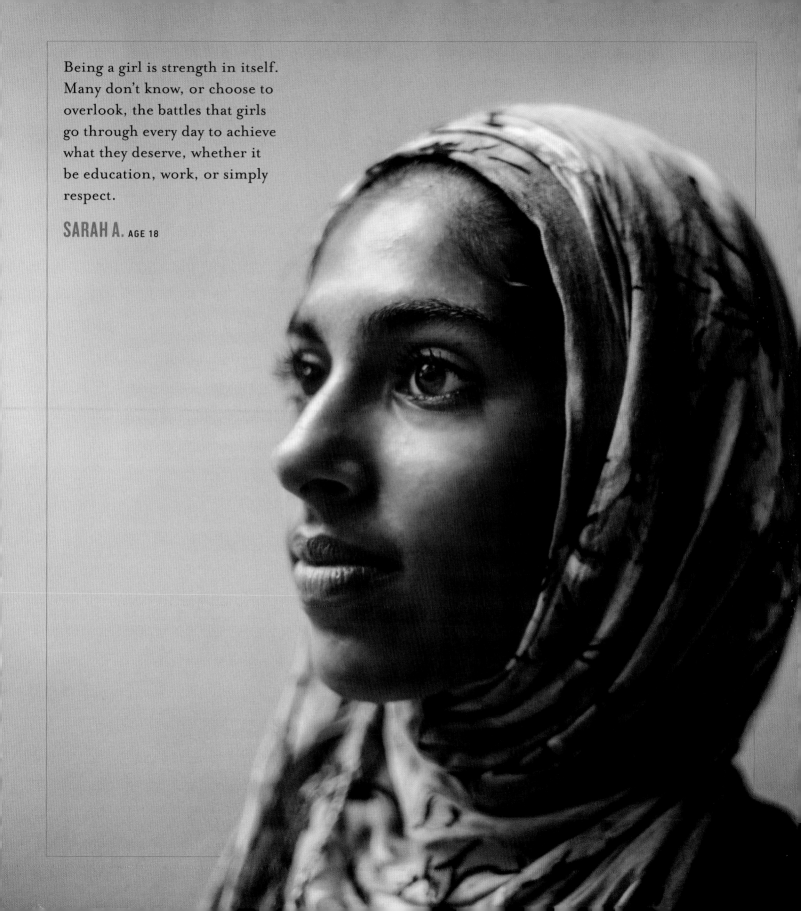

I'd love to win, but putting myself out there is winning already.

LENÉE AGE 13

I love the speed when I skate. I feel very alive and present—
feeling fluid and going fast is fun.

KEKAI AGE 12

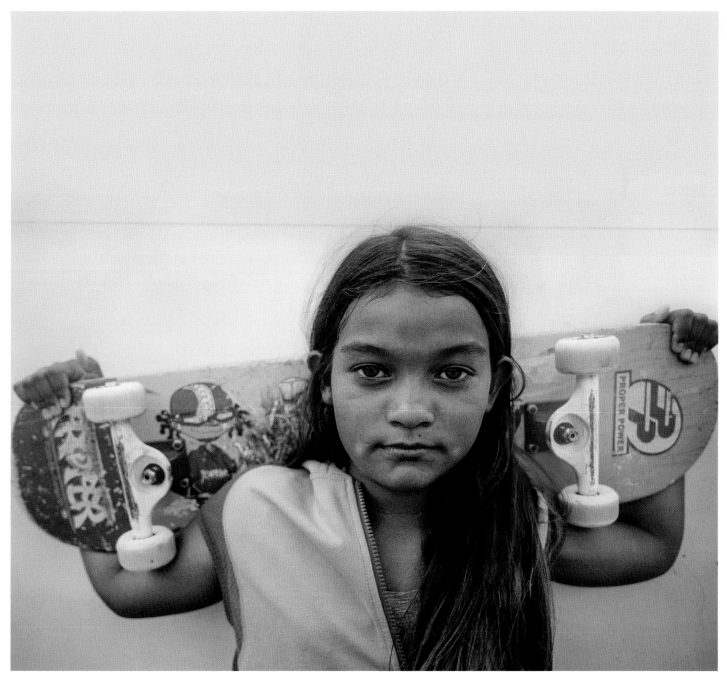

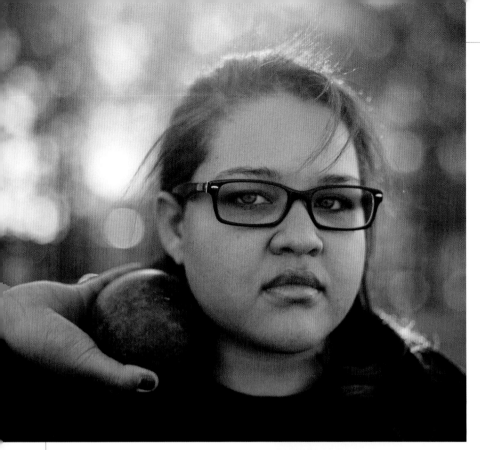

I don't see the competitors when I am ready to throw. I focus on my job and what I have to do.

ISABELLA AGE 19

I trusted myself and believed I could do it!

MICHELLE AGE 9

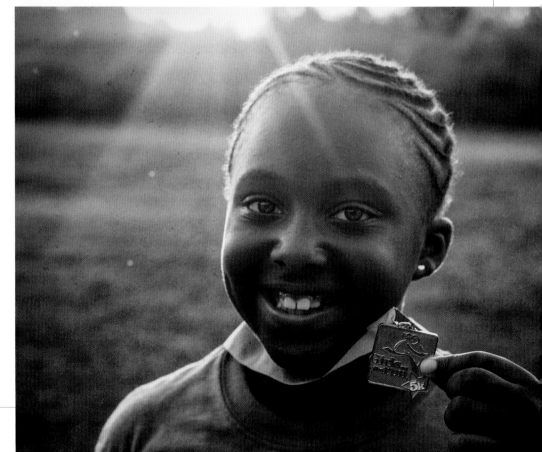

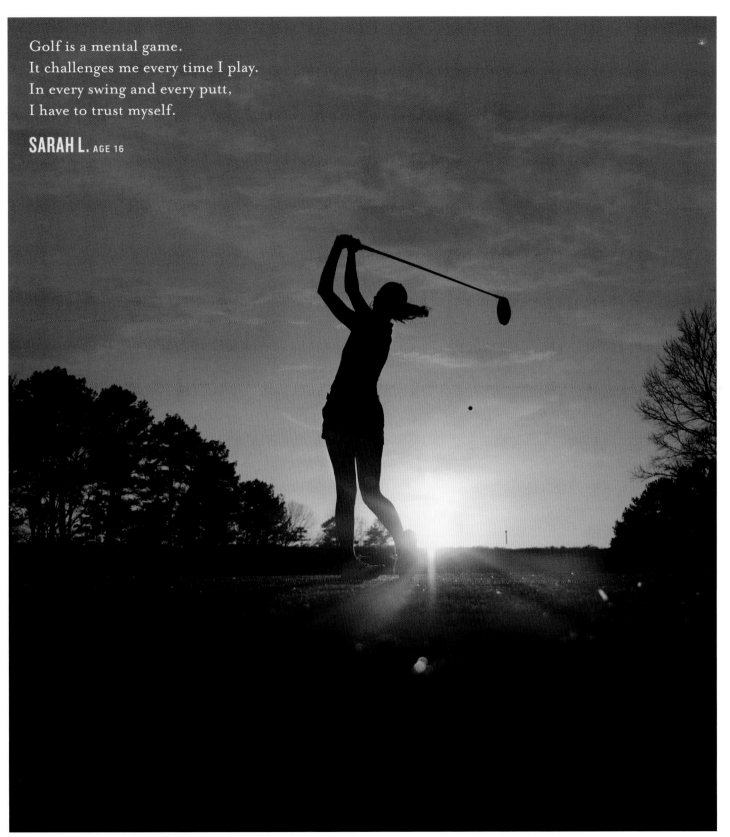

Golf is a mental game.
It challenges me every time I play.
In every swing and every putt,
I have to trust myself.

SARAH L. AGE 16

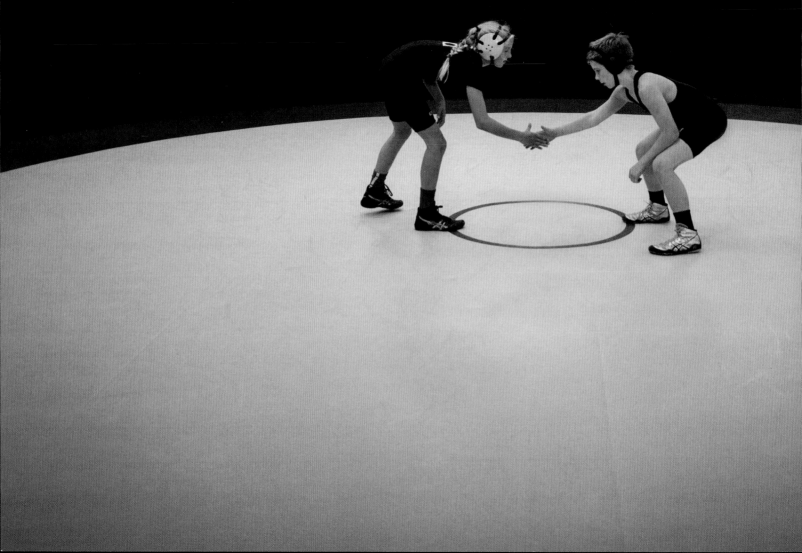

In wrestling, girls have an advantage. The guys think less of you until you are face-to-face with them!

RACHEL AGE 11

I'M SMALL, BUT I HAVE A BIG VOICE AND I KNOW HOW TO USE IT.

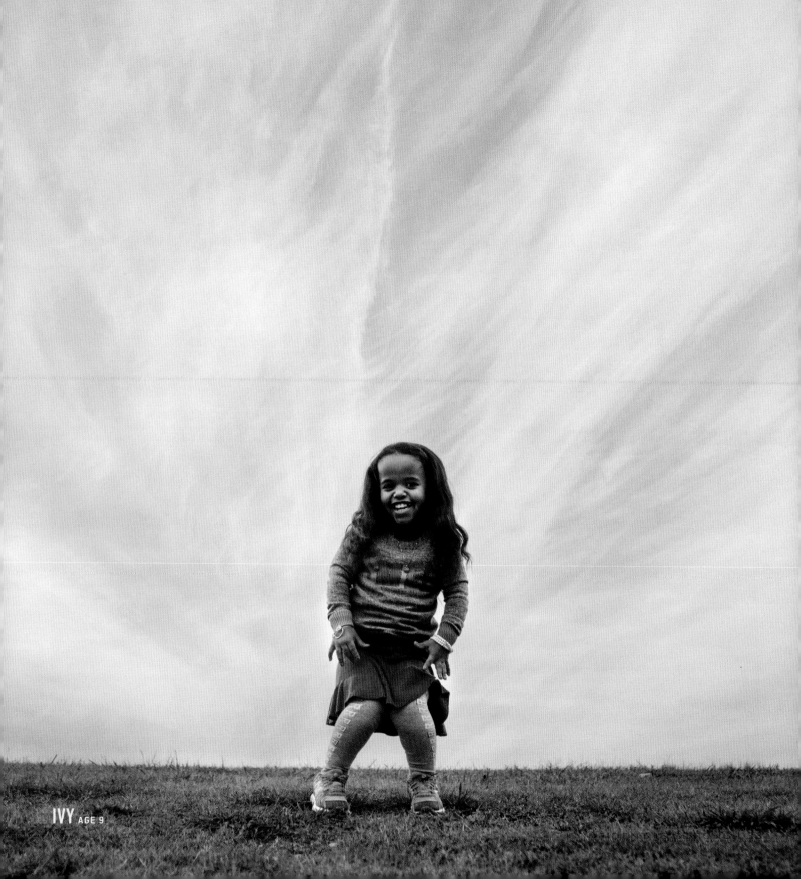

IVY AGE 9

Being a girl
means that
I am awesome.

NAKIA AGE 11

I'll never give up.

CHASE AGE 9

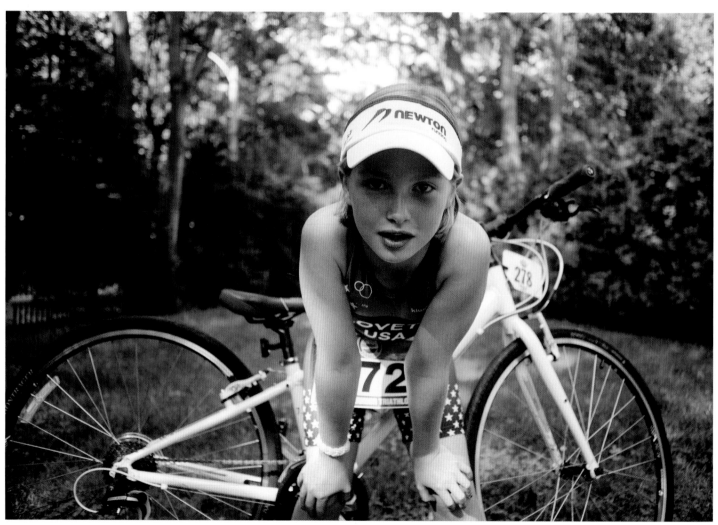

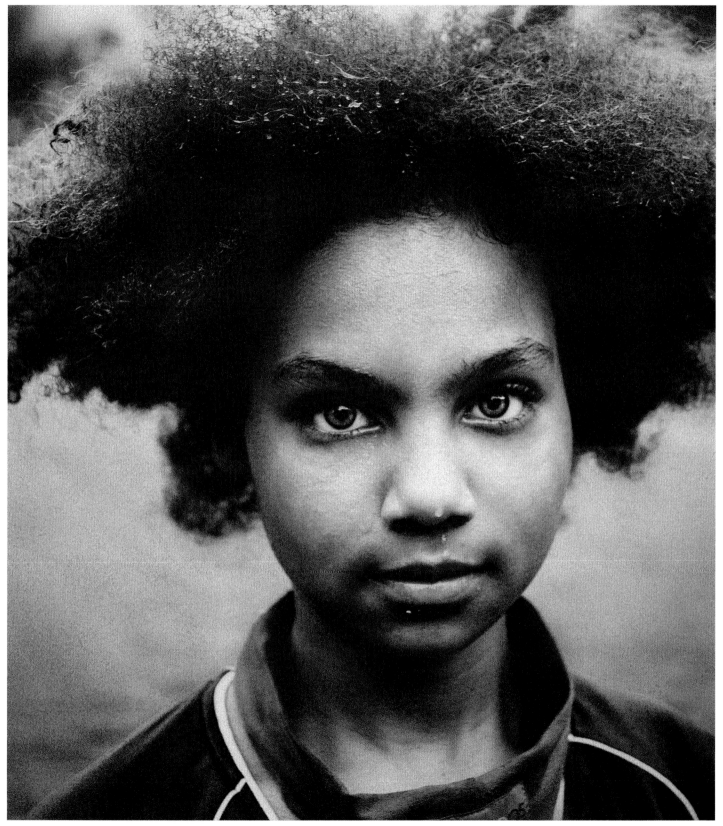

I love water polo and I can lift just one eyebrow and I speak Farsi and play tennis and I can make people laugh by making funny faces. And I taught my little sister, Penny, to read when she was 3.

SABRINA AGE 6

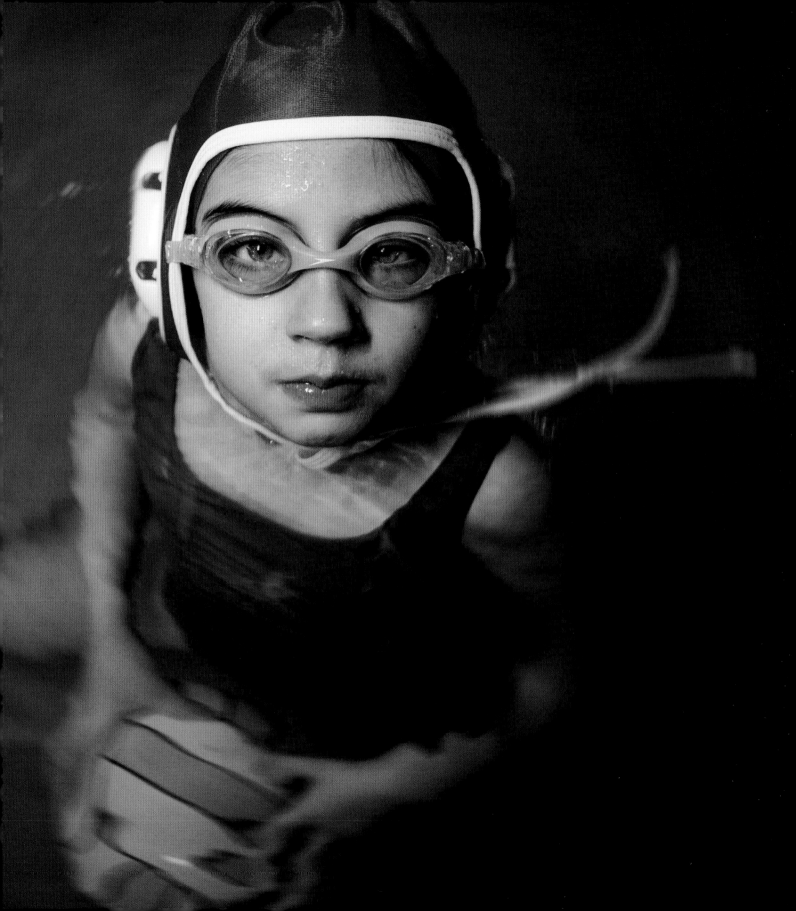

I always try new things.
If I don't like something,
at least I know how it was
or how it felt.

LAILANI AGE 15

"Do things that **scare** you, but only what you're **ready** for."

DEBBY RYAN

WILD
IS STRONG

———◆———

It's easy to come up with so *many* reasons why you shouldn't be who you are or where you are. And those reasons constantly work to stifle the uniqueness that makes you *you*. Being spontaneous is one of the quickest ways to reveal and appreciate your true self—and your true self is a culmination of your innermost dreams, joys, triumphs, mistakes, and experiences.

To be wild is to be full of life and color—capable of bursting at the seams with excitement. To be loud and brash—unapologetically so. It's about being brave enough to be 100 percent committed to your emotions. To play, to be silly, to do things you weren't sure you could—*that* is what it means to be wild and free. And although having that courage is liberating, it also requires strength. The power that wild girls wield is that they're not held back by what people think of them. They're aware of it—but that awareness doesn't stop them. Once that fear is banished, there's no limit to what they can do or who they can become. Because ultimately, being wild is being free: free to try new things without self-judgment, to be loud, silly, unkempt, and unruly. It's a full embrace of all the weird and crazy in you.

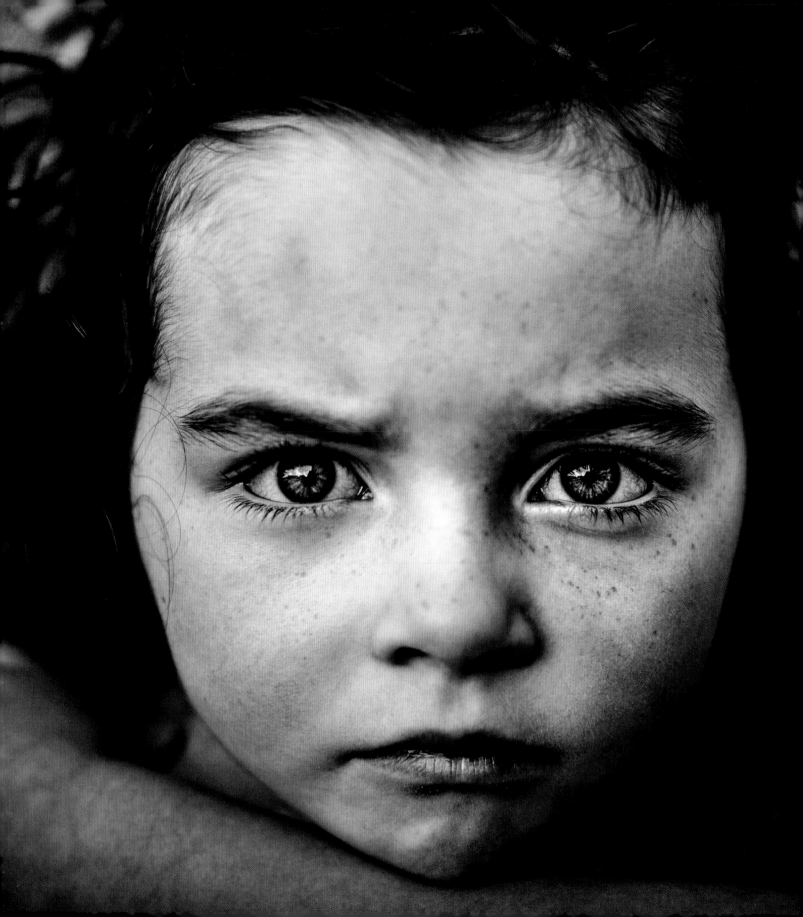

I have a little bit
of a temper.

ALICE AGE 7

My dad calls me "bush cat." I think it means I get a little crazy and don't care if I get messy or dirty when I play. I like it.

TAYLA AGE 7

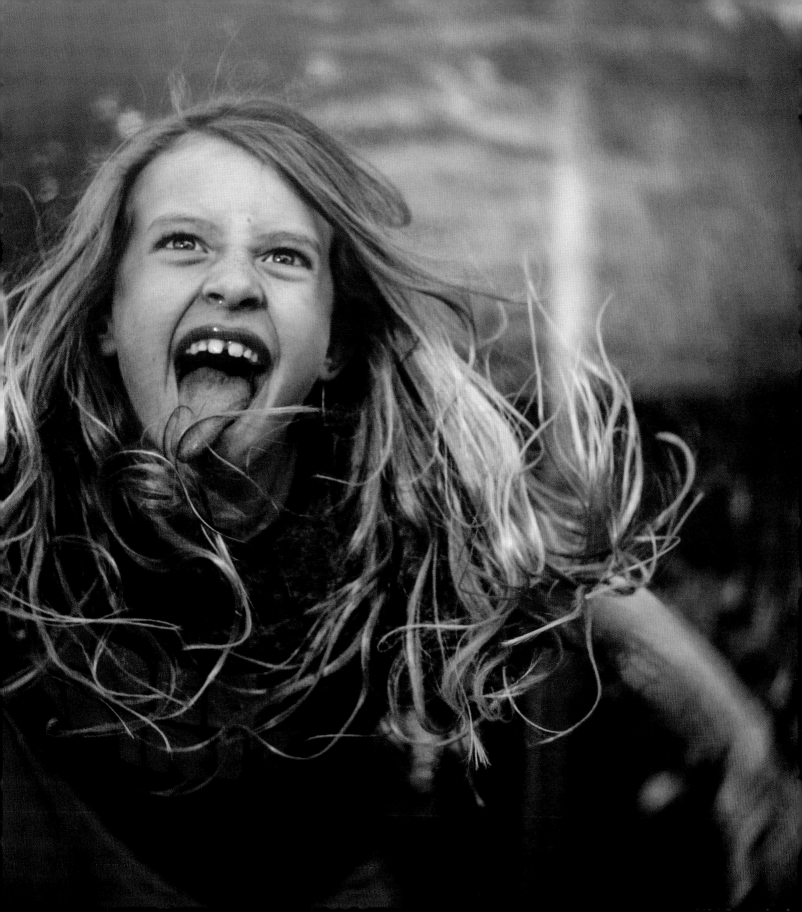

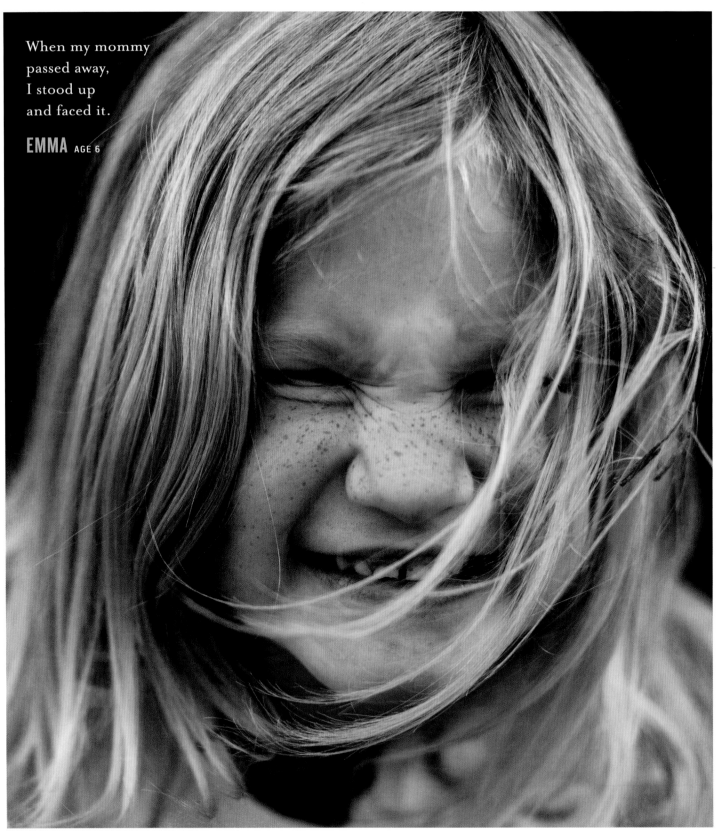

When my mommy
passed away,
I stood up
and faced it.

EMMA AGE 6

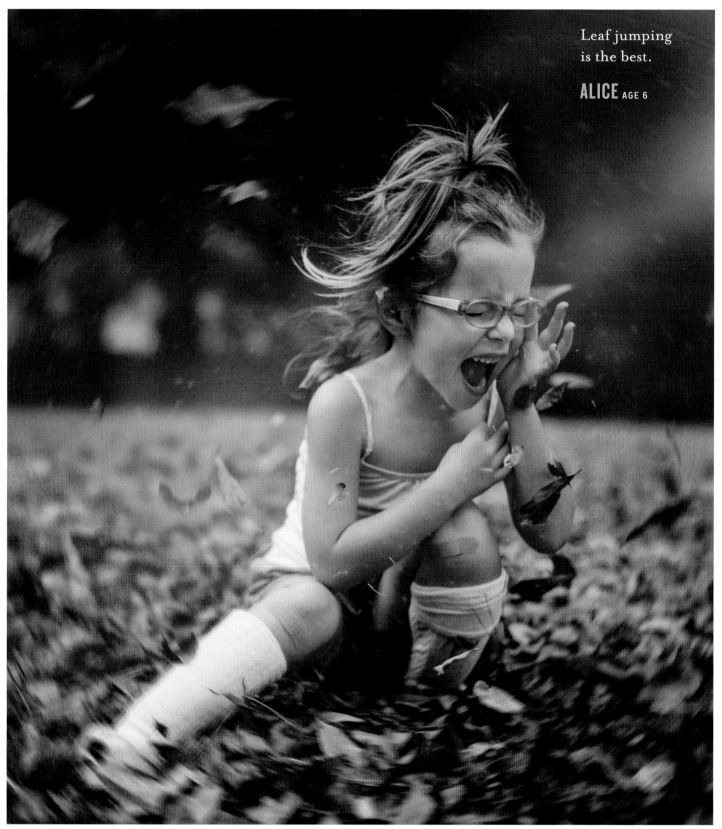

Leaf jumping
is the best.

ALICE AGE 6

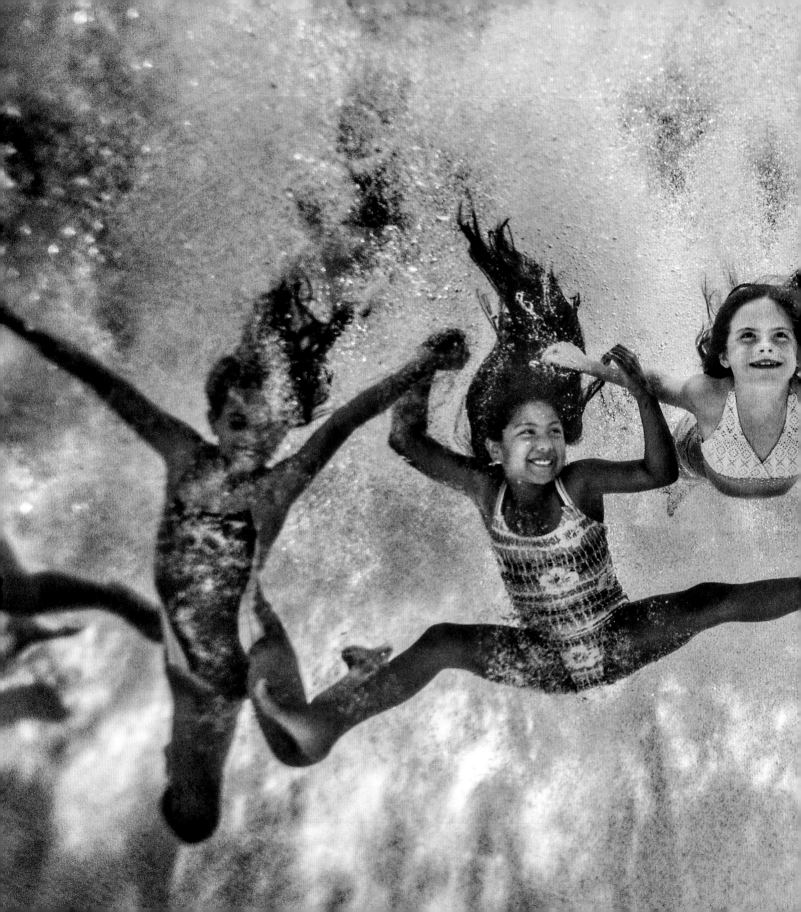

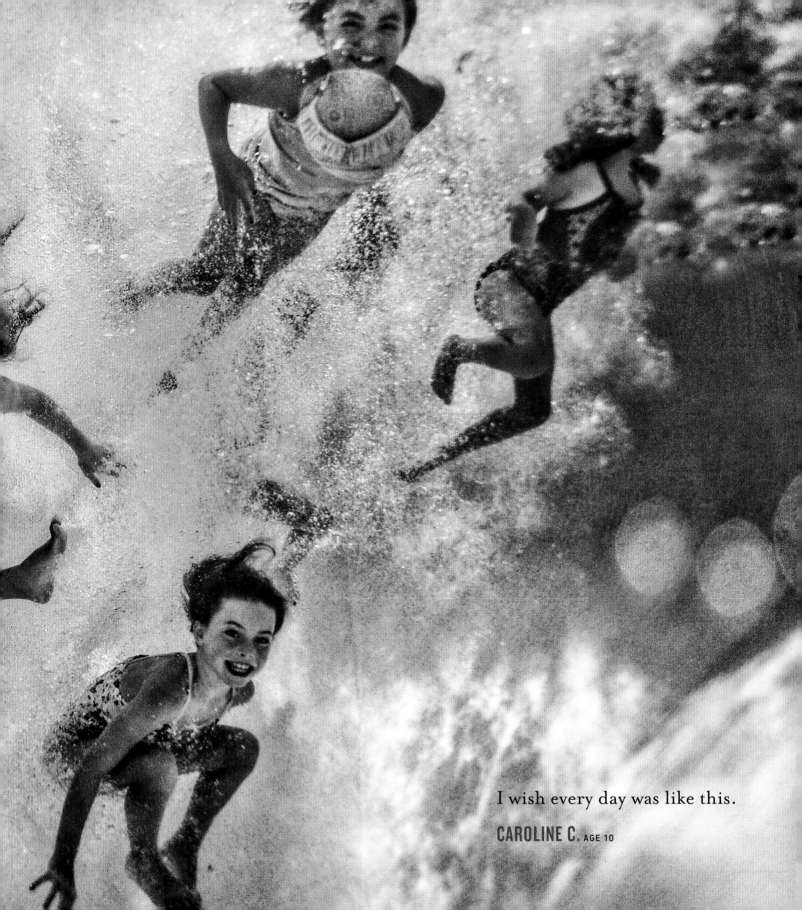

I wish every day was like this.

CAROLINE C. AGE 10

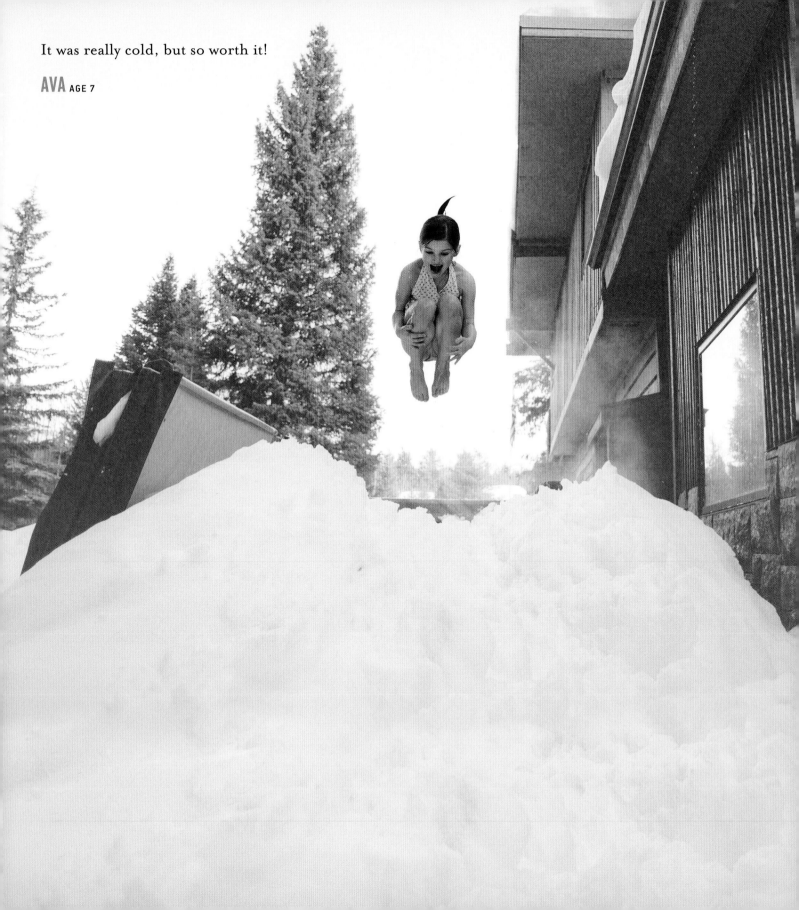

It was really cold, but so worth it!

AVA AGE 7

Snakes don't scare me.
Why would they?

SADI AGE 8

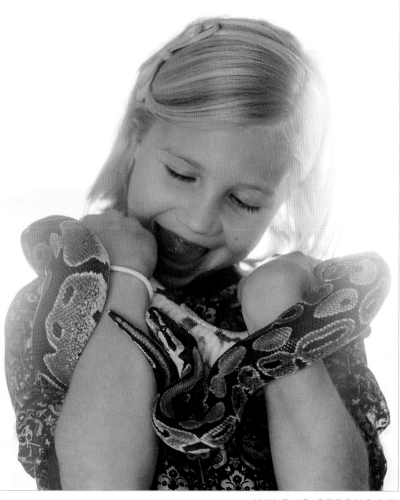

The floor got soaked and
we forgot to wash our hair.

ALICE AGE 7

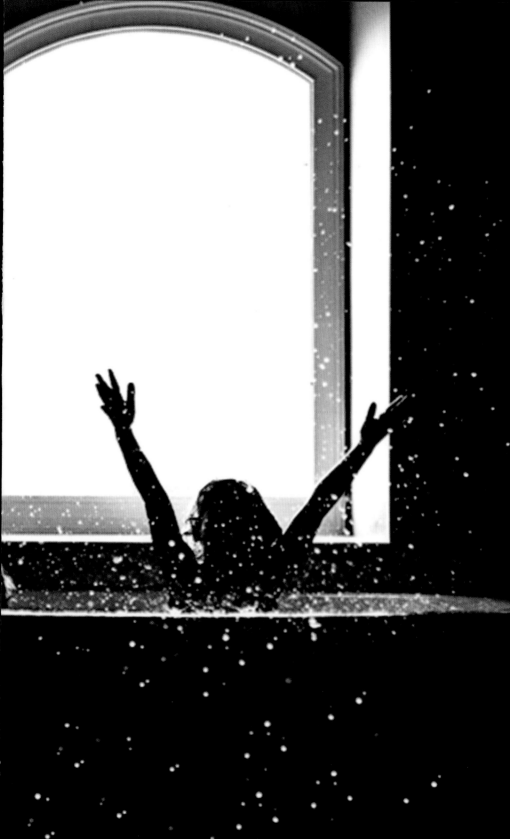

GIRLS AND BOYS CAN DO WHATEVER THEY WANT. GIRLS CAN DO BOY STUFF, AND BOYS CAN DO GIRL STUFF.

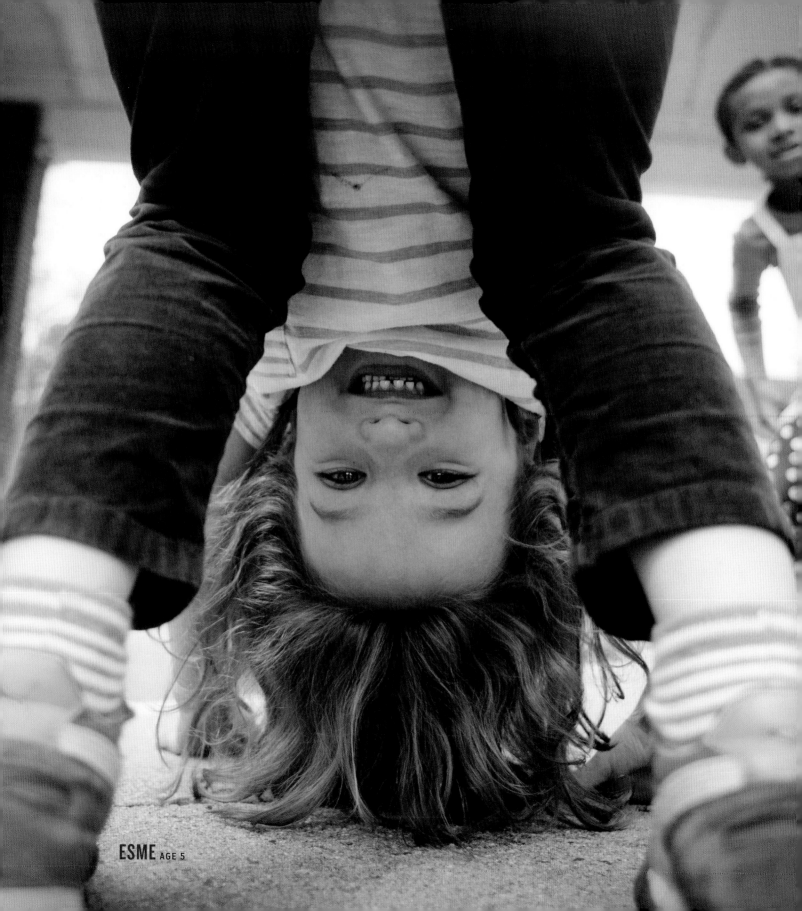

ESME AGE 5

I tried to bulldoze
my little brother,
but my mom said no.

SYD AGE 8

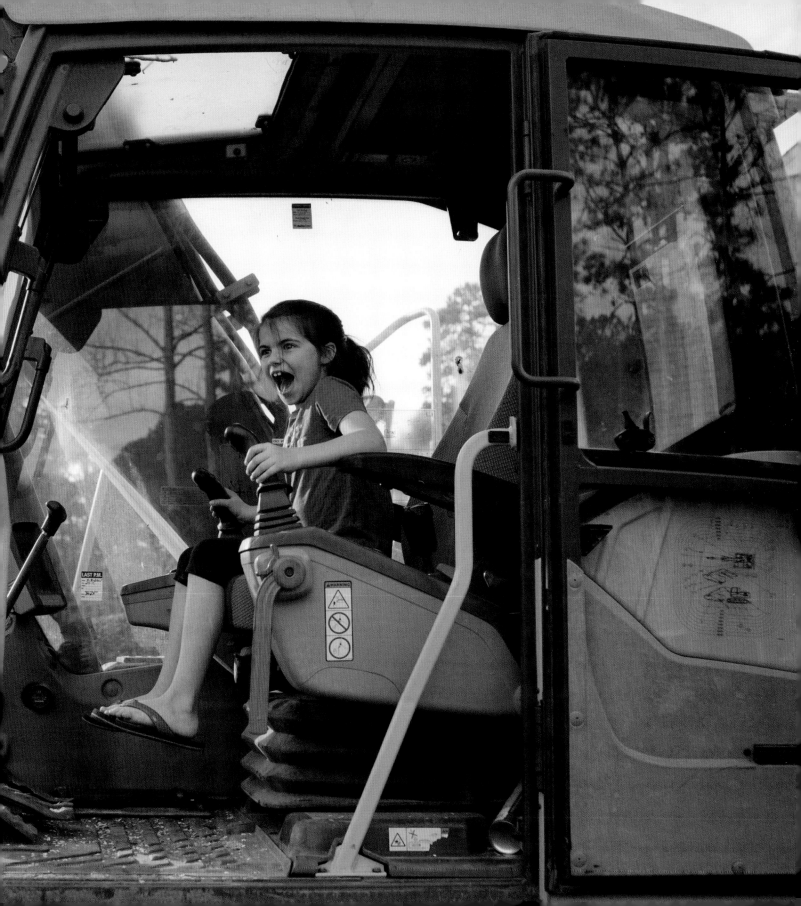

You can always expect a little craziness when we are together.

JULIANA AGE 8

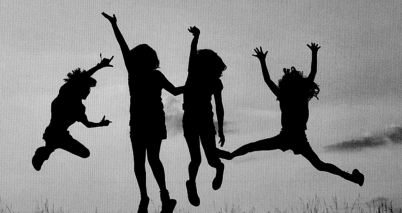

Strong girls stick up for themselves,
are brave, and have equal rights as boys.

MAE AGE 8

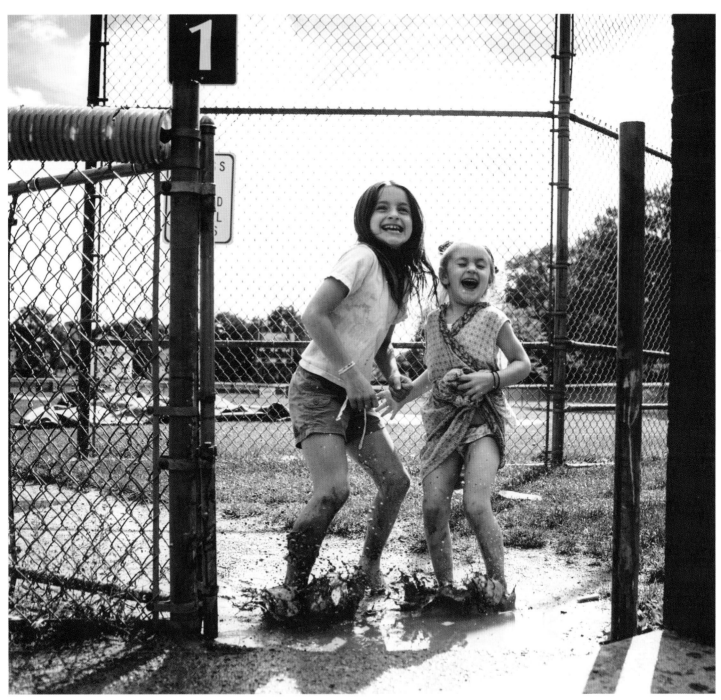

We are making a
clubhouse, and it's my job
to make the mortar.

TAYLA AGE 6

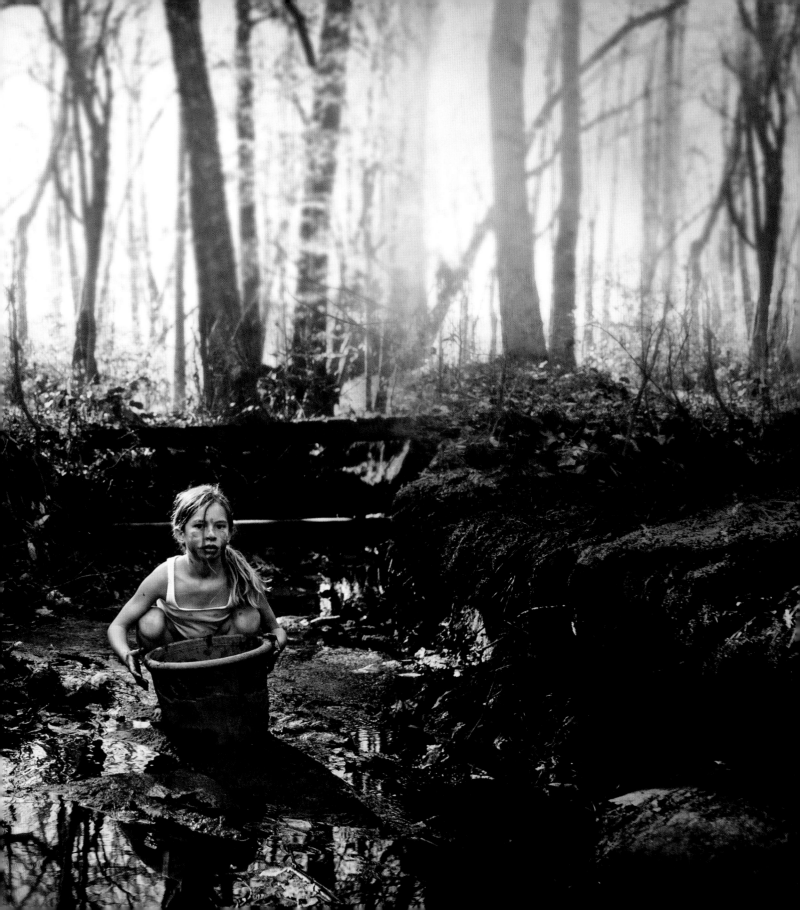

DID YOU KNOW THAT THIS DINOSAUR ATE ONLY PLANTS? ROAR!

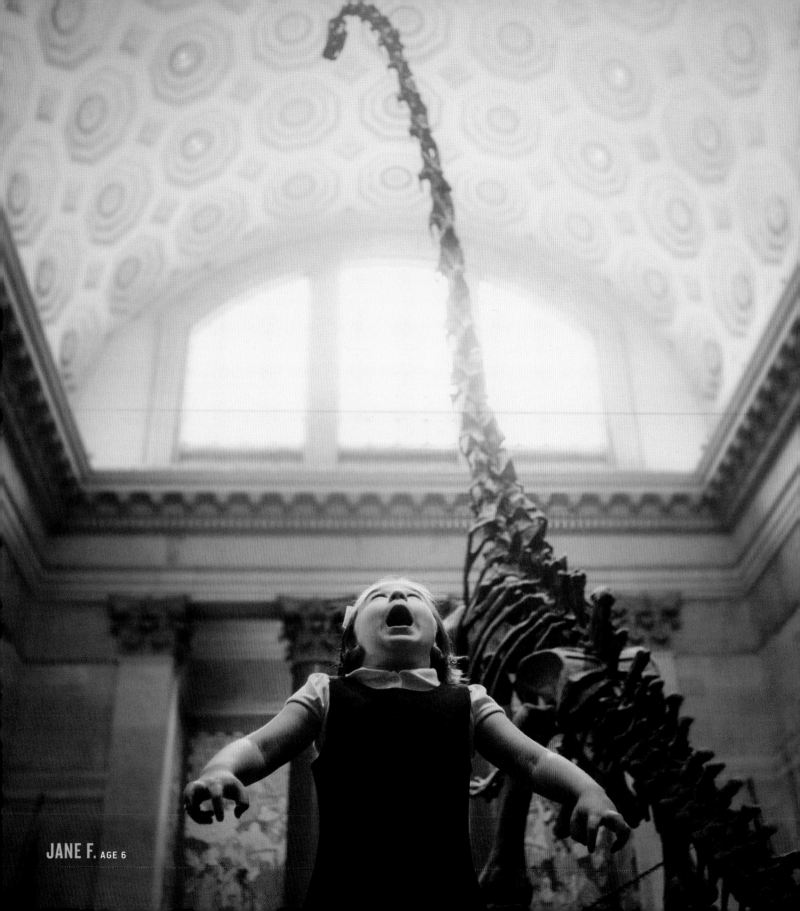

JANE F. AGE 6

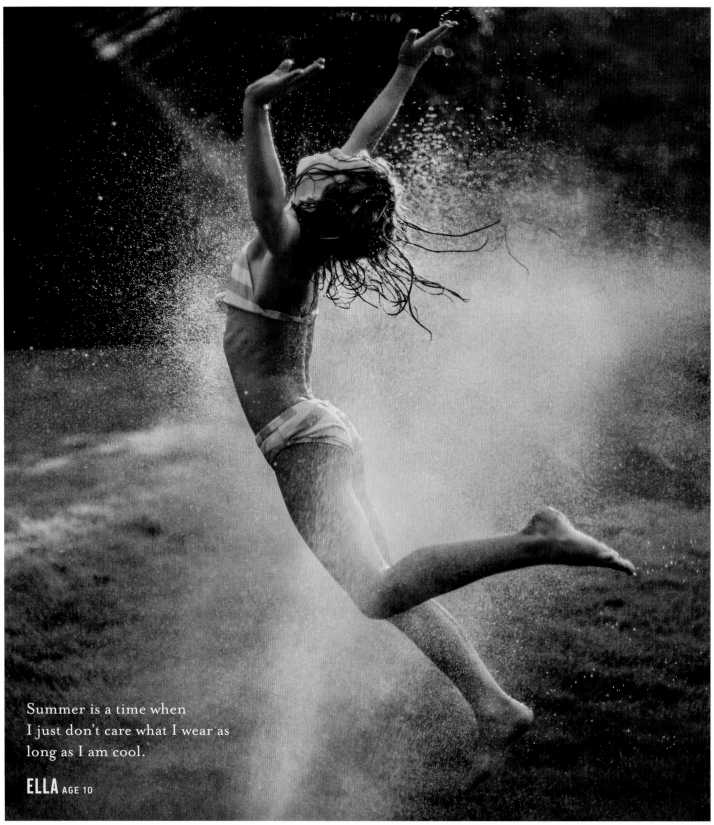

Summer is a time when
I just don't care what I wear as
long as I am cool.

ELLA AGE 10

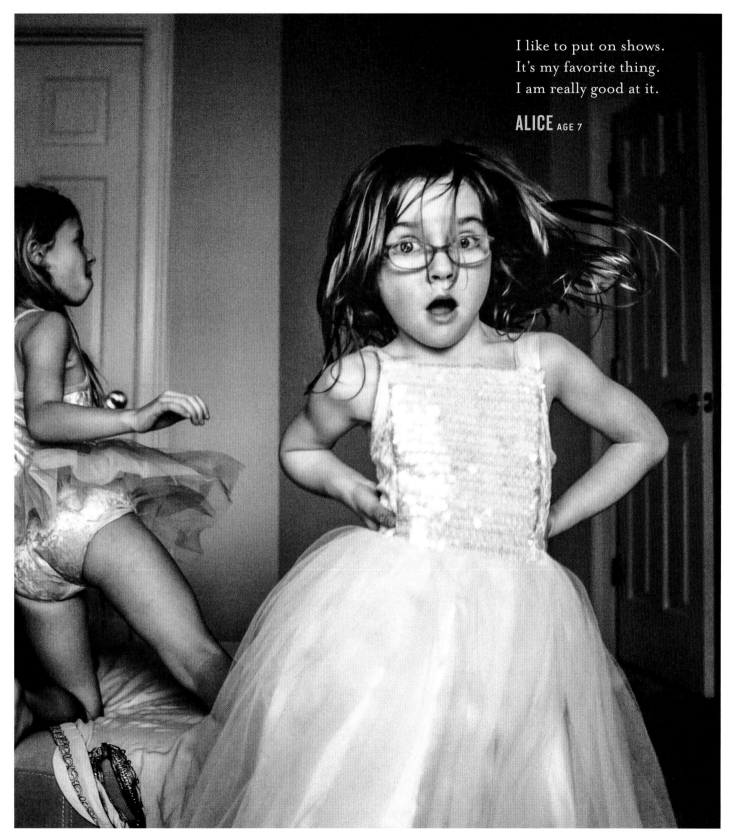

I like to put on shows.
It's my favorite thing.
I am really good at it.

ALICE AGE 7

"I say if I'm beautiful.
I say if I'm strong....
I stand here and am amazing,
for you.
Not because of you."

AMY SCHUMER

RESILIENT
IS STRONG

W e all get knocked down and kicked around. We fall. We fail. At work, at play, at school. Sometimes it feels unfair (*why did I get picked last for the team*?), and sometimes it feels like we brought it upon ourselves (*how could I have forgotten it was due today*?).

Regardless, the message is the same: Life will be tough sometimes. There's not one person on this earth who doesn't experience hard times or failures. And the girls in this chapter have experienced life in some of the most challenging extremes: cancer, broken bones, hurt feelings, Hurricane Katrina, juvenile arthritis. Their strength is apparent in how they have reacted to those hard times, whether they faced illness, injury, or bad luck. A bad call is just a bad call. A missed opportunity means more opportunities are on the way. Life knocks them to the ground, but they don't stay there—they never stay there. Family and friends may help along the way, but resilience is about harnessing an inner strength to fuel a fierce persistence in the face of hardship. May we all learn from their stories and their wisdom, and infuse our own lives with some of their grit.

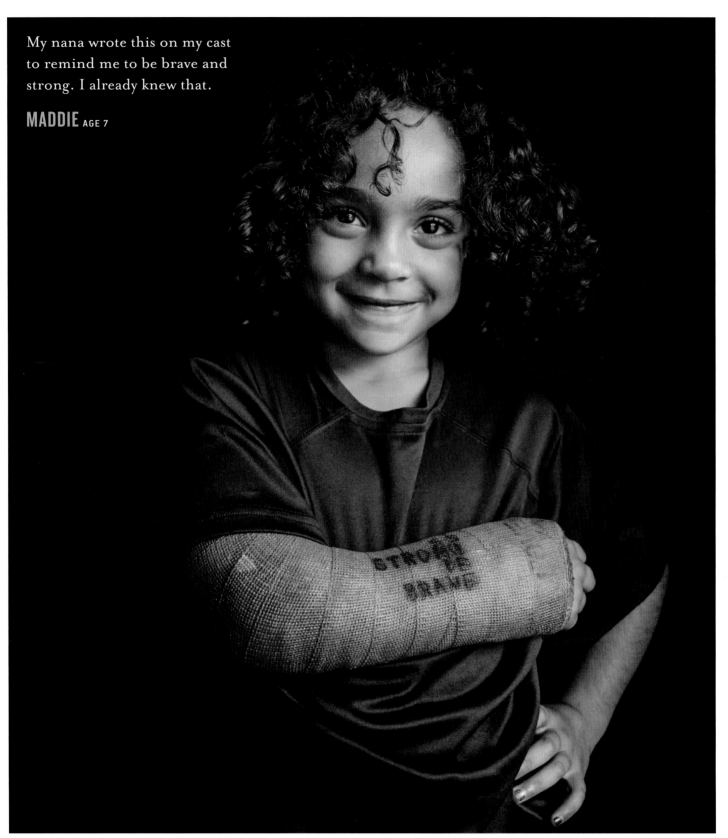

My nana wrote this on my cast to remind me to be brave and strong. I already knew that.

MADDIE AGE 7

Scars are worn by those who fought to overcome something hard in life and won.

PAIGE AGE 18

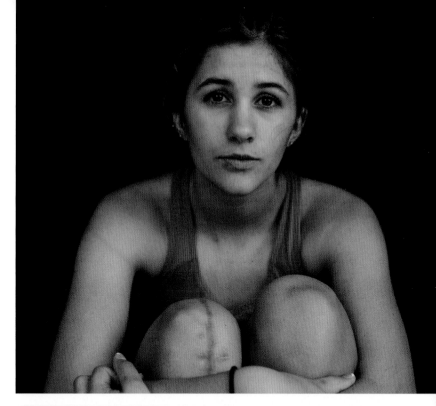

We worked really hard.

LULU AGE 9

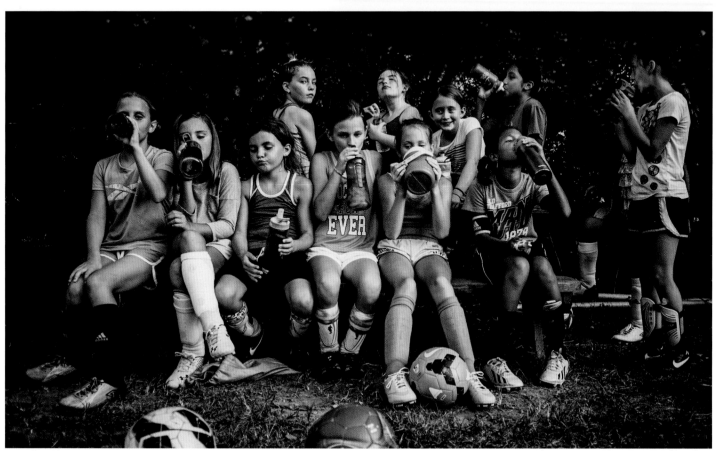

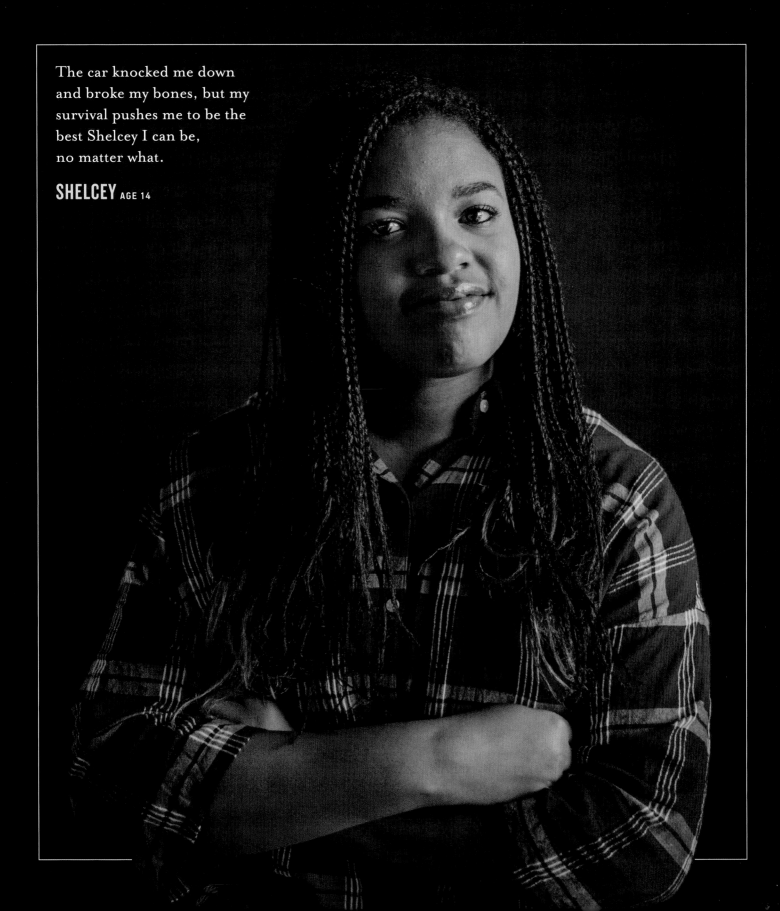

The car knocked me down
and broke my bones, but my
survival pushes me to be the
best Shelcey I can be,
no matter what.

SHELCEY AGE 14

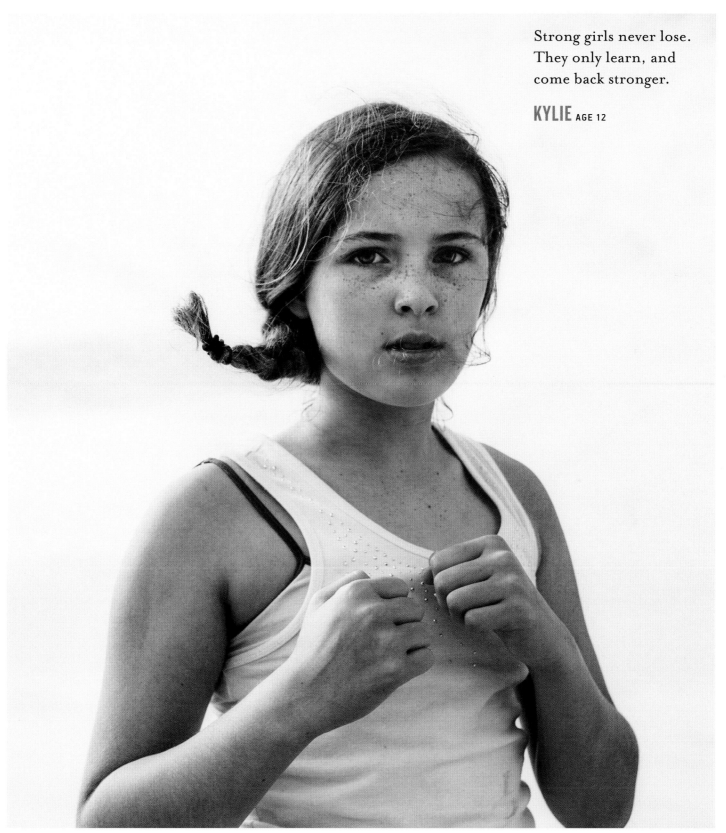

Strong girls never lose. They only learn, and come back stronger.

KYLIE AGE 12

If you're strong on the inside,
it means nobody can break you down.

CARLIE AGE 12

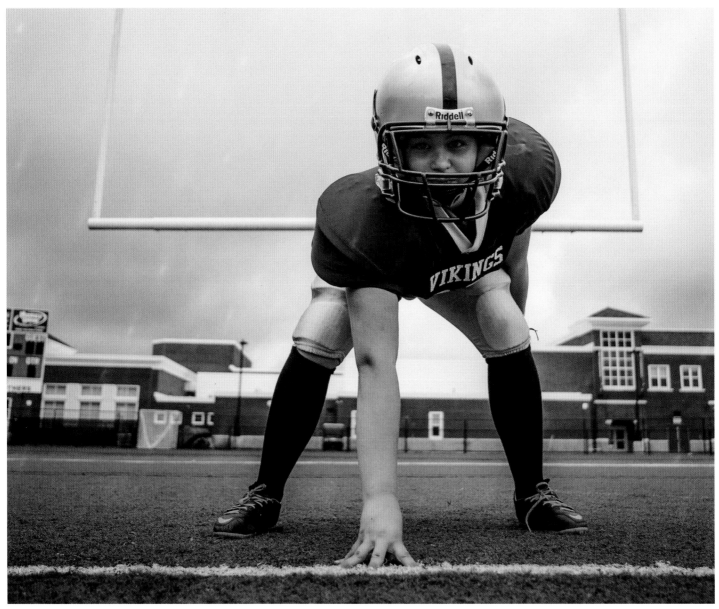

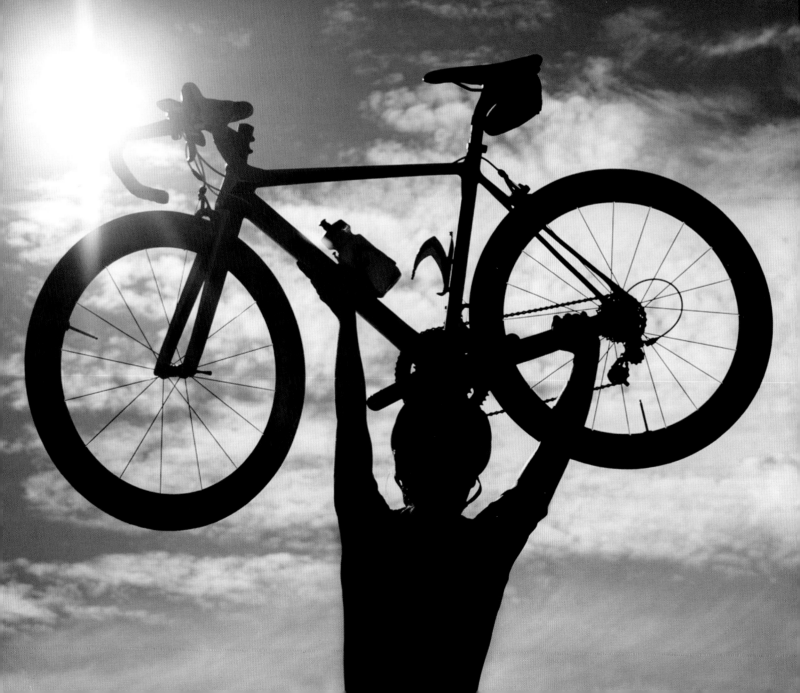

Cycling has taught me
that I can suffer more,
push harder, and dig
deeper than I ever
thought possible.

MEGAN H. AGE 16

Playing soccer isn't about looking pretty. It's about wiping away the tears, wiping away the blood, getting hugs from your teammates, and getting back on the field as soon as you can.

JULES AGE 9

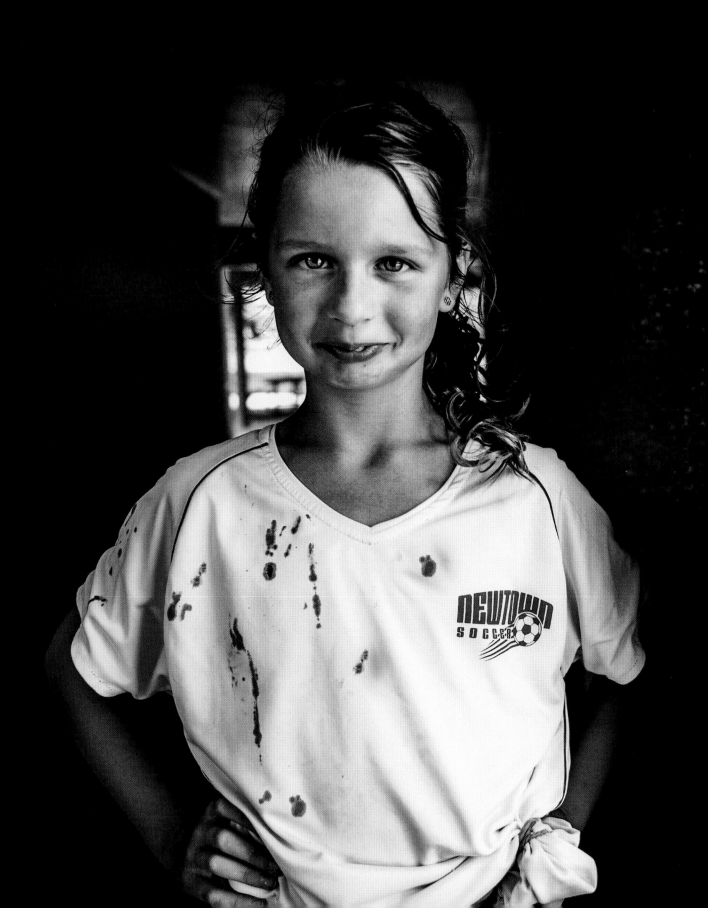

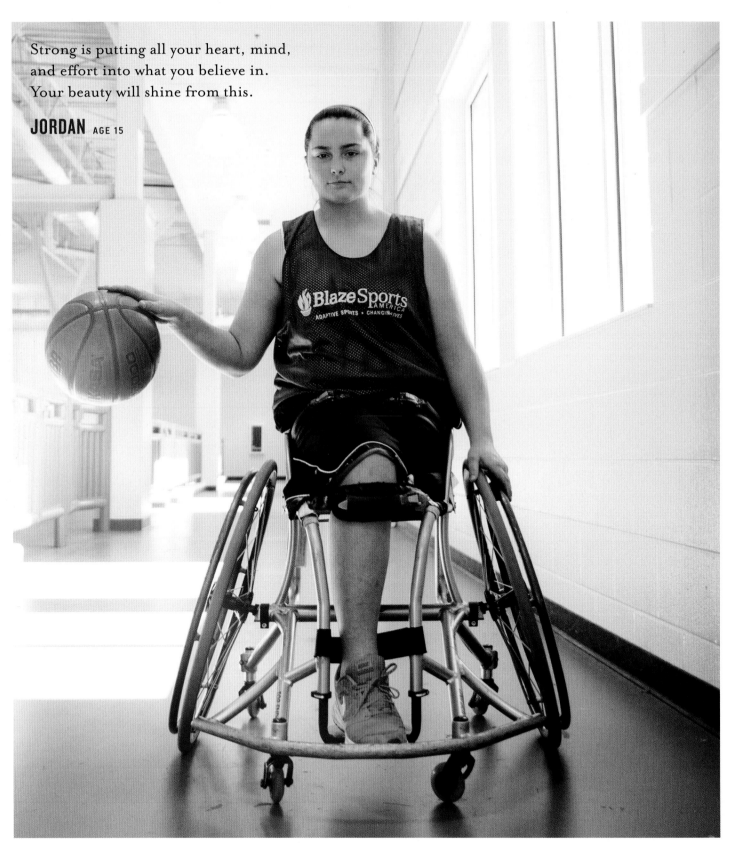

Strong is putting all your heart, mind, and effort into what you believe in. Your beauty will shine from this.

JORDAN AGE 15

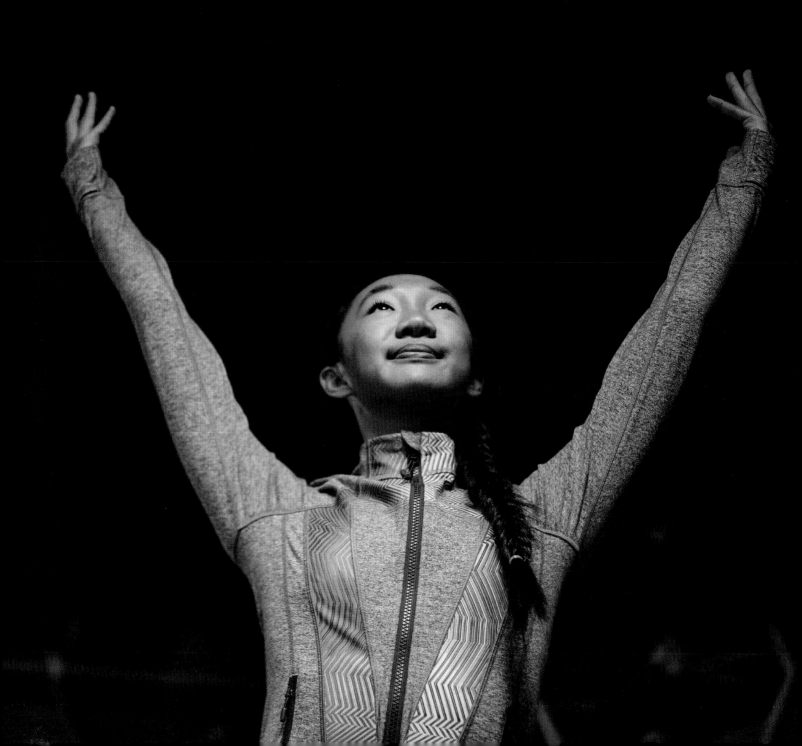

Dancing onstage gives me
a rush like nothing else.

EMILY T. AGE 15

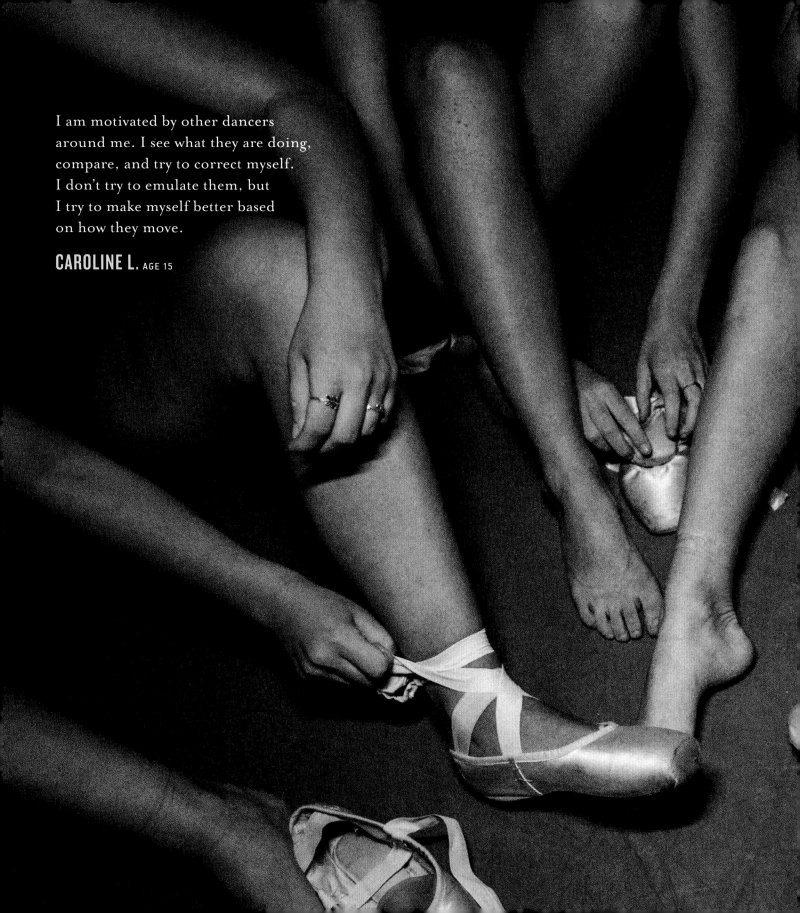

I am motivated by other dancers
around me. I see what they are doing,
compare, and try to correct myself.
I don't try to emulate them, but
I try to make myself better based
on how they move.

CAROLINE L. AGE 15

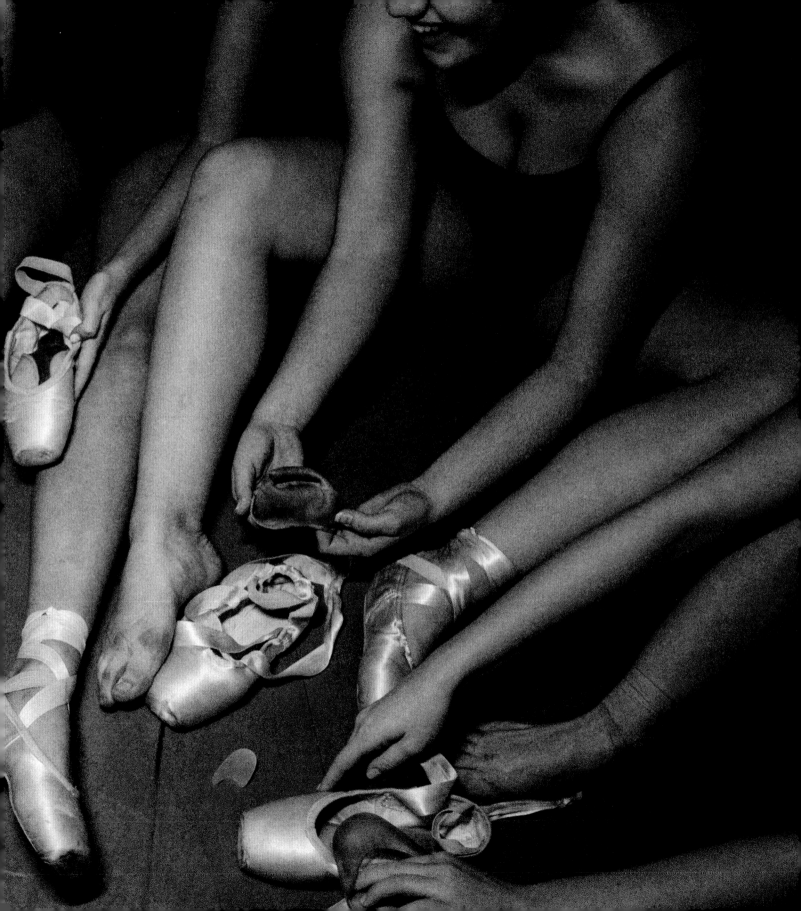

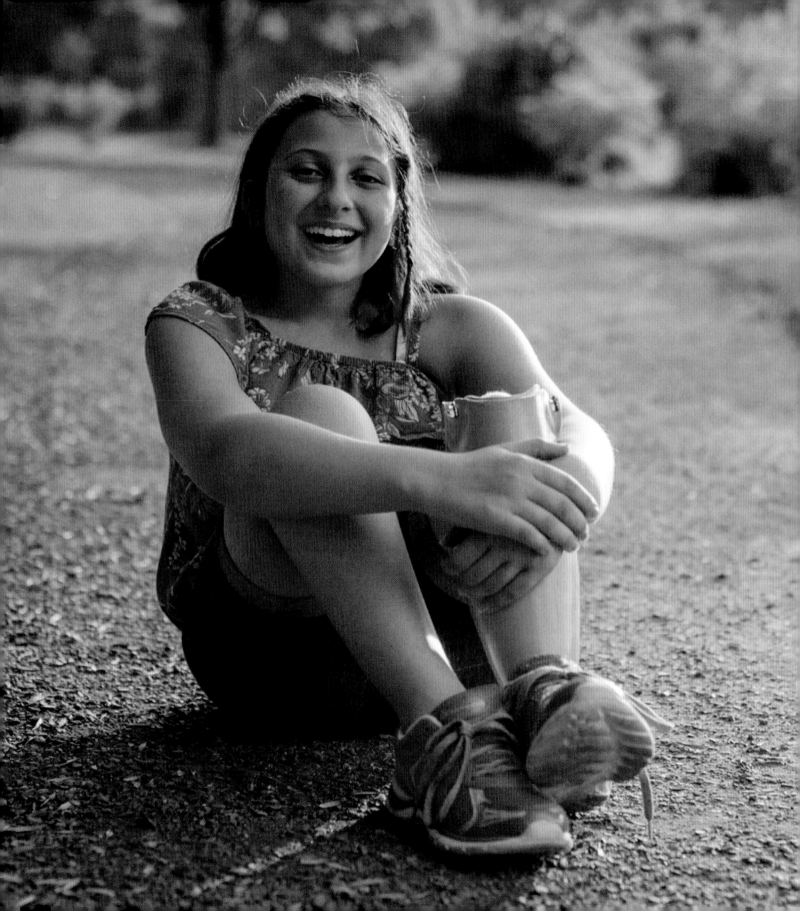

Who likes perfect anyway?
Perfect is boring.

NOUR AGE 11

Even a princess
can be a warrior.
My cancer didn't
stand a chance.

LAUREN M. AGE 12

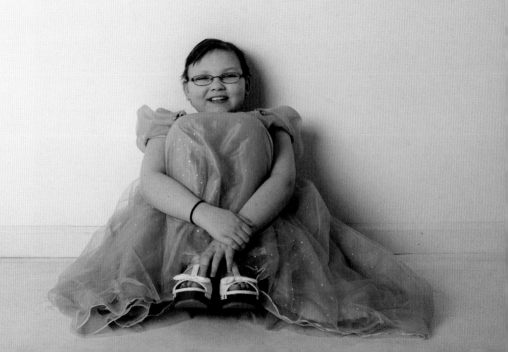

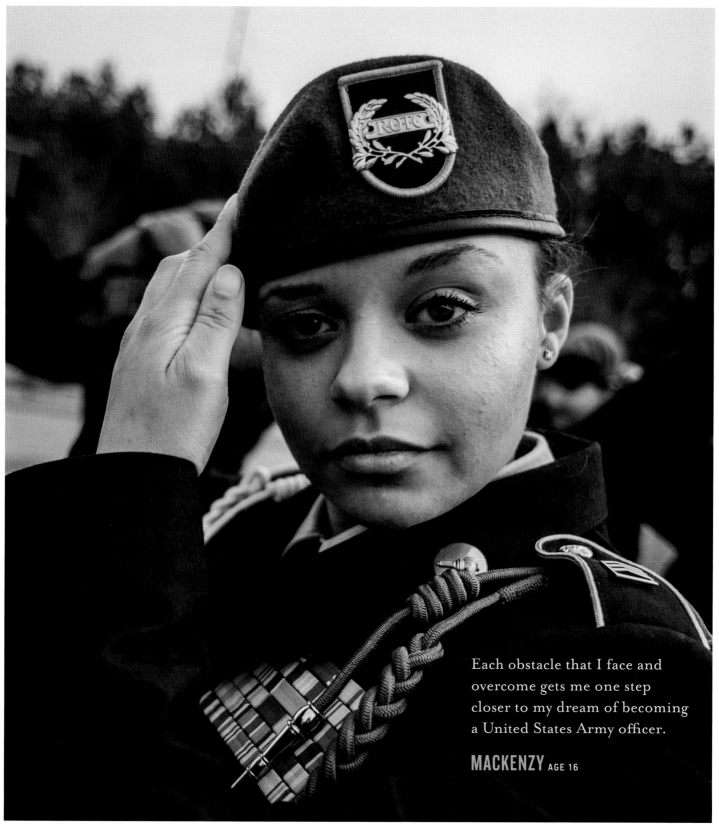

Each obstacle that I face and overcome gets me one step closer to my dream of becoming a United States Army officer.

MACKENZY AGE 16

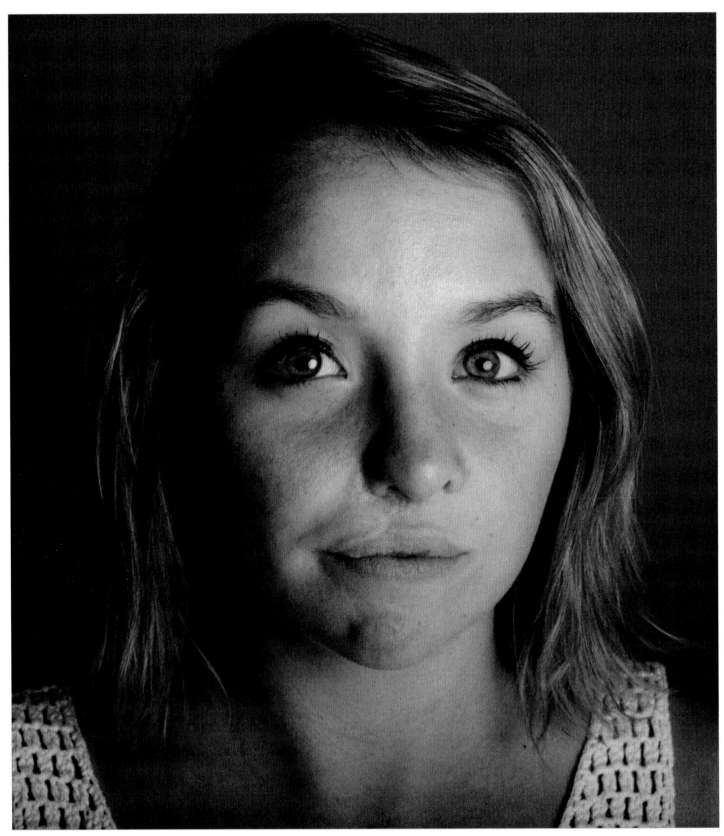

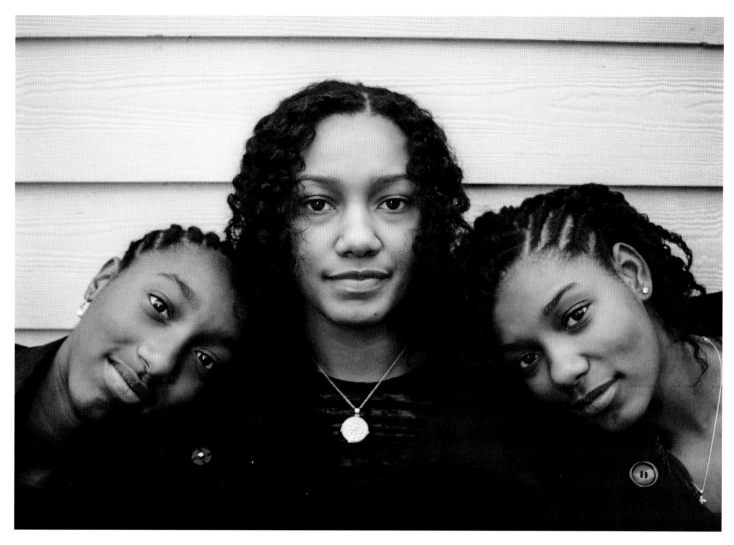

It was scary when Hurricane Katrina hit, but I was not afraid to be strong and be there for the people I love.

DIARRA AGE 16

Strong is being able to look at a challenge and foresee the magnificent outcomes that it may bring.

GRACE P. AGE 18

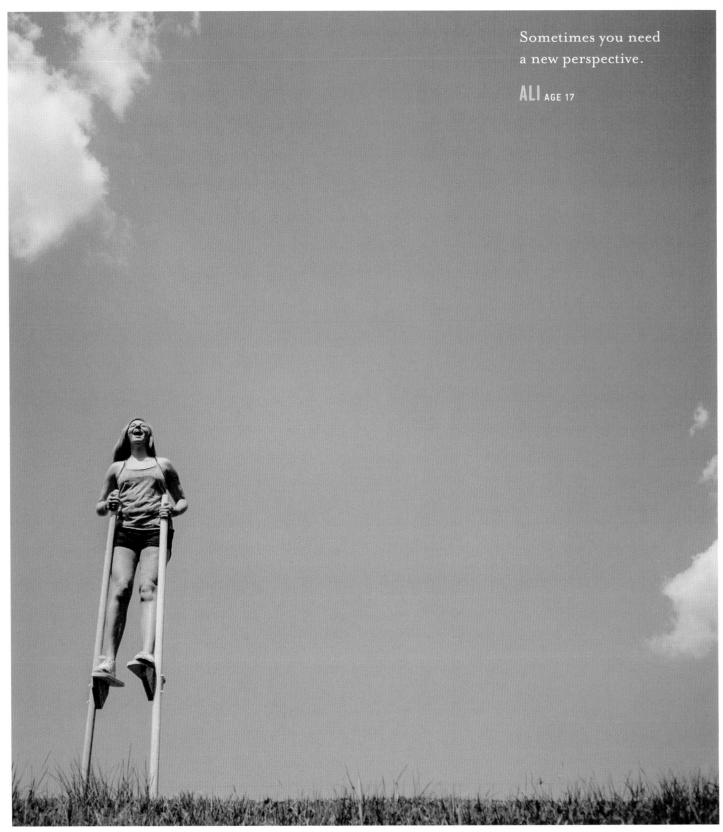

Sometimes you need
a new perspective.

ALI AGE 17

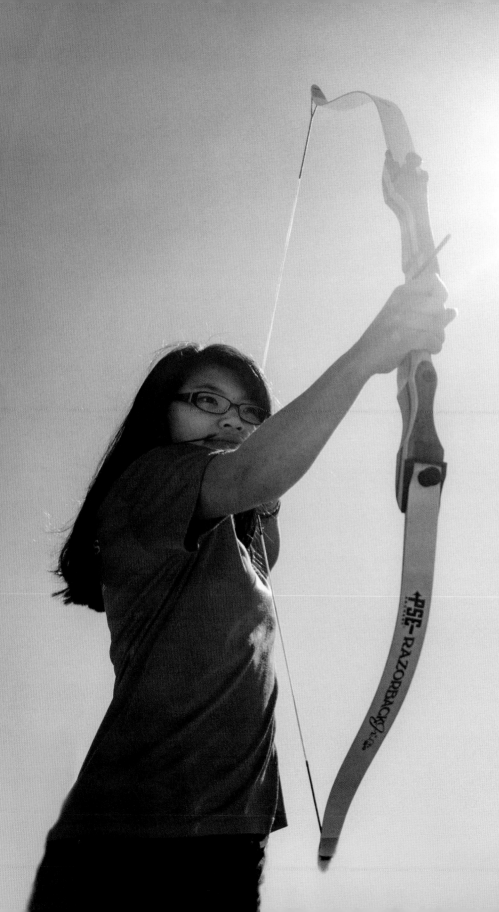

Last year I chose to move to a
different lunch table instead of
being ignored by people who
I thought were my friends.

NATALIE AGE 15

"A woman with a **voice** is, by definition, a strong woman."

MELINDA GATES

CREATIVE
IS STRONG

◆

Y ou know those things that you dream about during the day when you're stuck in a dull meeting? The project you can't wait to start, the adventure you're planning, the plan you can't wait to discuss with your best friend? Those are the irrepressible ideas that nudge and nudge and nudge until you finally pay attention. *Pay attention*.

Creativity is magic, a burning curiosity, but it is also hard work—and it may involve revealing vulnerability. But using your own imagination to solve problems or to express yourself is also an expression of power. We *each* have an imagination, but it's that ability to hold on to our creativity as we grow and mature that keeps it strong: The more you exercise it, the more it becomes second nature.

Creativity isn't just for the rising Frida Kahlos and Beyoncés among us; it's for everyone brave enough to act on those thoughts and daydreams. The girls in this chapter are inspiring for their drive—their tireless pursuit of a passion, whether they're on the road to becoming valedictorian, perfecting a pirouette, making an imaginary world out of a cardboard box, or simply discovering a solution that no one else has considered. When it comes time to paint the painting, write the play, raise their hand to ask the question, turn over the rock to see what's underneath, score the goal, open the door, explore the unknown, or obliterate expectations, they're that much better prepared because they imagined it a million times already.

I love decorations.
Everywhere!

ALICE AGE 7

We play "spy" and imagine we
are spying on the bad guys and
protecting the good guys.

MIA AGE 9

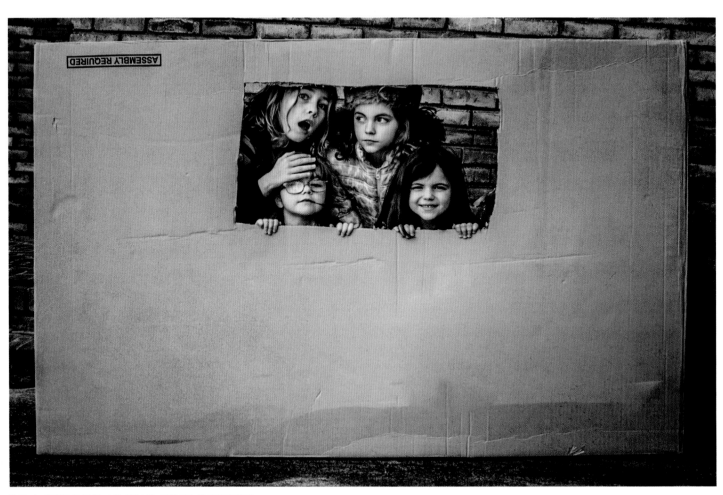

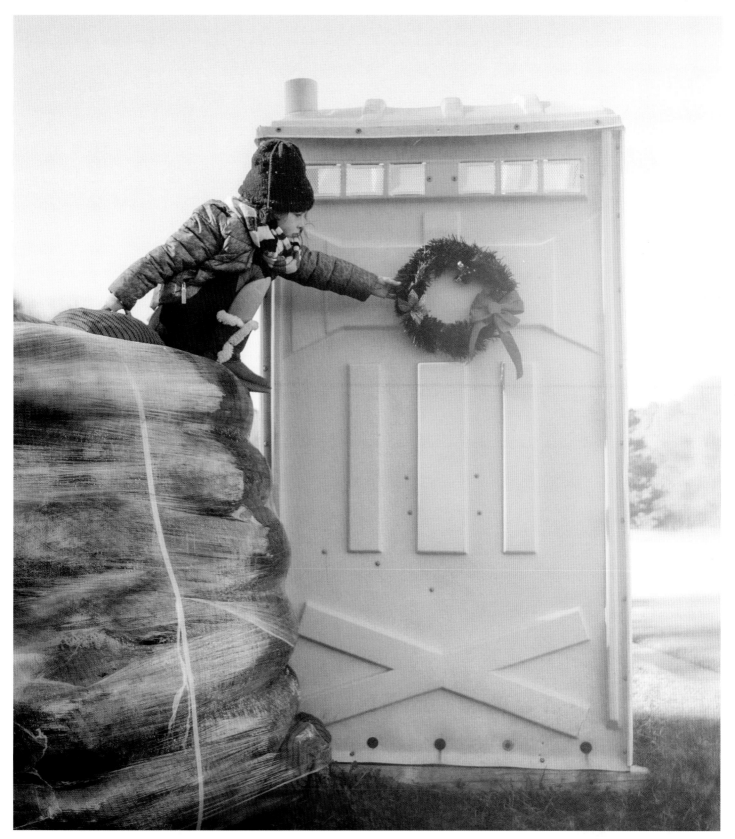

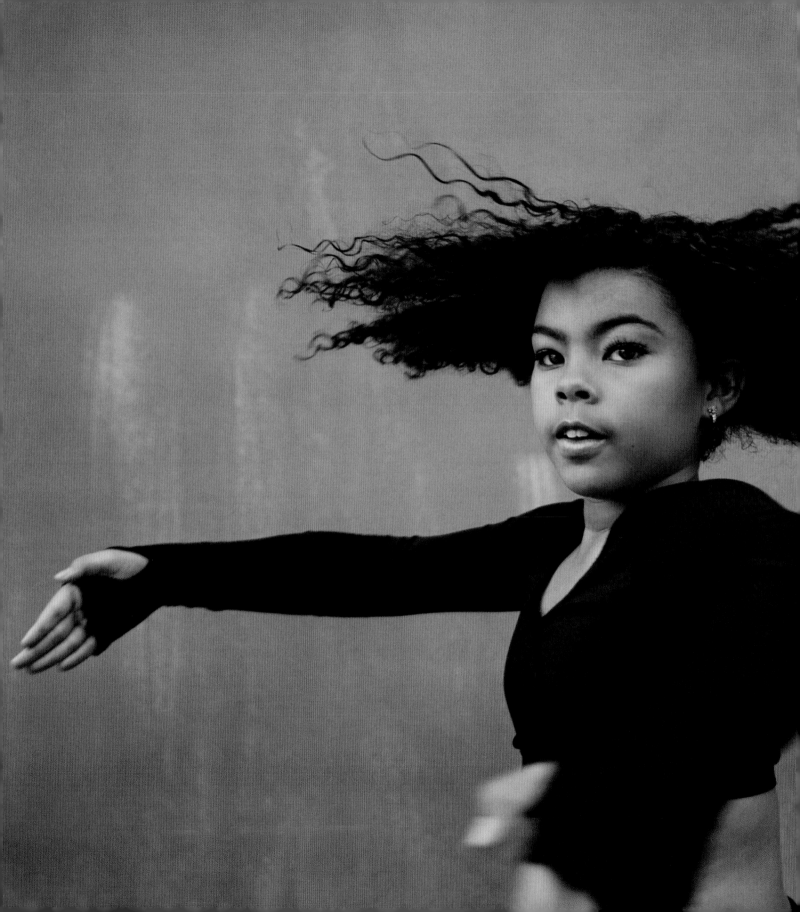

Some people don't think dance
is a real sport, but it takes a lot
of strength to master the technique,
it takes time to make improvements,
and it takes passion and dedication
to reach your goal.

KAMI AGE 11

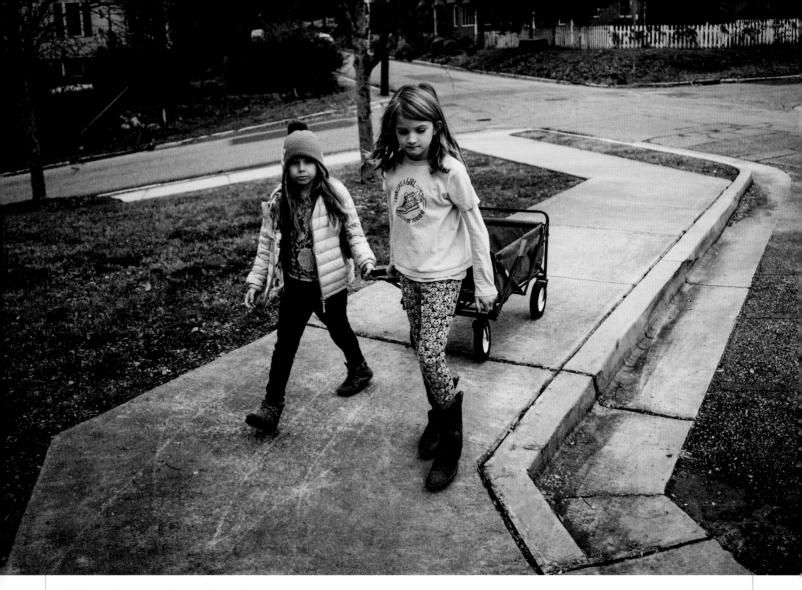

When I am with my friends,
nothing is impossible.

SLOANE AGE 8

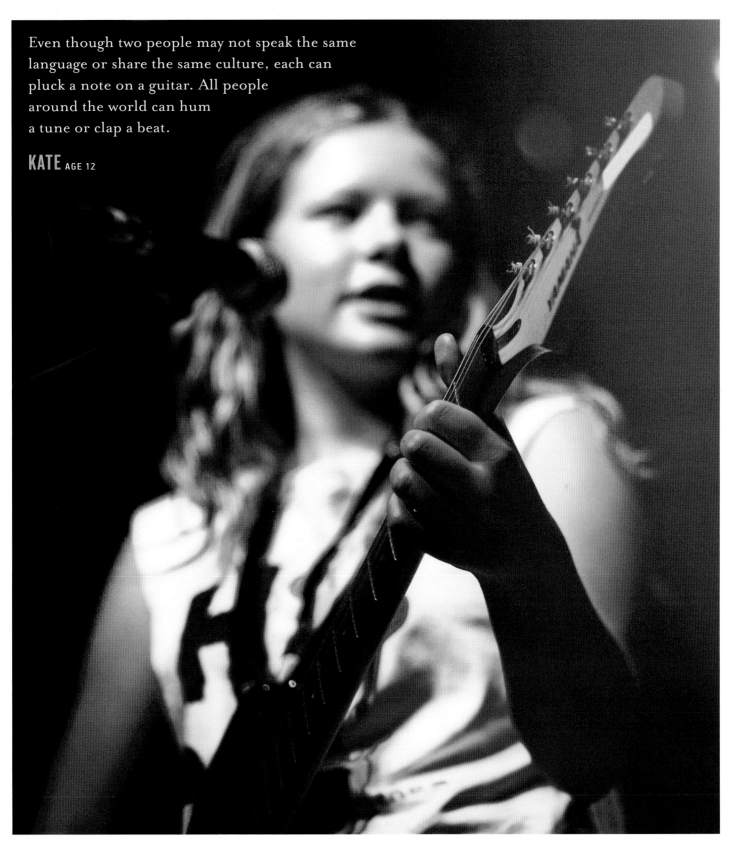

Even though two people may not speak the same language or share the same culture, each can pluck a note on a guitar. All people around the world can hum a tune or clap a beat.

KATE AGE 12

Being creative brings innovation and
cultural diversity into the world.

HERMELLA AGE 13

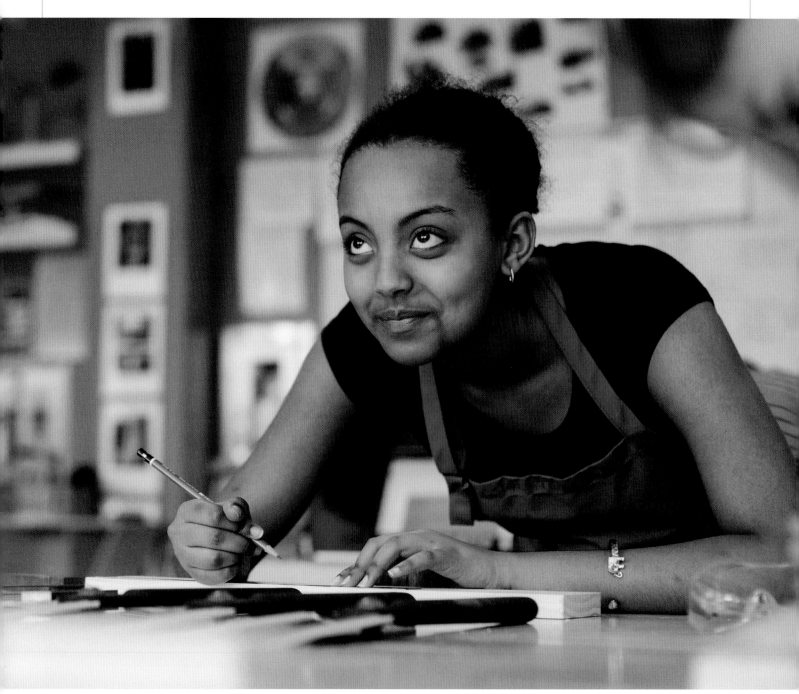

We catch the crabs, but then we let
them go before they die.

TAYLA AGE 6

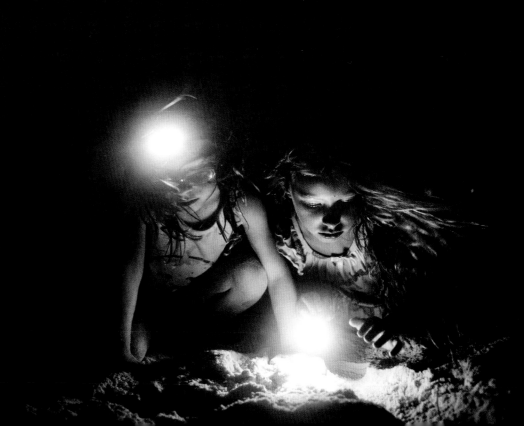

The beach at night is my favorite place
in the world. No one is here, it is so quiet,
and all these little animals come out to say hello.

ELLA AGE 10

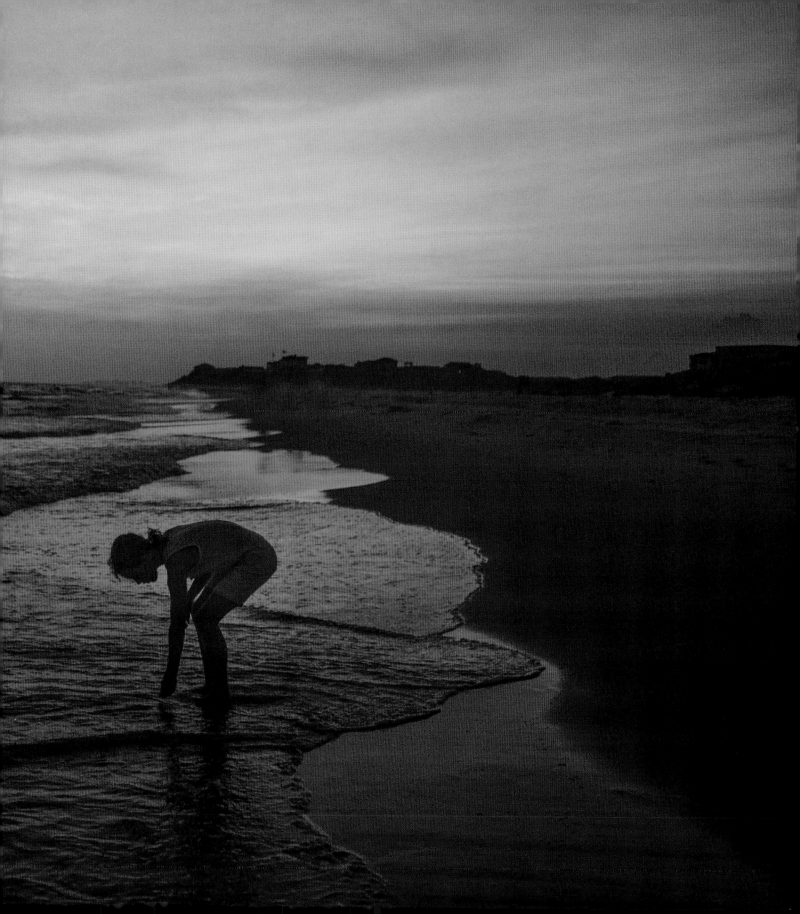

I LOVE MY FRECKLES. THEY'RE PART OF ME.

ELLA D. AGE 9

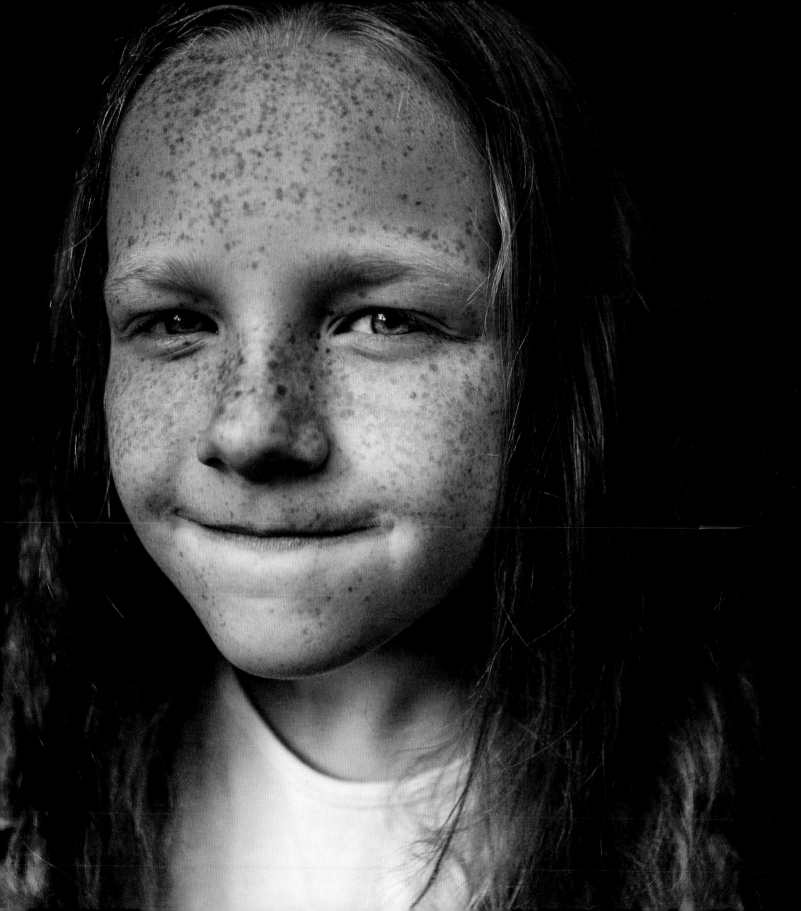

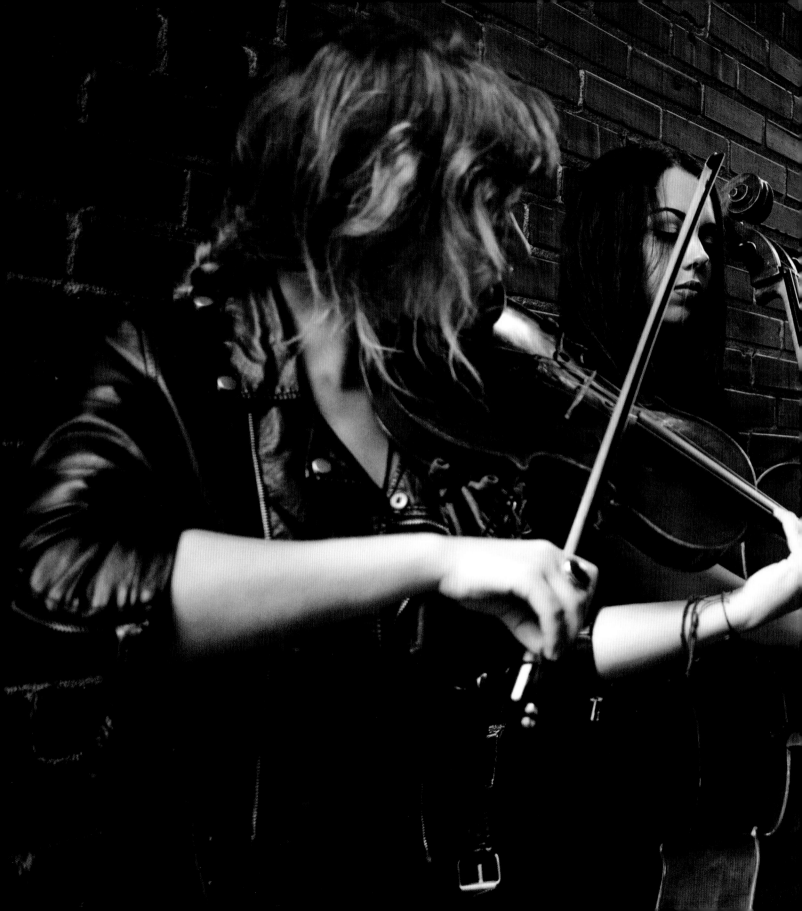

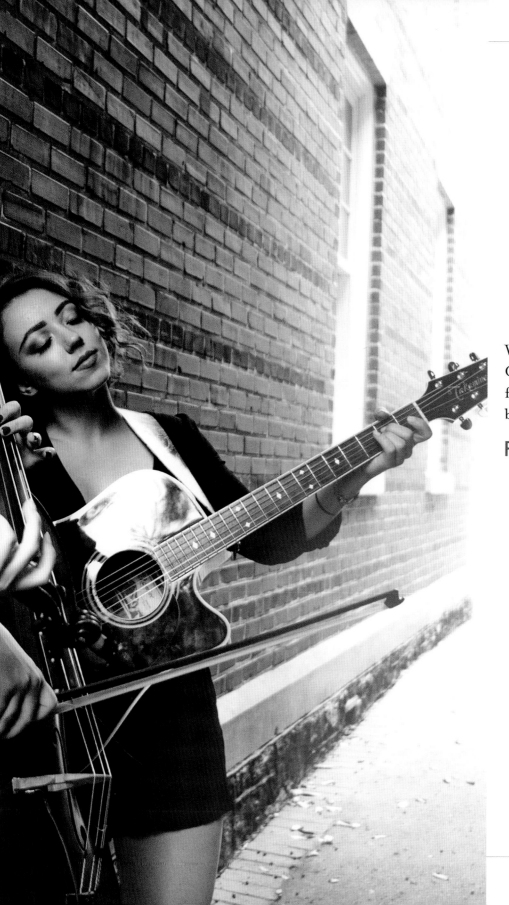

We are a band of sisters.
Our strength comes through
finding our own voices and
being brave enough to use them.

FIONA AGE 18

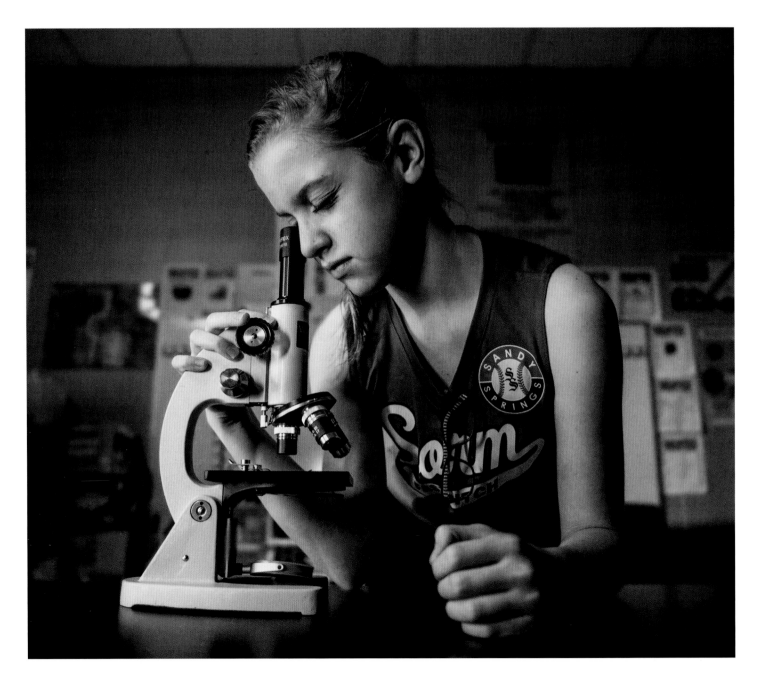

Science is awesome.
I have an A-plus in my science class.

WHITNEY AGE 10

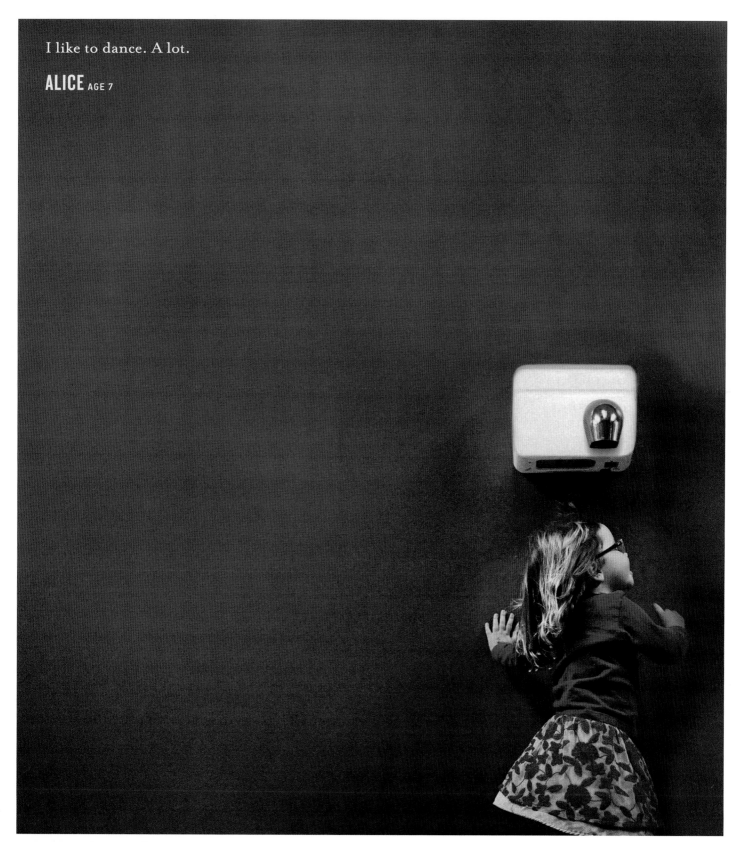

I like to dance. A lot.

ALICE AGE 7

I am into all animals,
except spiders. I have three
things I want to be when
I grow up: a zookeeper,
a paleontologist, and
I forgot the third.

BRIEL AGE 7

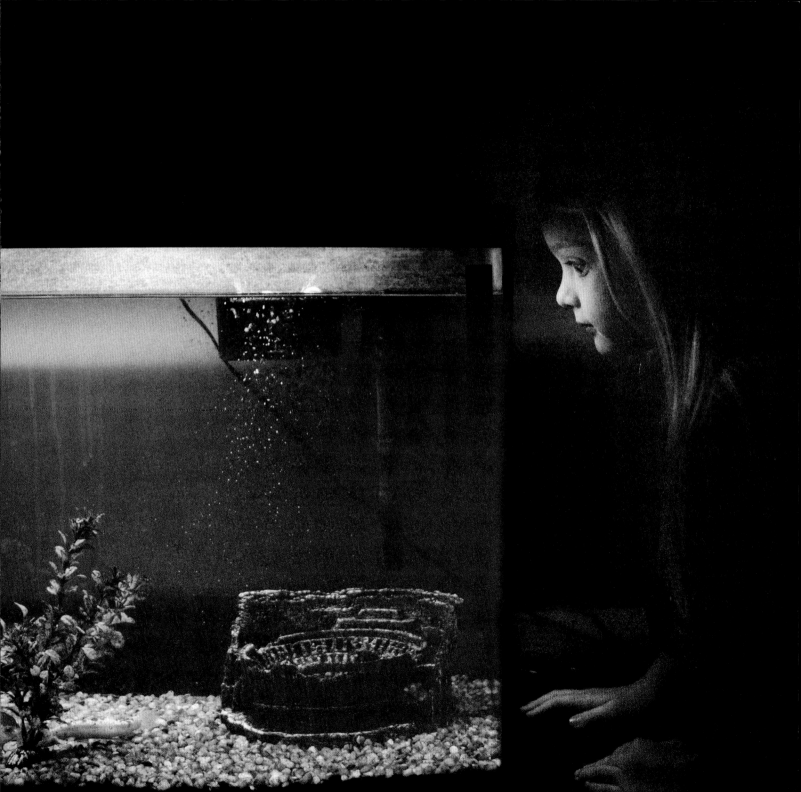

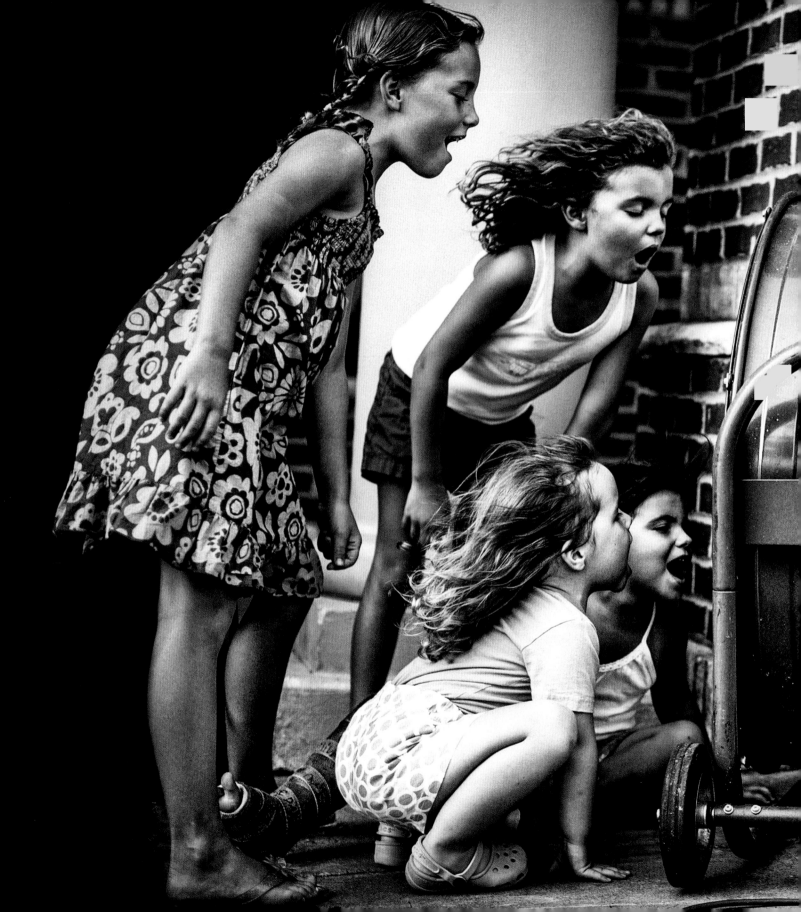

You know that sound
when you yell into a fan?
You should try it sometime.

MIA AGE 8

Lizards are hard to catch,
but so awesome when you do.

ALICE AGE 7

If I know the answer, I always
put my hand way up high.

LILY B. AGE 11

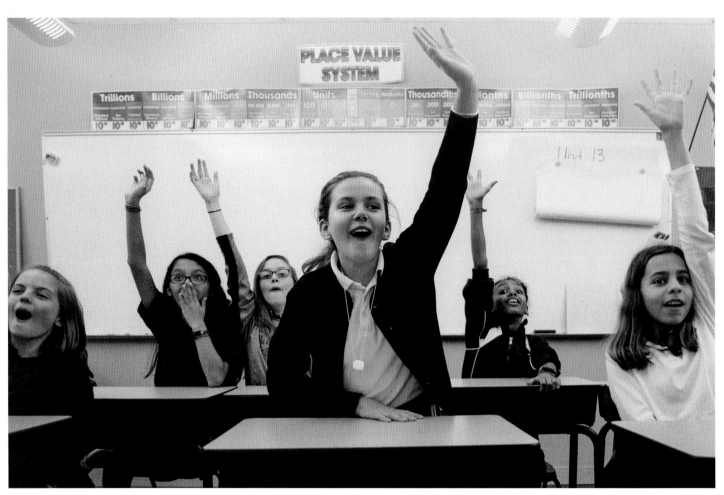

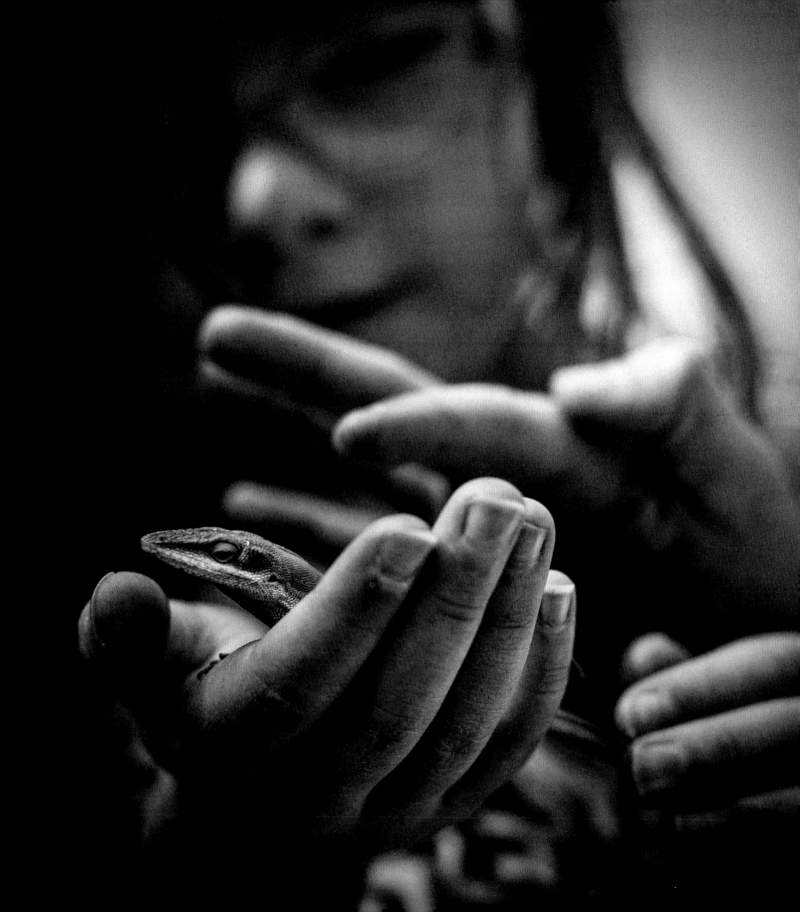

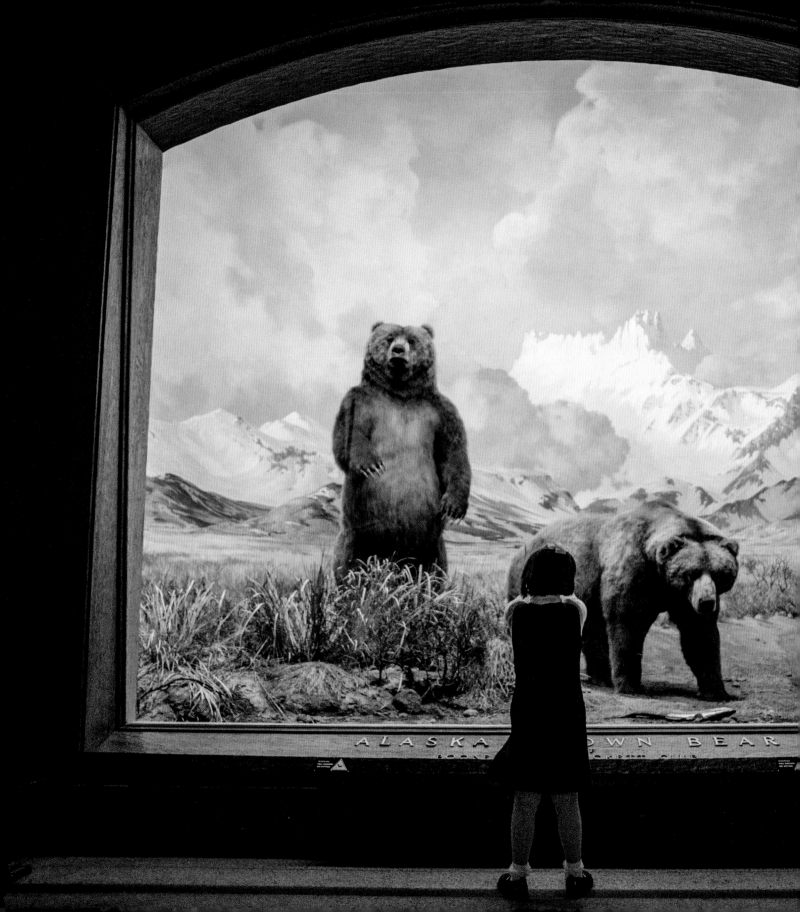

I love going to museums because
it feels like I am standing super-close
to real, live bears.

JANE F. AGE 6

"Being **strong** is pursuing my **dream** 100 percent by **pushing** toward my goal without quitting or **giving up.**"

GABBY DOUGLAS

DETERMINED
IS STRONG

◆

I tell my daughters all the time that *the only thing you can control is how hard you work*. But determination isn't mindless. Just like any kind of strength, determination is dynamic. If that wall you're banging on won't come down, then look for ways around it, over it, under it. But keep looking. Determination is powered by curiosity and sheer will, and you can see it in the faces of the girls on the following pages.

No matter what happens, no matter how many times they've been told no or how many times they've failed, they won't be outworked. It's the only part of the equation that they get to completely control. They keep moving, they keep talking, they keep their heads in it and focused, and they know good things will happen. Finish lines will be crossed, next levels unlocked, more chapters read. Talent and timing and ability are all great, but I'll bet on a determined girl to win it. Every day.

I give it my all, always, even when nobody is watching. My mom says that is what integrity is all about.

PARKER AGE 10

I never thought I could finish a three-mile race, but when I'm with my friends, I feel like I can do anything.

RASHELLE AGE 9

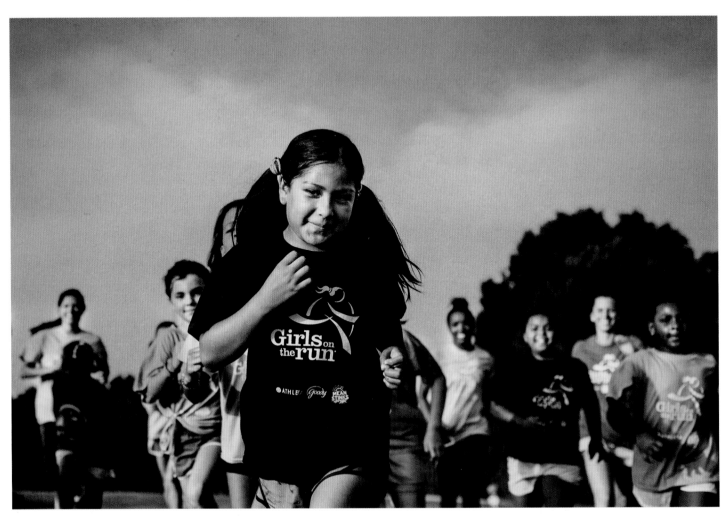

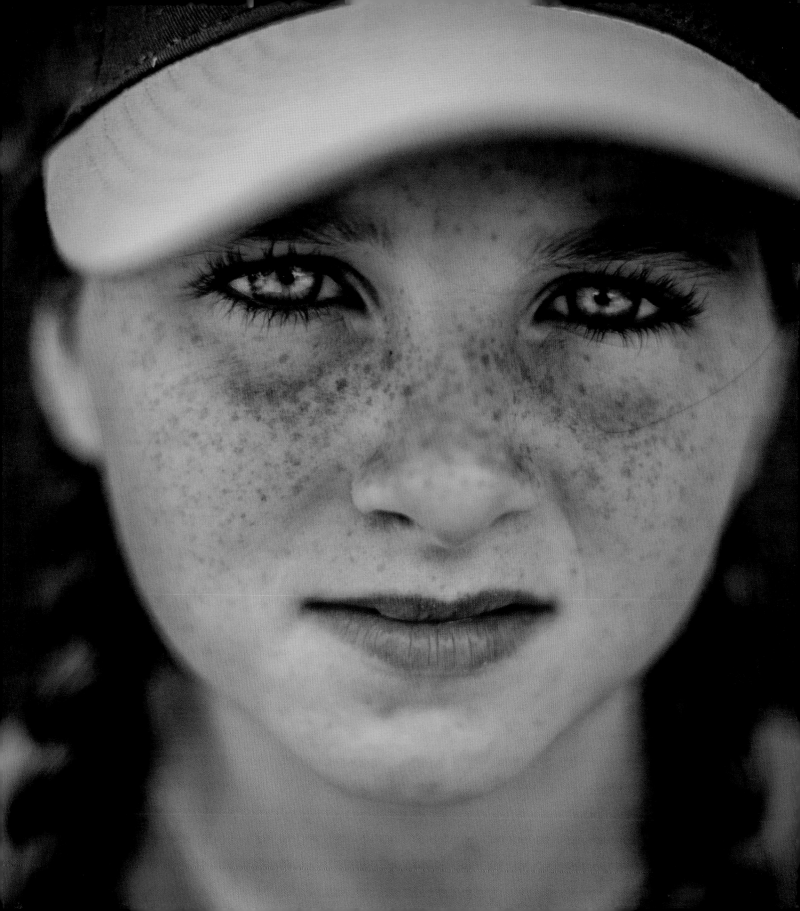

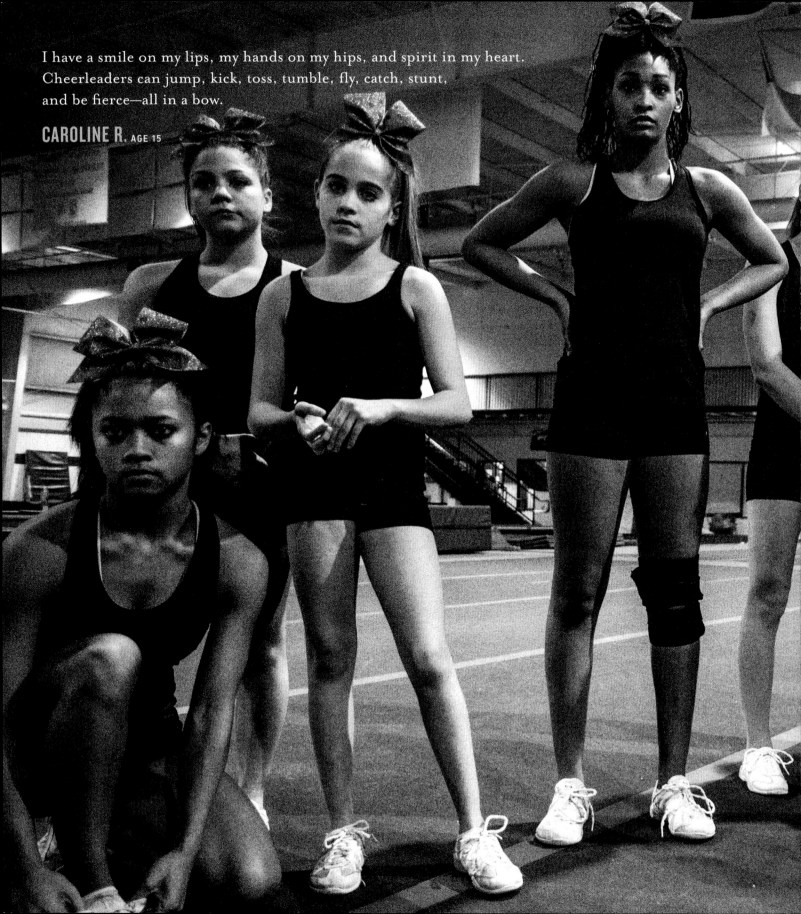

I have a smile on my lips, my hands on my hips, and spirit in my heart.
Cheerleaders can jump, kick, toss, tumble, fly, catch, stunt,
and be fierce—all in a bow.

CAROLINE R. AGE 15

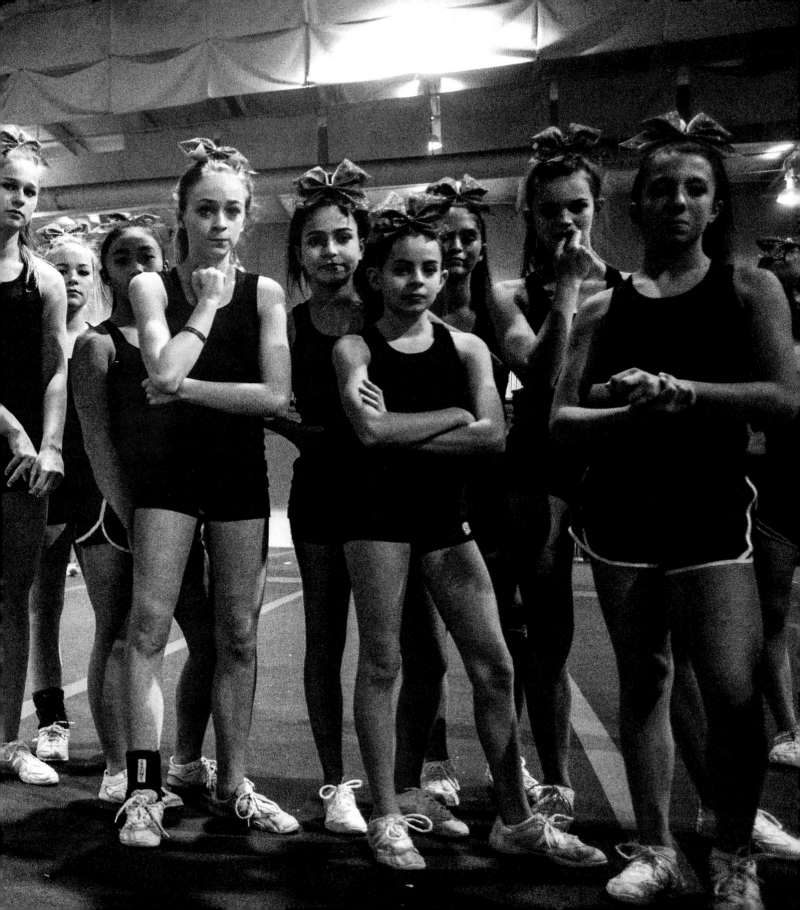

The best part of being on a
roller derby team is finding
your inner strong.

ISABEL AGE 8

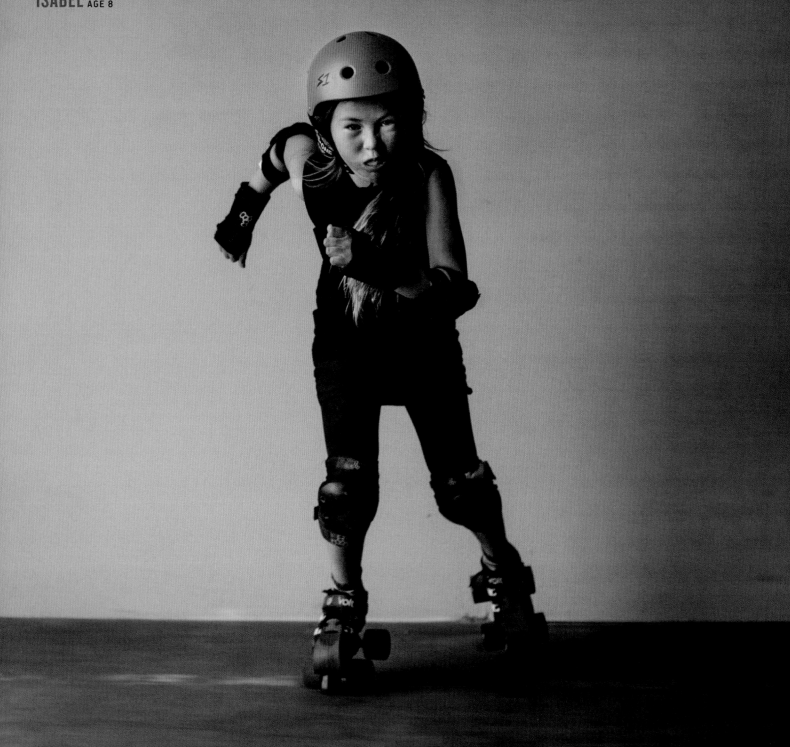

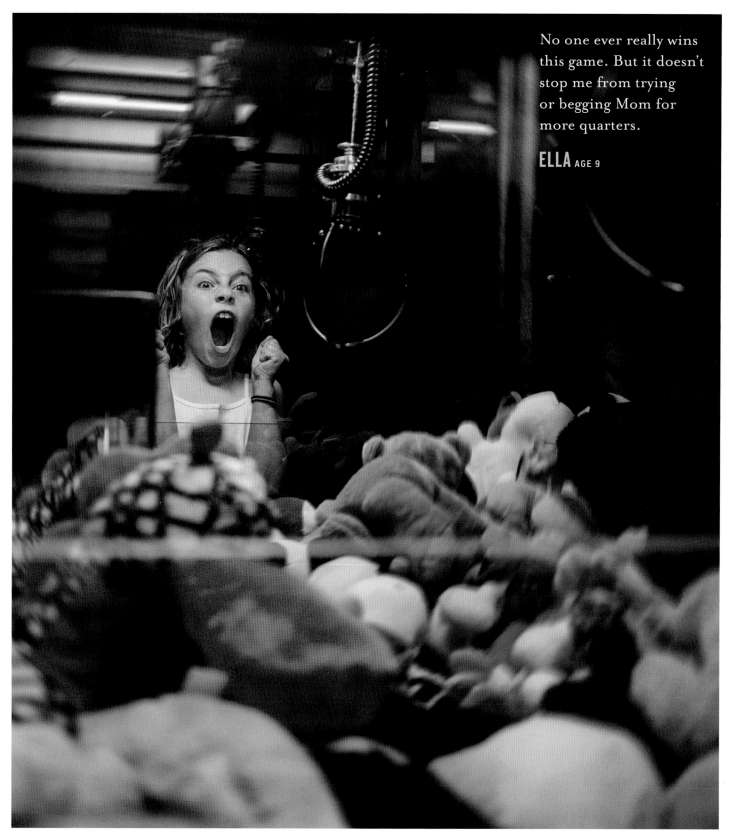

No one ever really wins this game. But it doesn't stop me from trying or begging Mom for more quarters.

ELLA AGE 9

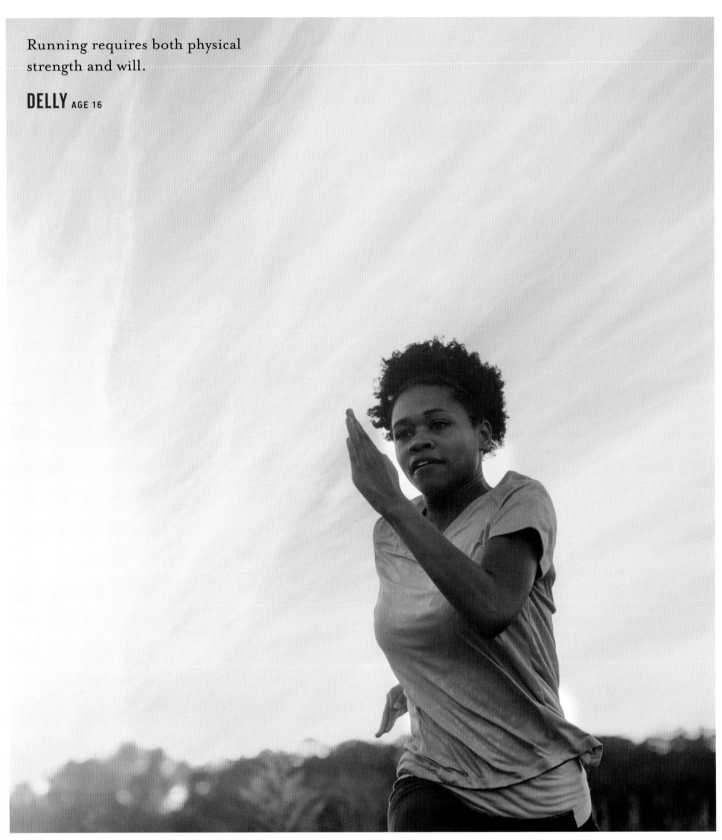

Running requires both physical strength and will.

DELLY AGE 16

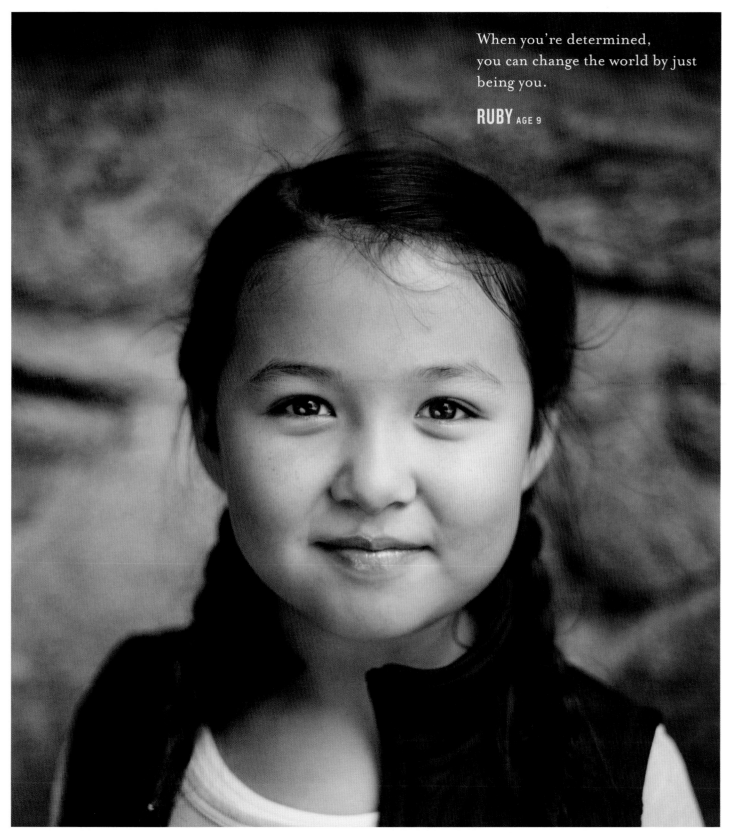

When you're determined,
you can change the world by just
being you.

RUBY AGE 9

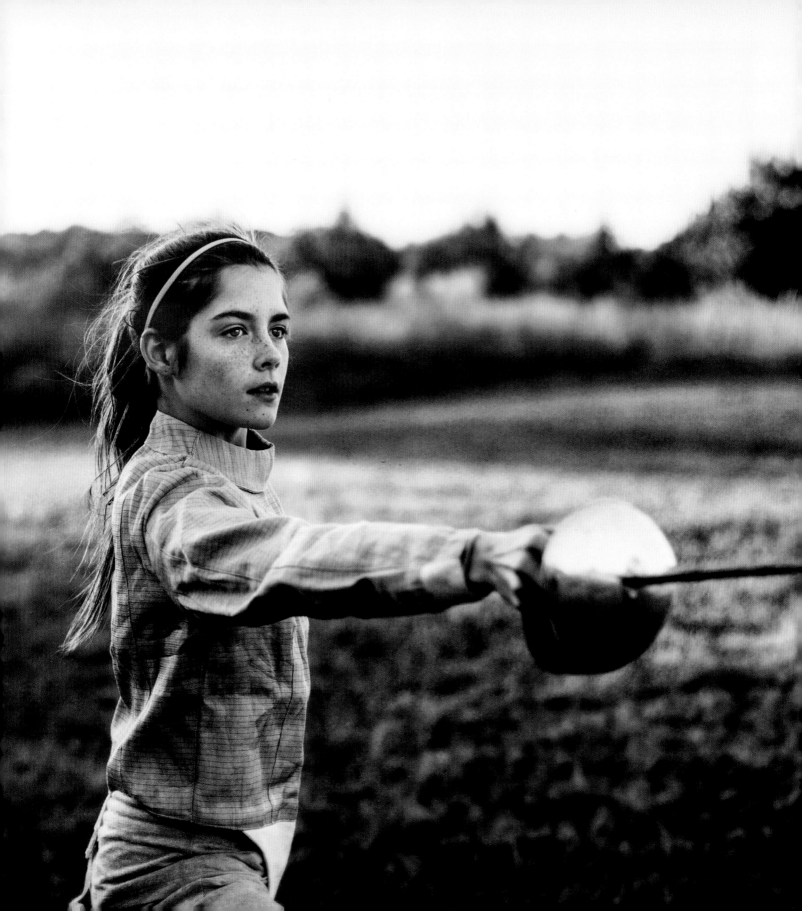

Being mentally strong is ten times harder than being physically strong. Mental stamina does not come from the muscles or from training. It comes from the heart . . . and from the mind. Calling on my heart is far more difficult than calling on my muscles.

CATHERINE AGE 12

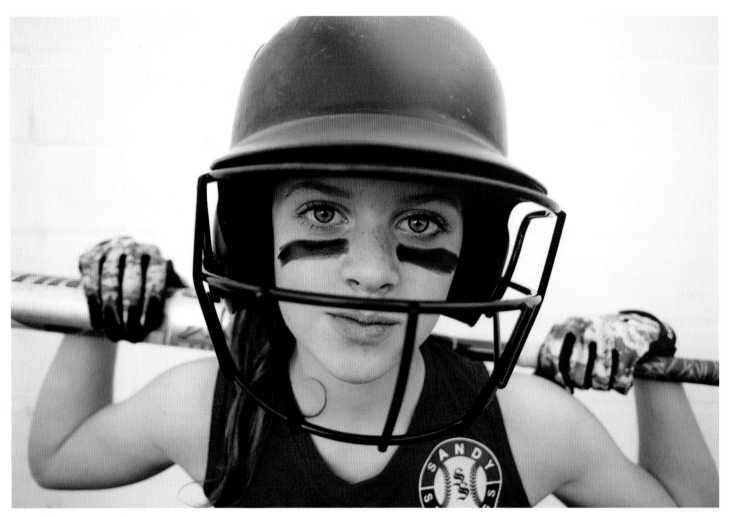

When you're at bat, you have to keep your eye on the ball. You have to block out everything—the cheering, your coaches—and just focus, focus, focus.

WHITNEY AGE 10

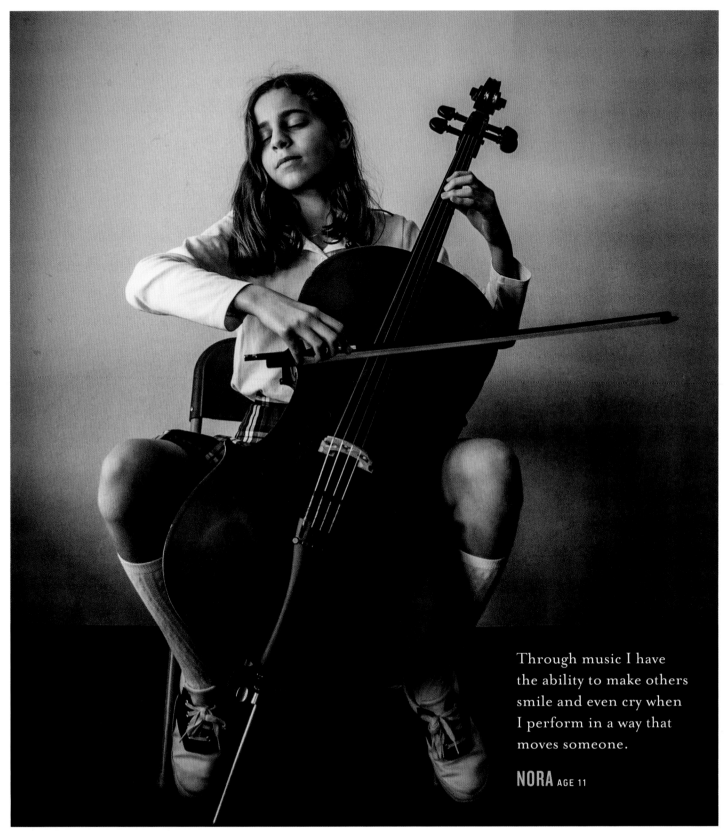

Through music I have the ability to make others smile and even cry when I perform in a way that moves someone.

NORA AGE 11

I can do lots of things people think
I'm not strong enough to do.

DILLAN AGE 6

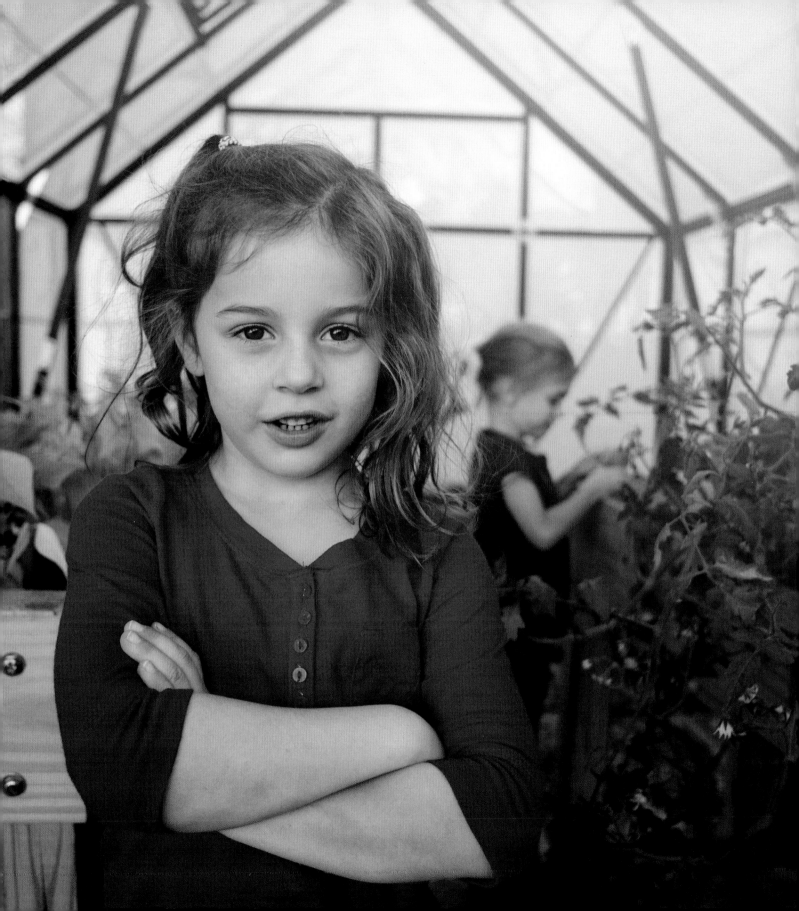

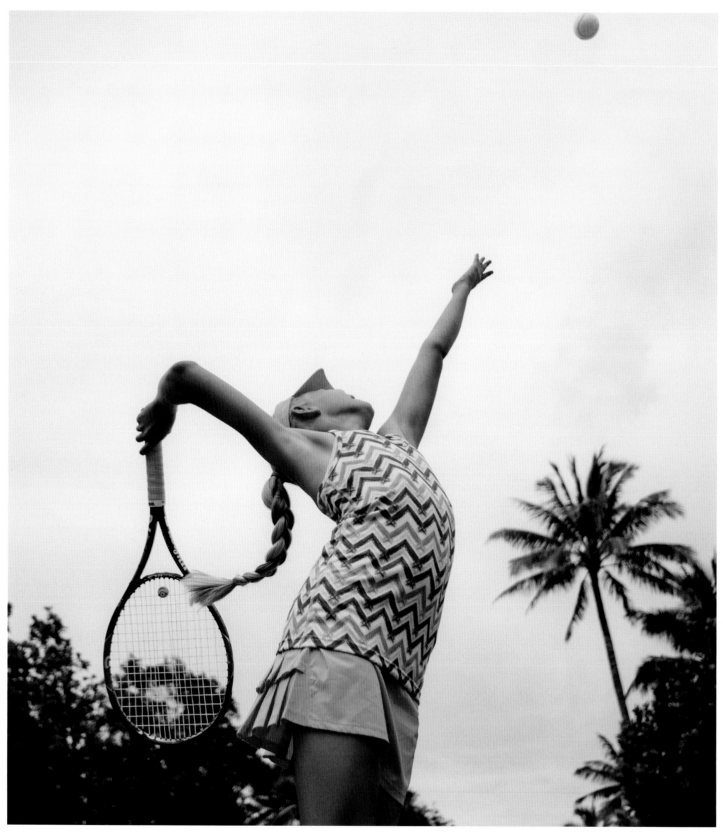

Be a good sport and have a positive attitude. When you walk off the court, no one should be able to tell if you won or lost.

HARLEY AGE 10

Some people think rowing is boring, but every day is different—I love that Mother Nature can bring so much challenge and happiness all at once.

LAURA AGE 15

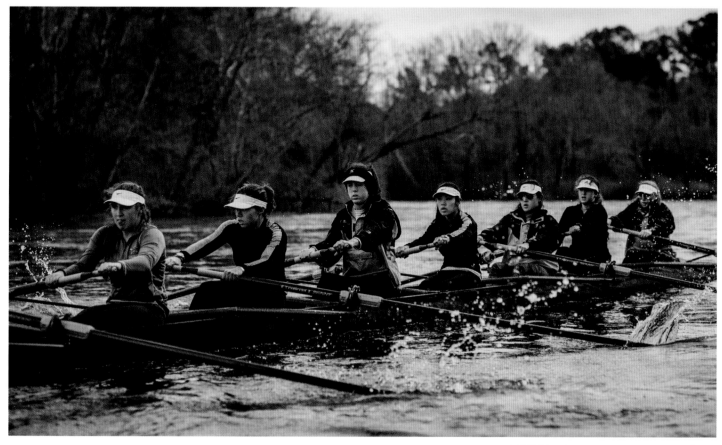

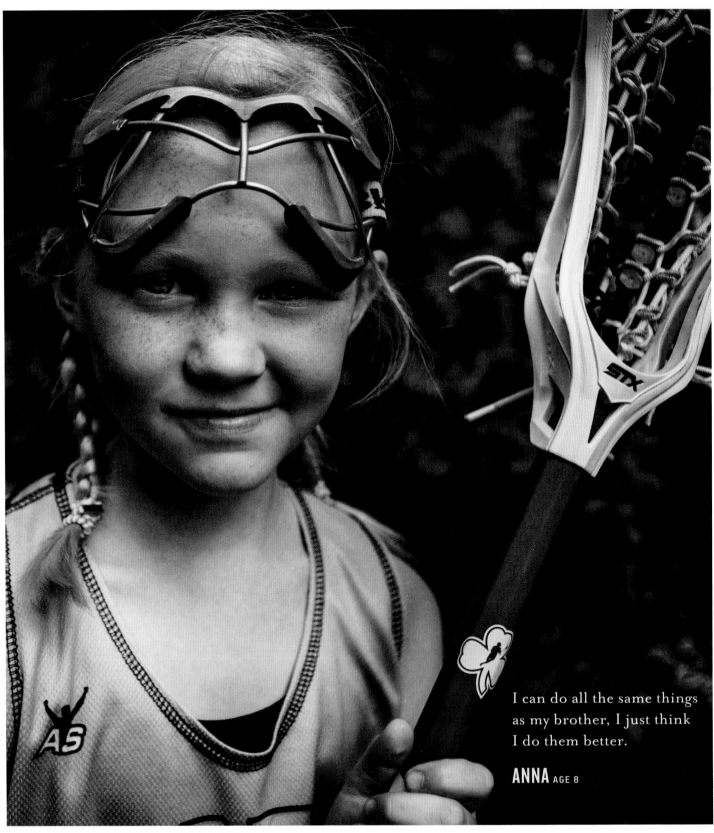

I can do all the same things as my brother, I just think I do them better.

ANNA AGE 8

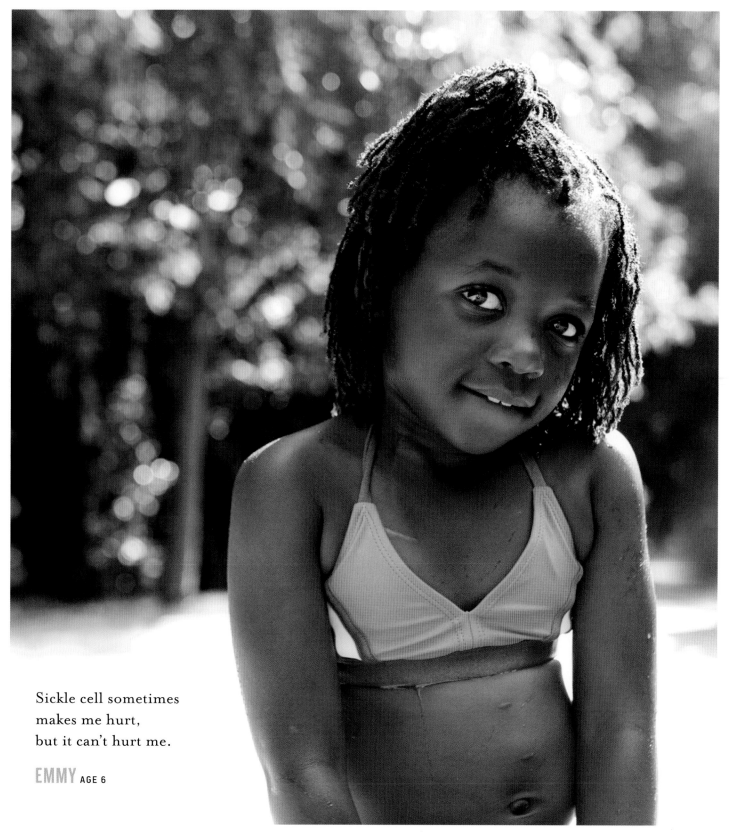

Sickle cell sometimes
makes me hurt,
but it can't hurt me.

EMMY AGE 6

When you train really hard
for a long time on a certain skill,
and you finally do it right,
it makes it all worth it.

ALICIA AGE 12

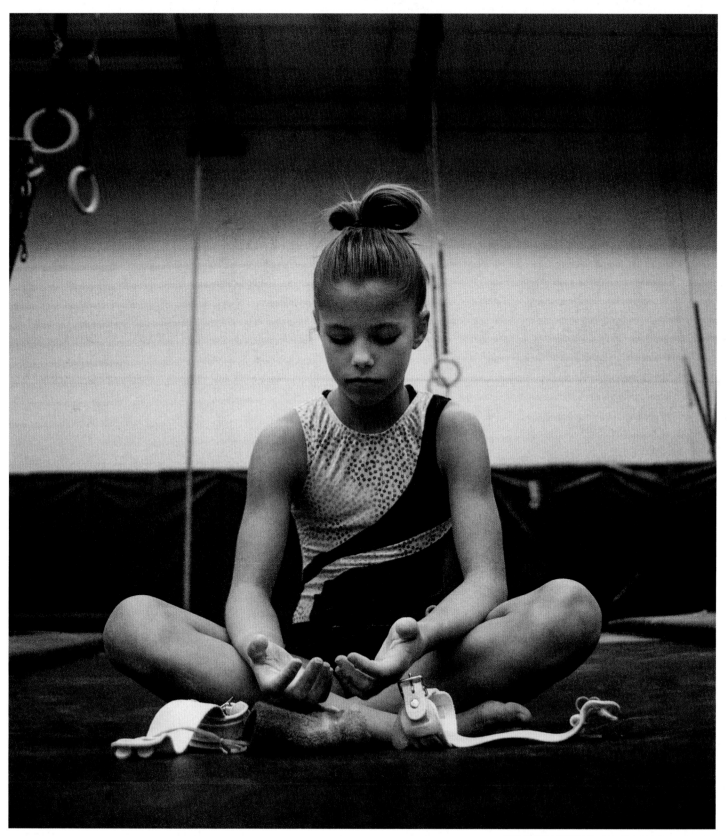

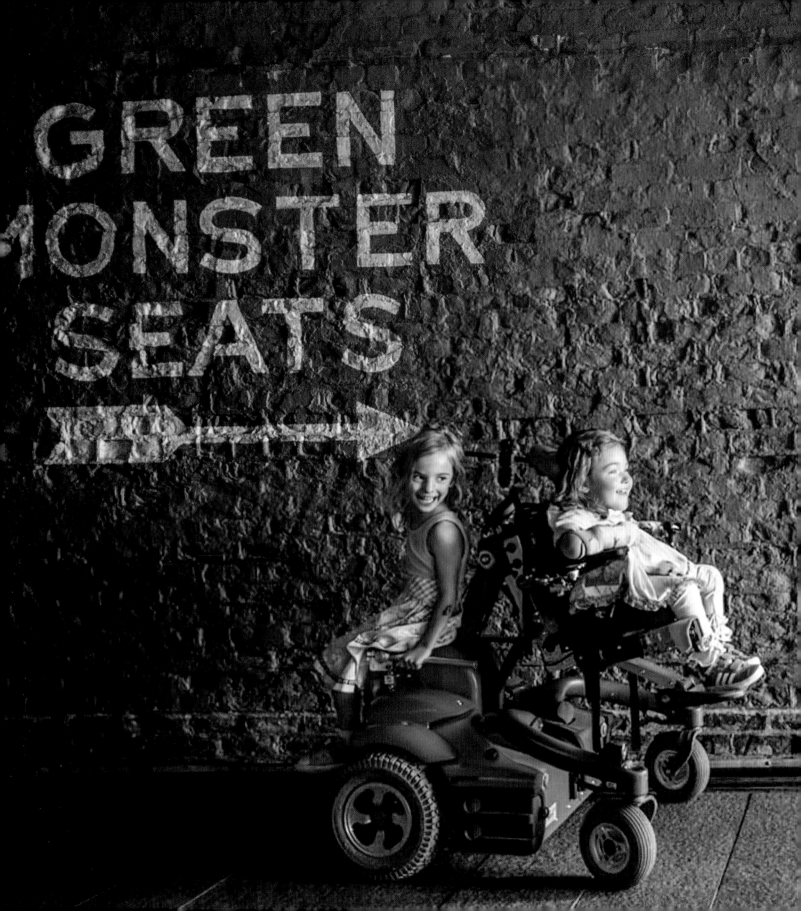

Everyone says my sister Harper
is the only good Boston driver.

OLIVIA O. AGE 6

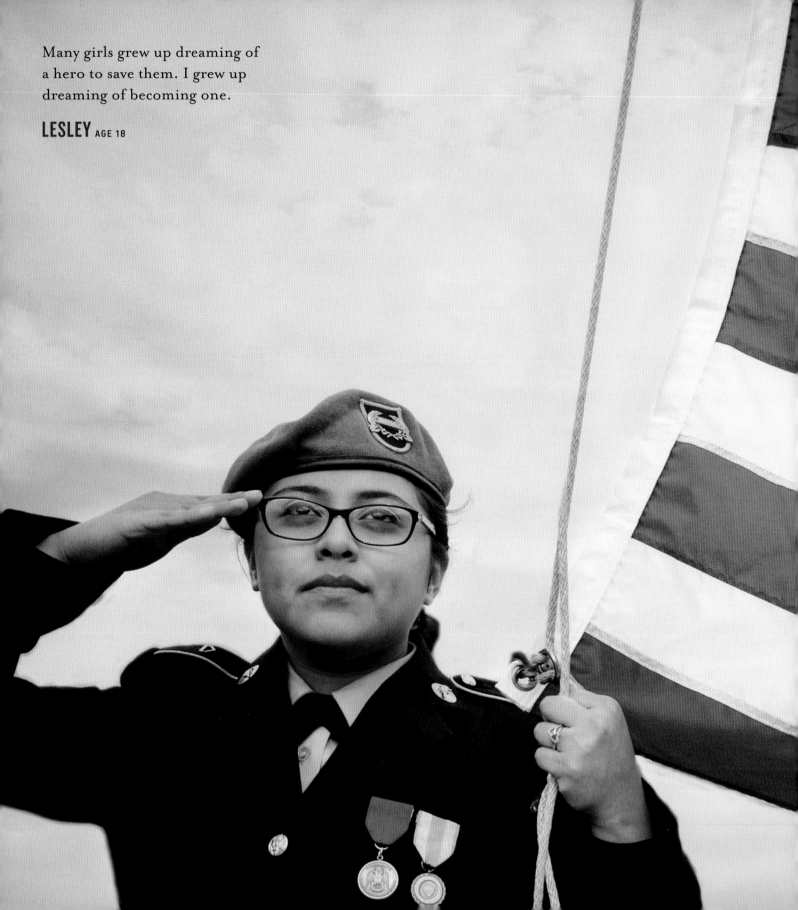

Many girls grew up dreaming of a hero to save them. I grew up dreaming of becoming one.

LESLEY AGE 18

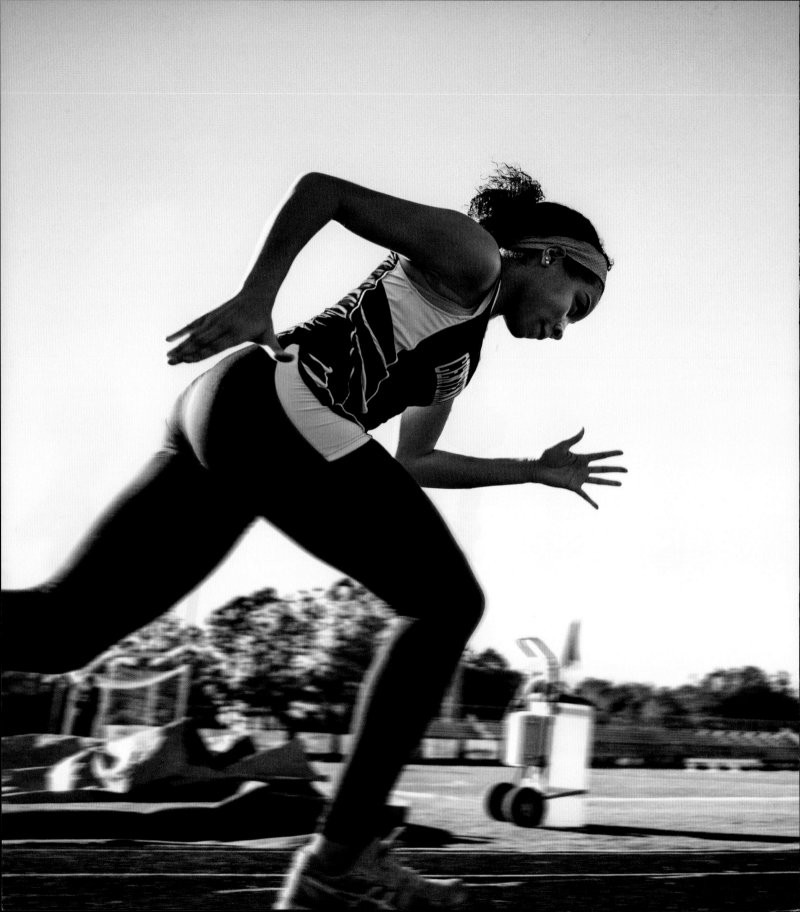

At the starting line,
I am in my own zone,
my own lane. I can't hear
the cheering. I just focus
on breaking a record.

PEYTON AGE 16

"Real strength is the ability to be loving, kind, and a force to be reckoned with."

GABRIELLE REECE

KIND
IS STRONG

——◆——

Being kind means showing your humanity, making someone's day a little brighter, their sorrow and hurt a little less painful. Kind people may not be the loudest ones, but in many ways they're the strongest, because they lift far more than their own weight: extending their arms for a hug, speaking up for a friend, thinking of another person first, or maintaining patience in a challenging situation.

Think of a time when you were the recipient of a small kindness. The moment that someone performs a caring act for us, we realize how very much it was needed. Whether it's lacing up a friend's shoe on the sports field, delivering food or clothes to someone in need, cracking someone up, or offering an encouraging word to someone who's been working his or her tail off, kindness is giving your strength to others who need it.

Kindness is a quiet but persistent strength that can be contagious, making the hard edges and sharp corners of life a little softer. It is all about action, about making an effort, about doing something or saying something when you see a need.

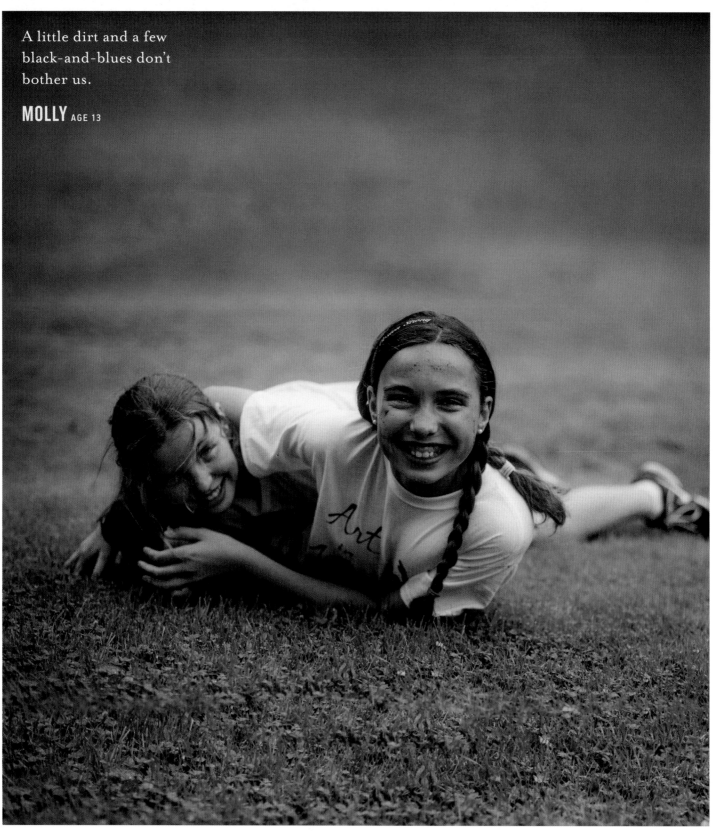

A little dirt and a few black-and-blues don't bother us.

MOLLY AGE 13

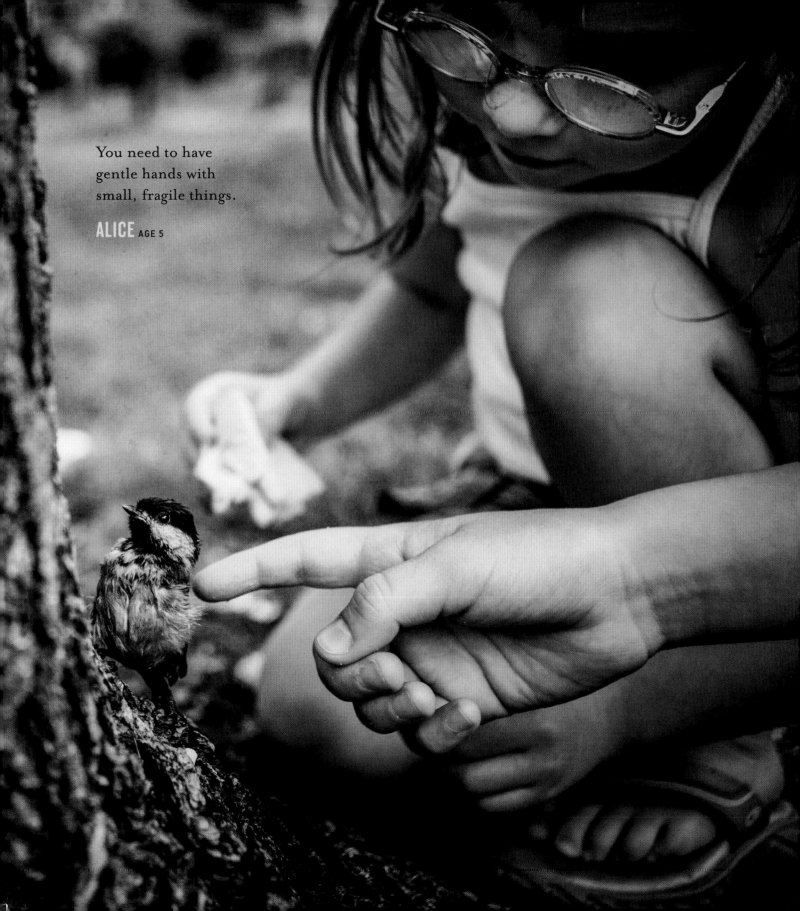

You need to have
gentle hands with
small, fragile things.

ALICE AGE 5

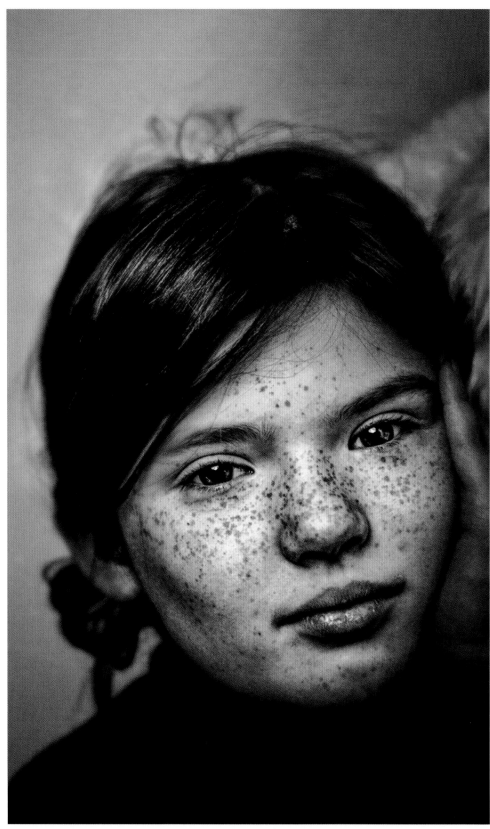

Kindness is friends
coming to cheer you
up when you're down.

JORDAN S. AGE 9

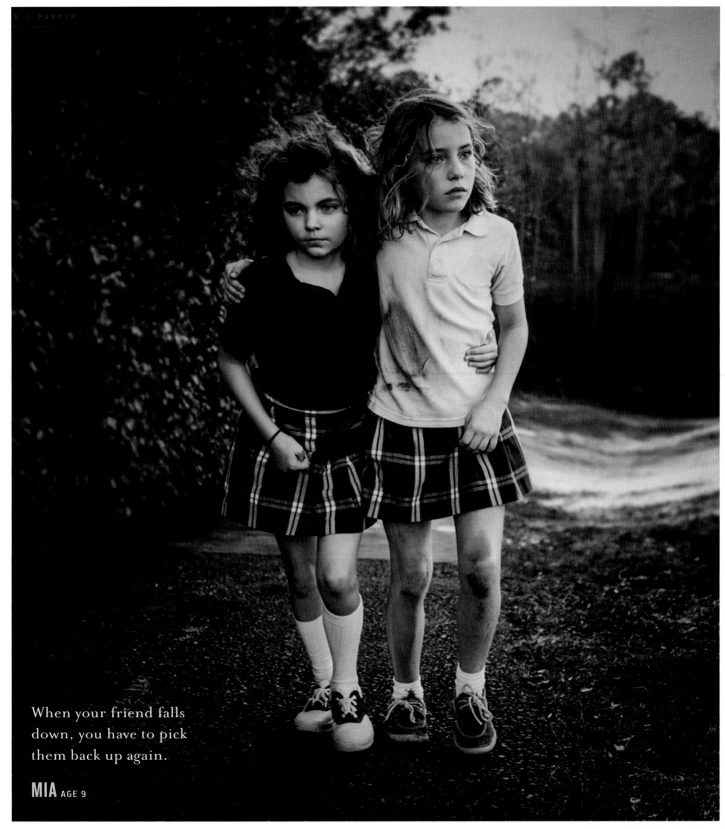

When your friend falls
down, you have to pick
them back up again.

MIA AGE 9

So many things are hard to do but when I smile,
it seems like I can get through.

TATIANA AGE 11

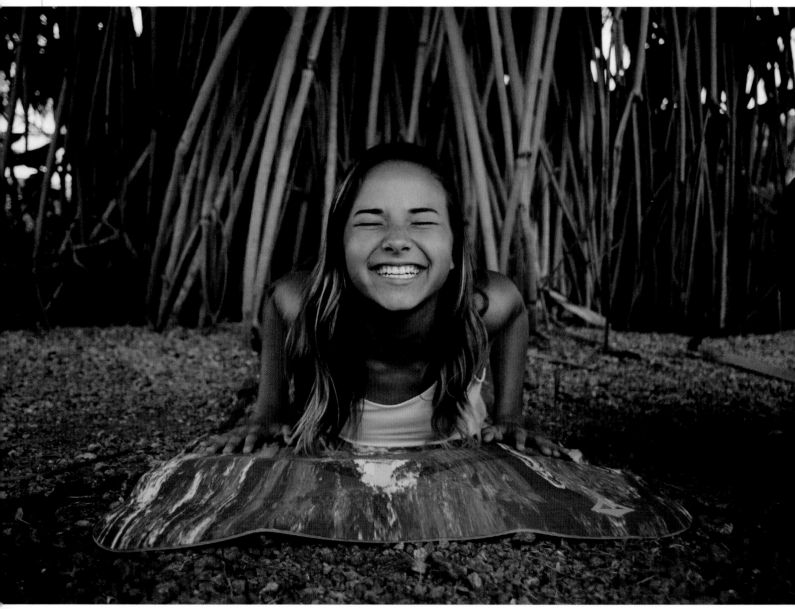

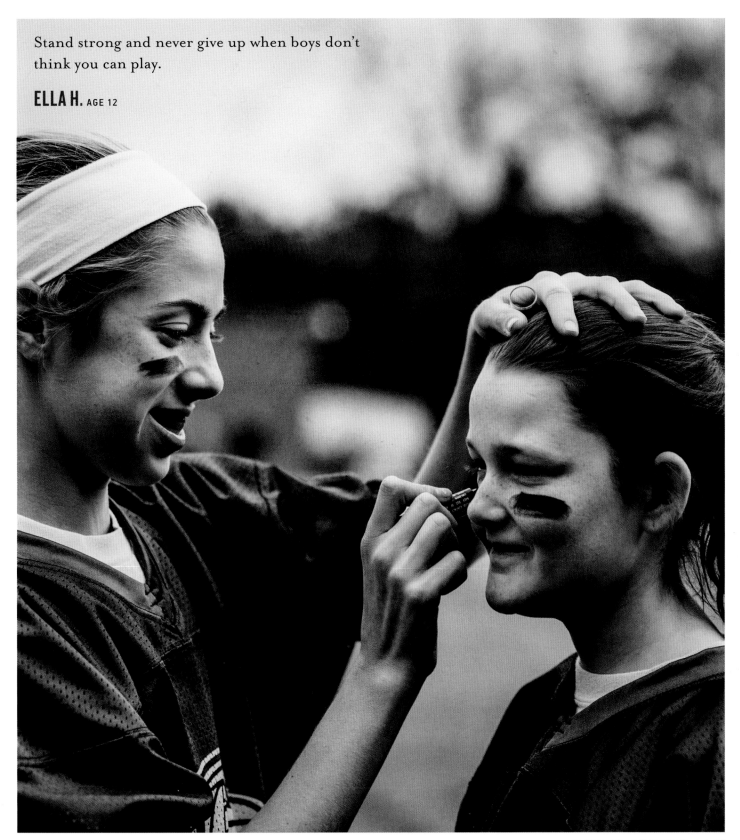

Stand strong and never give up when boys don't think you can play.

ELLA H. AGE 12

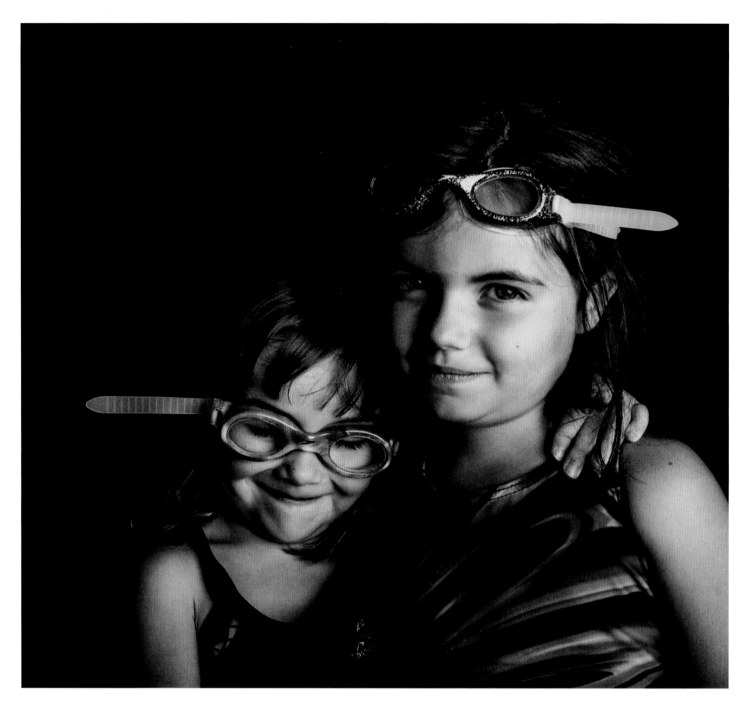

She was scared to swim on the swim team. I wasn't.
We're good friends, and I was like her blankie at the practices
and made her feel safe. That's what friends do.

SYD AGE 9

I feel free and alive when I run
with my friends.

PAYTON AGE 11

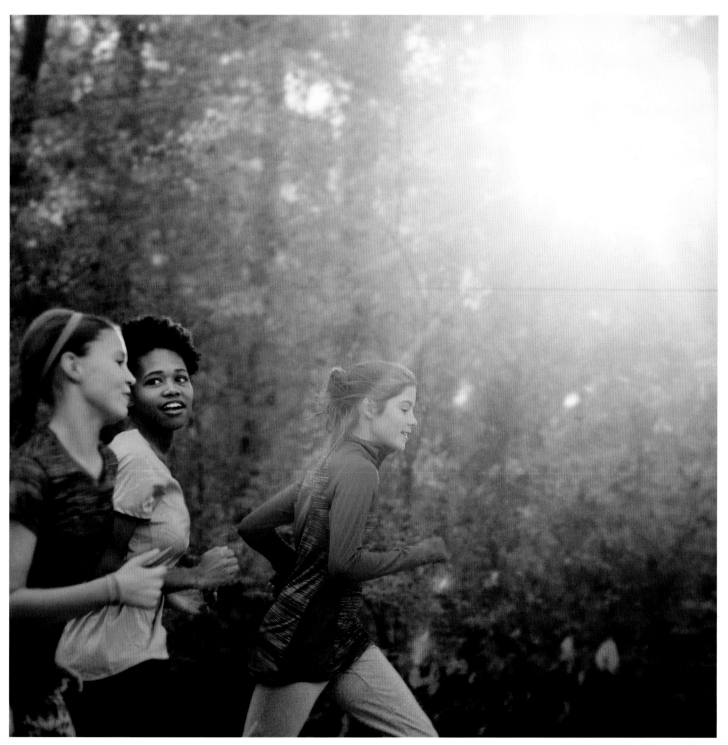

I feel happy and *valente* (brave)
when I hug my friends and
my mama.

SOPHIA M. AGE 4

Girls get to be everything:
tomboy, pretty, soft, and strong.

LOGAN AGE 13

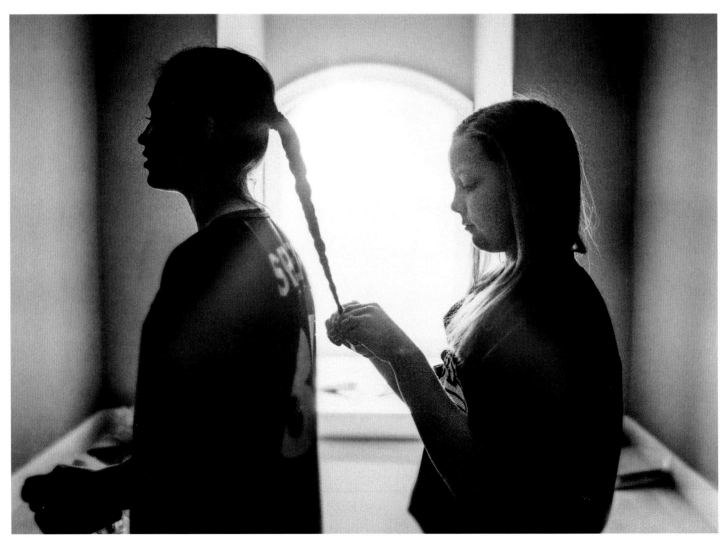

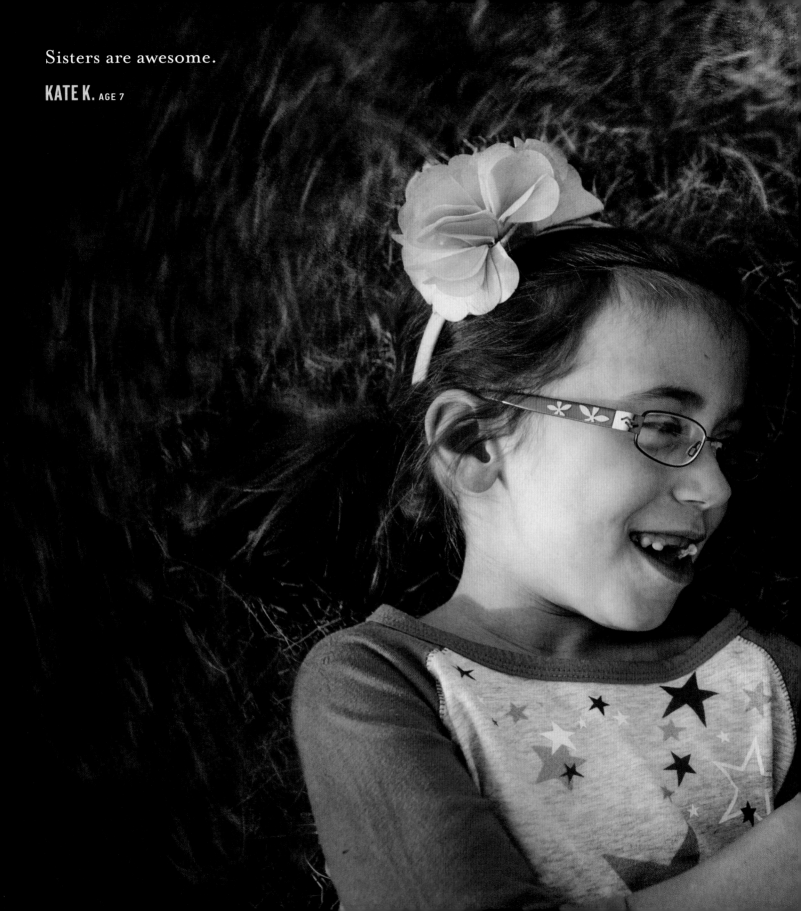

Sisters are awesome.

KATE K. AGE 7

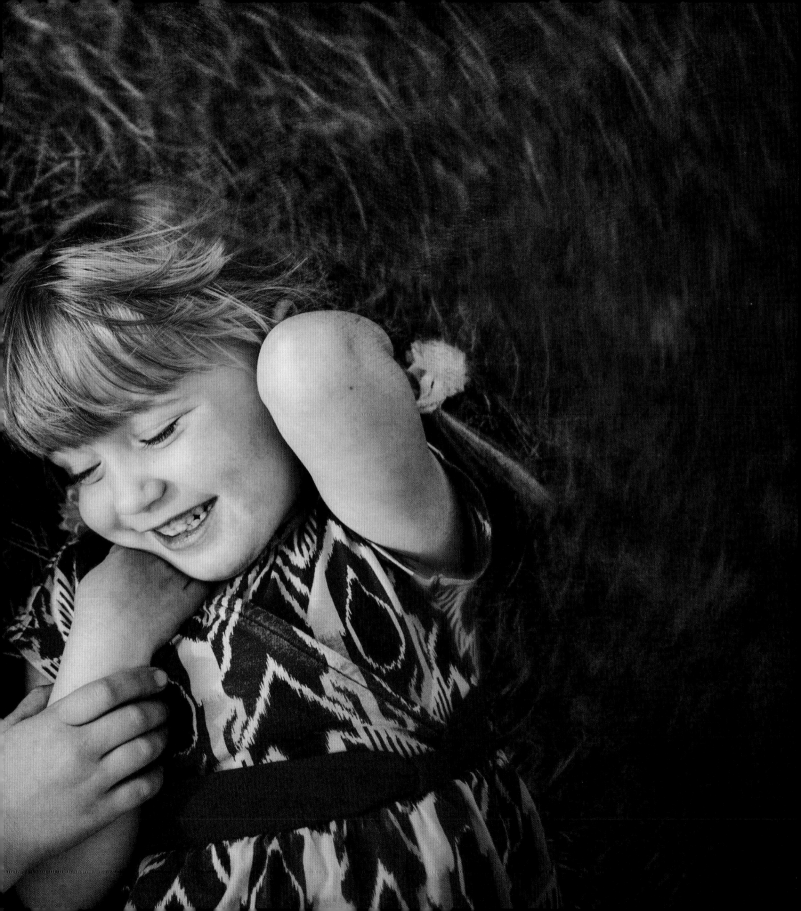

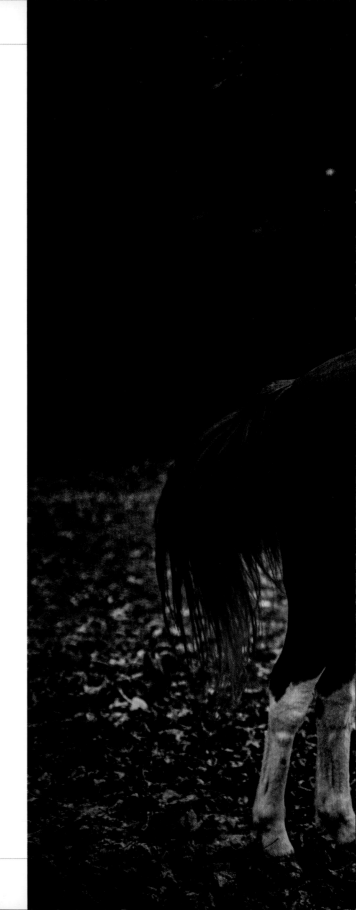

My pony, Max, is the
sweetest thing in the world.
I'll always love Max.

SIENA AGE 5

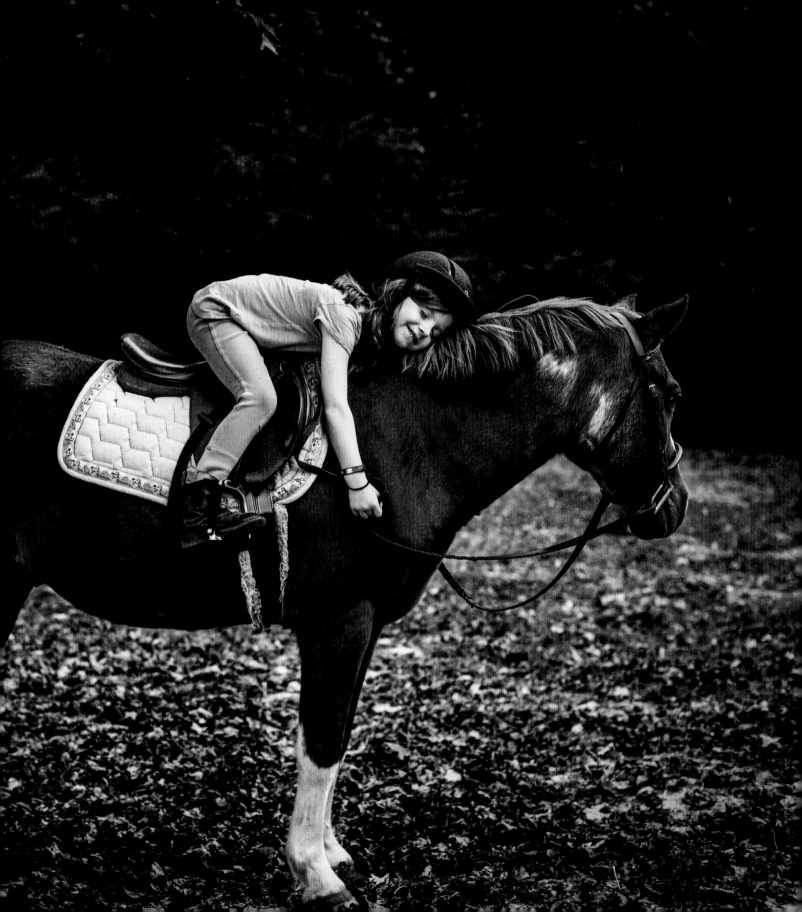

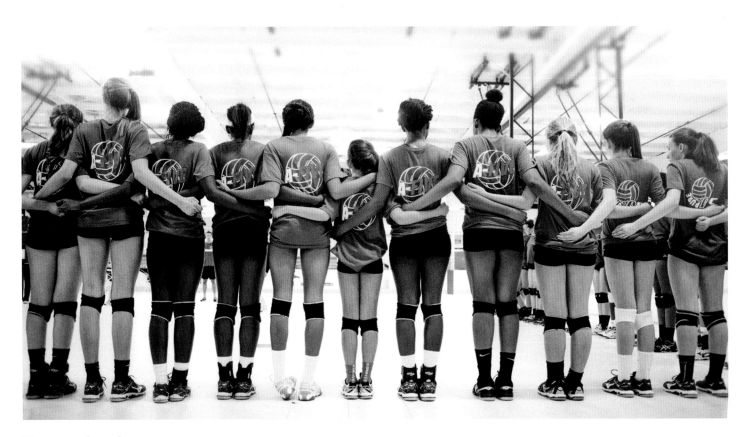

Teamwork is the most important part
of volleyball. By the end of the season,
we aren't friends, we are sisters.

ELIZA AGE 13

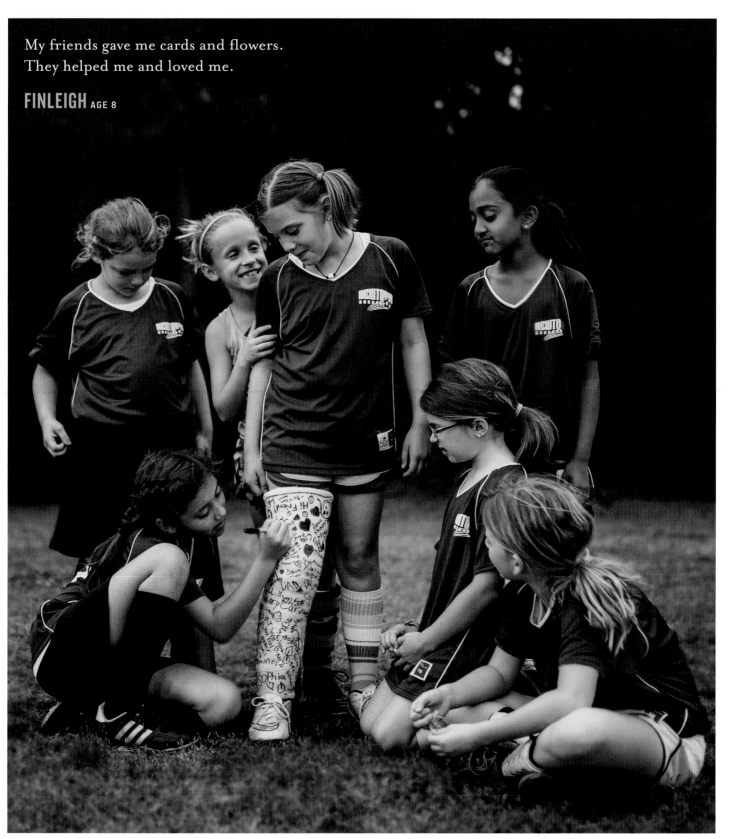

My friends gave me cards and flowers.
They helped me and loved me.

FINLEIGH AGE 8

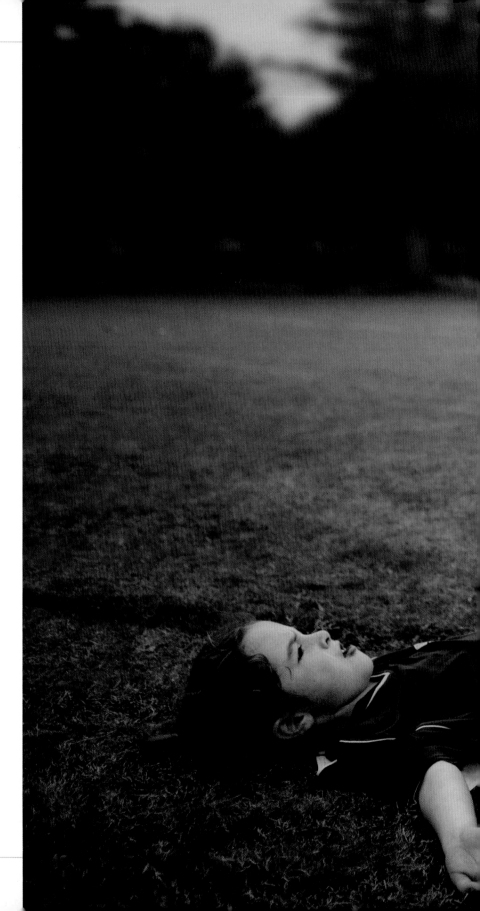

She had a knot in her cleats.
I'm really good at untying knots,
so I helped.

LILY S. AGE 5

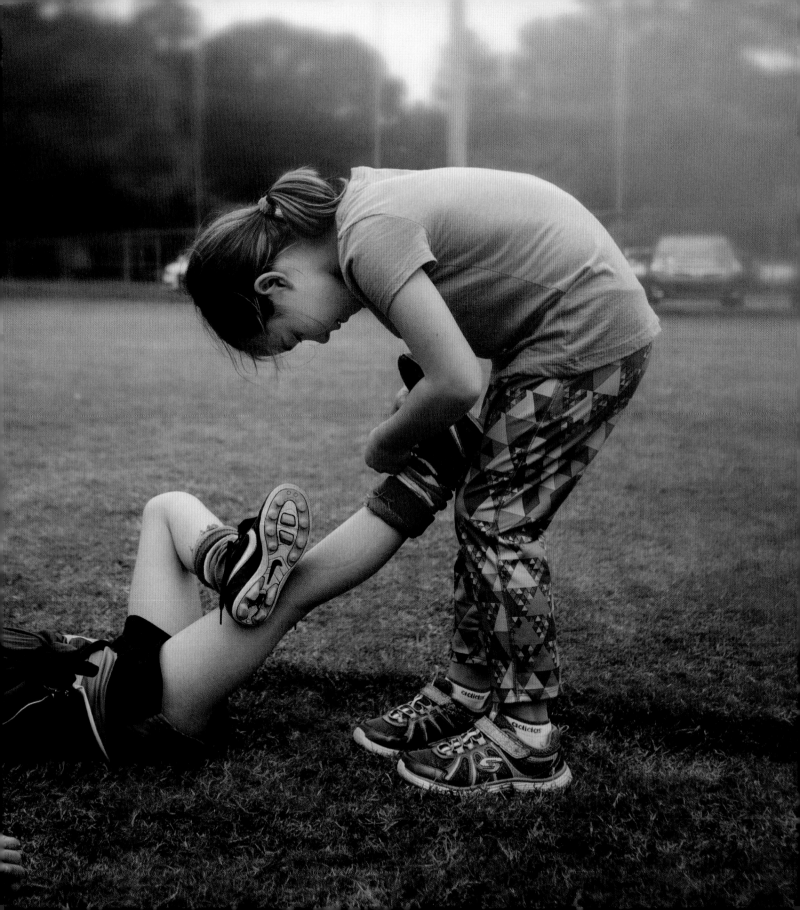

I did more pull-ups than
all the fifth-grade boys.

ELLA T. AGE 11

Jordan broke her leg, so we
came over to let her know we
were sorry. She's a good friend.

ELLA AGE 8

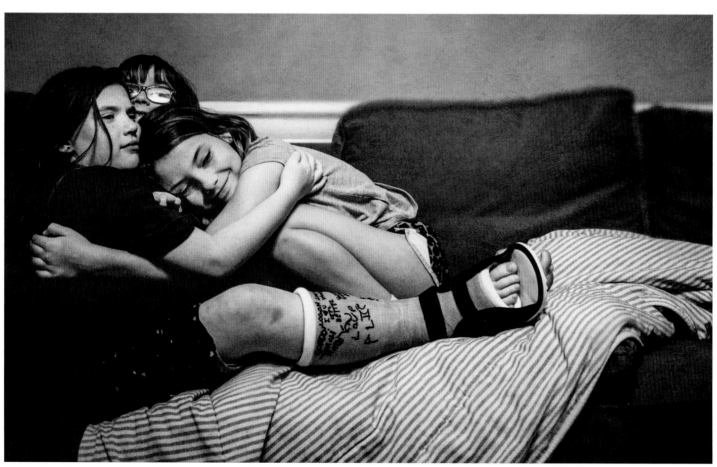

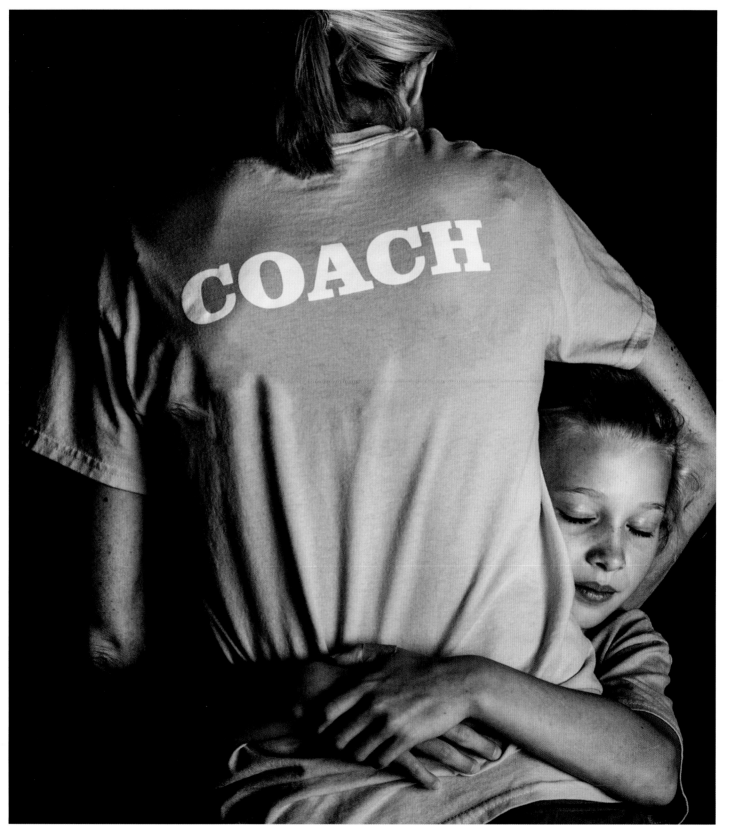

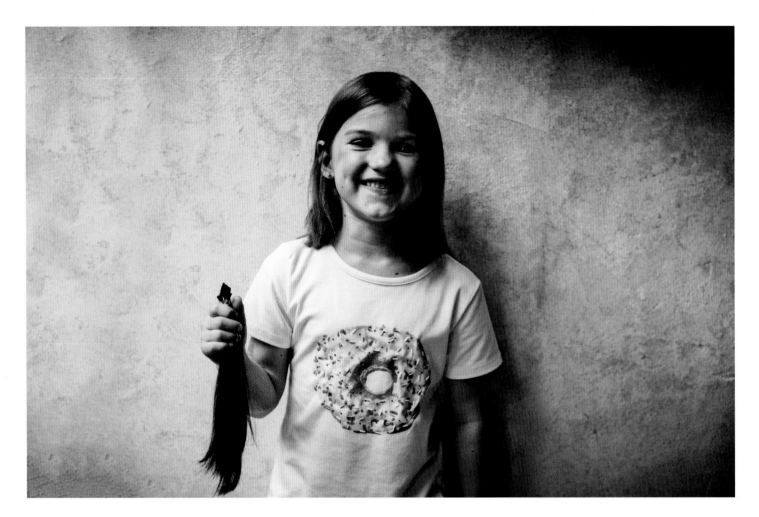

I grew my hair for a whole year
to donate to sick kids who lost theirs.
I'm gonna do it again.

AVA AGE 6

Being a girl doesn't change anything.
It's just a different body. Strength
measures how powerful you are even
when others doubt you.

ORIANA AGE 12

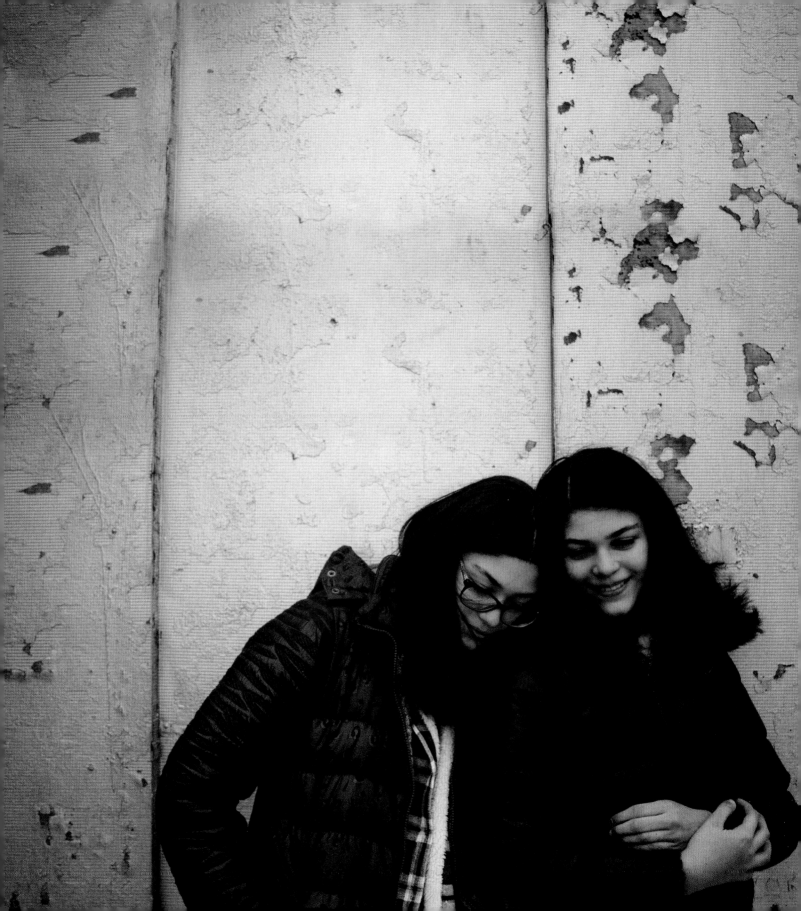

"Be fearless. Have the courage to take risks.

Go where there are no guarantees."

KATIE COURIC

FEARLESS
IS STRONG

◆

Not one of us goes through life unafraid. Fear is normal, but it can shrink the world if you let it, and fear shouldn't be restrictive. What I learned from the girls in this chapter is not to get caught up in the idea of "being fearless," just act fearless. You can't let fear stop you from doing what you want to do.

Challenge yourself: Launch an idea and know that your colleagues and peers will support you. Put faith in your legs and climb that mountain, one step after the next. Sign up for a class in a subject that terrifies you. Start something new. Fearless girls are able to separate their fear from what they have to do in that moment: learning to fly a plane despite a fear of heights, twirling in the air and trusting your teammates to catch you, or believing in your ability to conquer something that no one, even you, thought you could do.

There are too many amazing things to experience to ever let fear hold you back. Feel the fear in your heart, acknowledge it, and do whatever the heck you want to anyway.

I was scared of the deep water, but it didn't matter how deep it was. I never fell.

TAYLA AGE 6

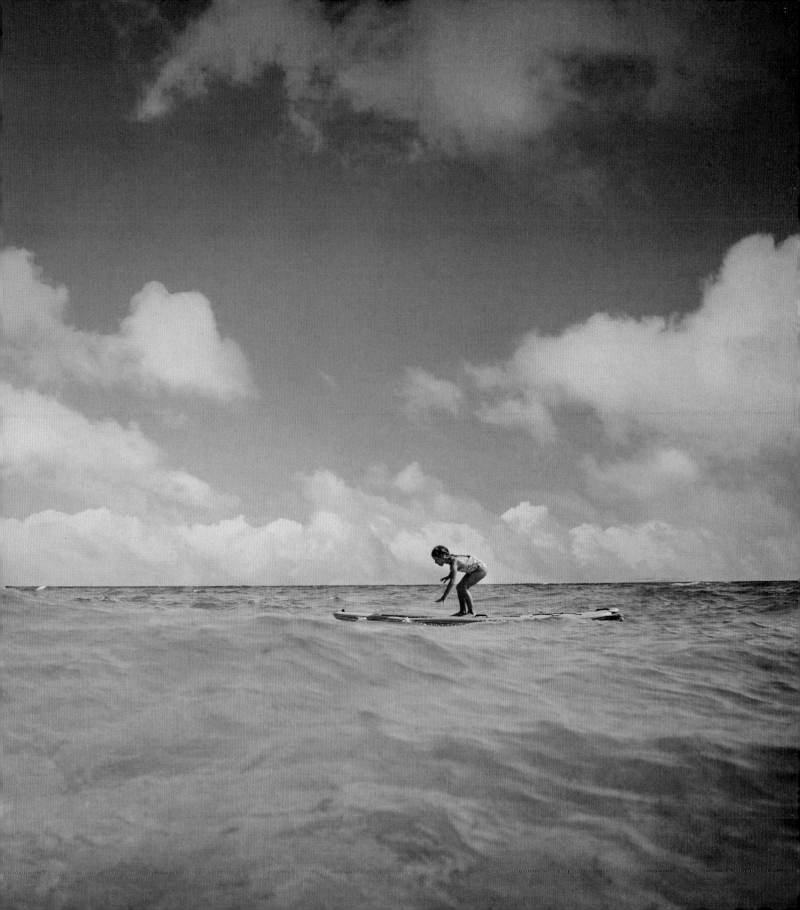

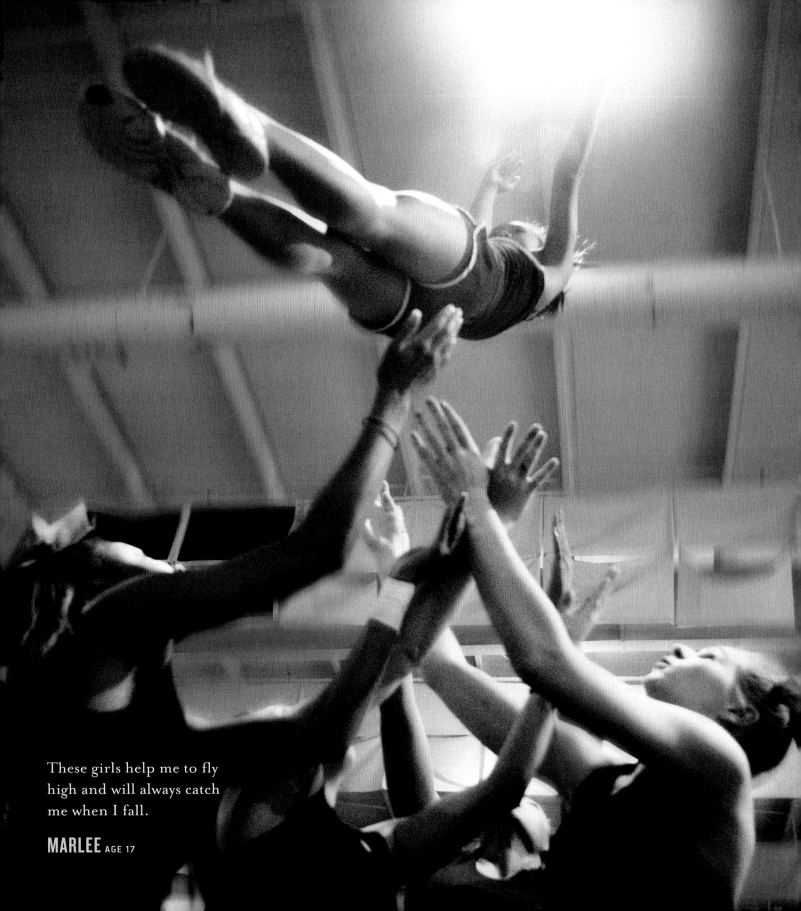

These girls help me to fly
high and will always catch
me when I fall.

MARLEE AGE 17

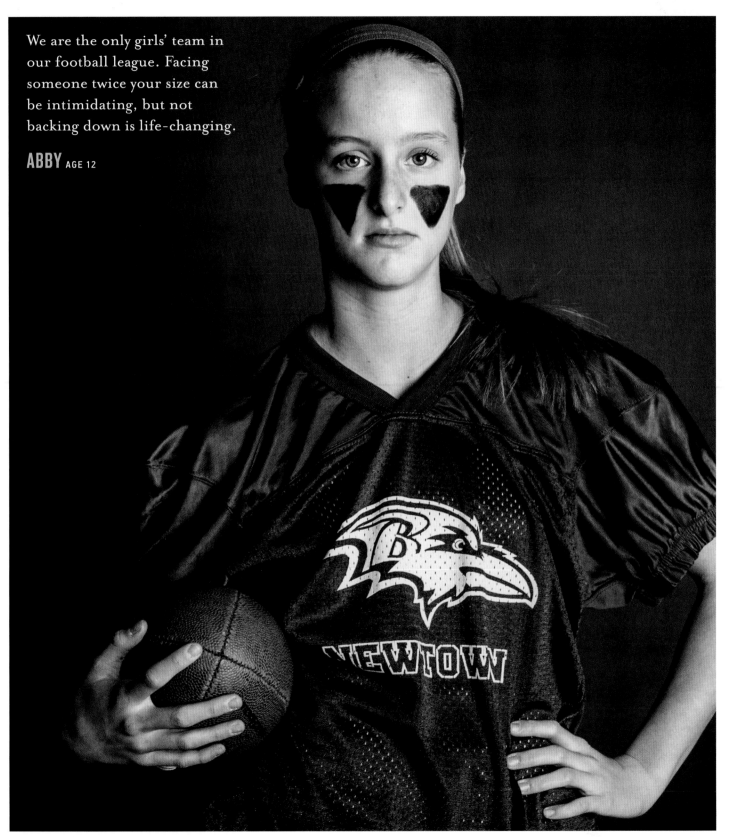

We are the only girls' team in our football league. Facing someone twice your size can be intimidating, but not backing down is life-changing.

ABBY AGE 12

I always get back up. Falling and sometimes even getting really hurt is just a part of skateboarding. I always get back up and work on it some more. Skateboarding makes me feel like I can do anything. I believe I can do it, and then I can.

MINNA AGE 9

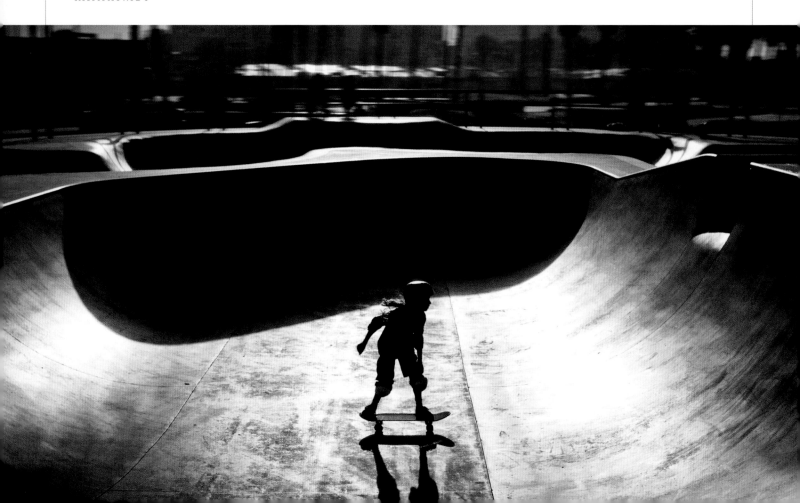

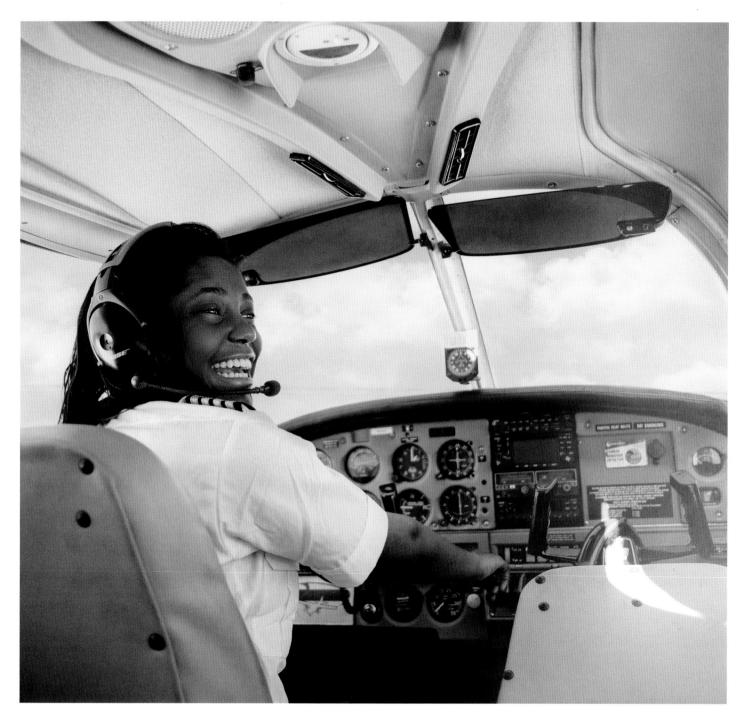

The liberation, thrill, and excitement when I climb
into the cockpit is indescribable to those who
have not taken the controls in their own hands.
The sky is not the limit—it's just a view.

ARIS AGE 16

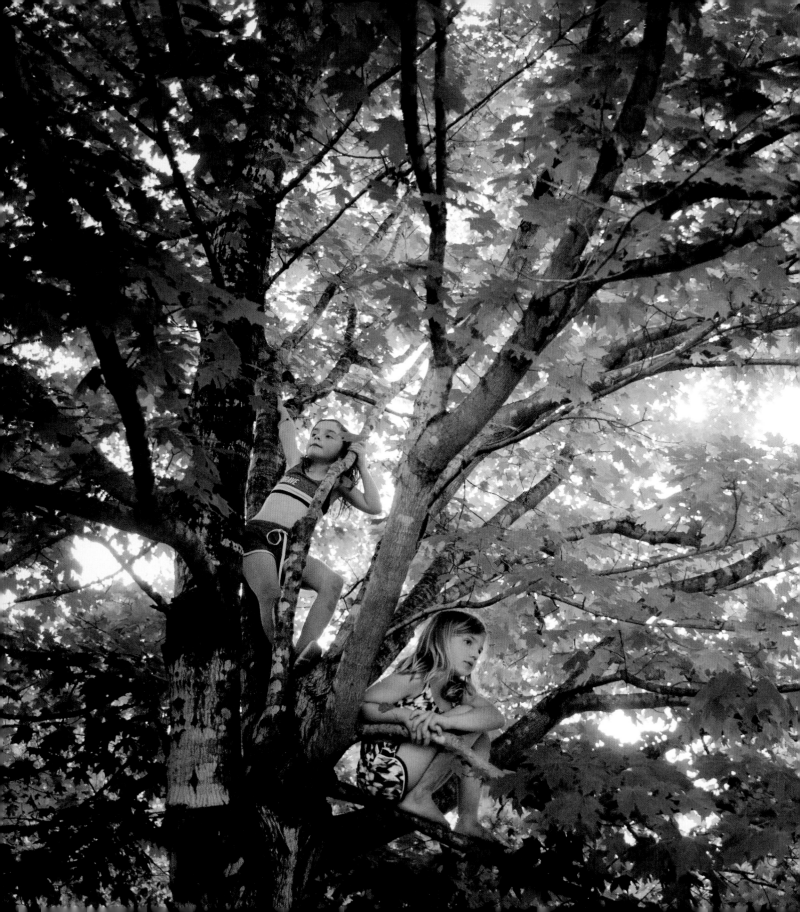

We weren't supposed
to climb this high,
but the view is better
up here.

EMME AGE 7

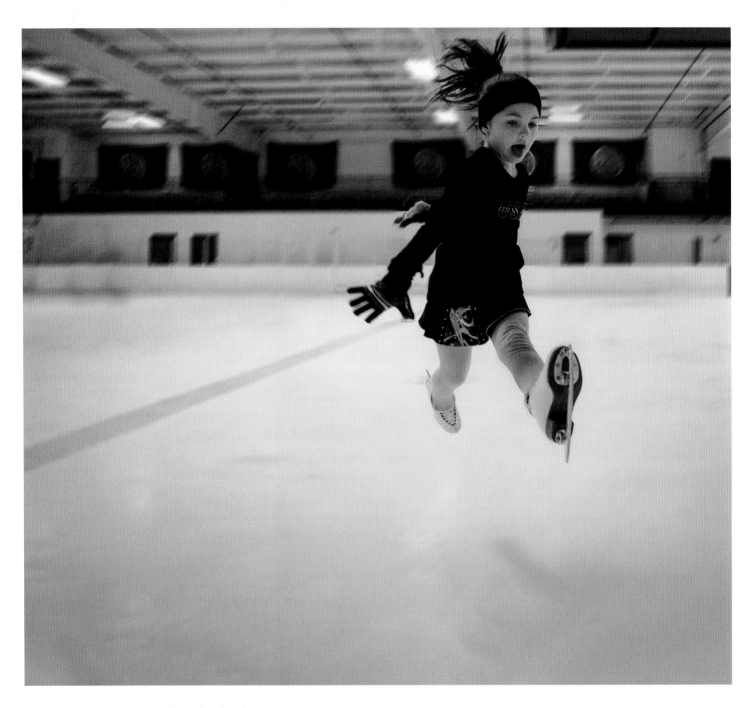

Even though I might break a body part,
like when I broke my arm skating, I still
want to jump.

REED AGE 6

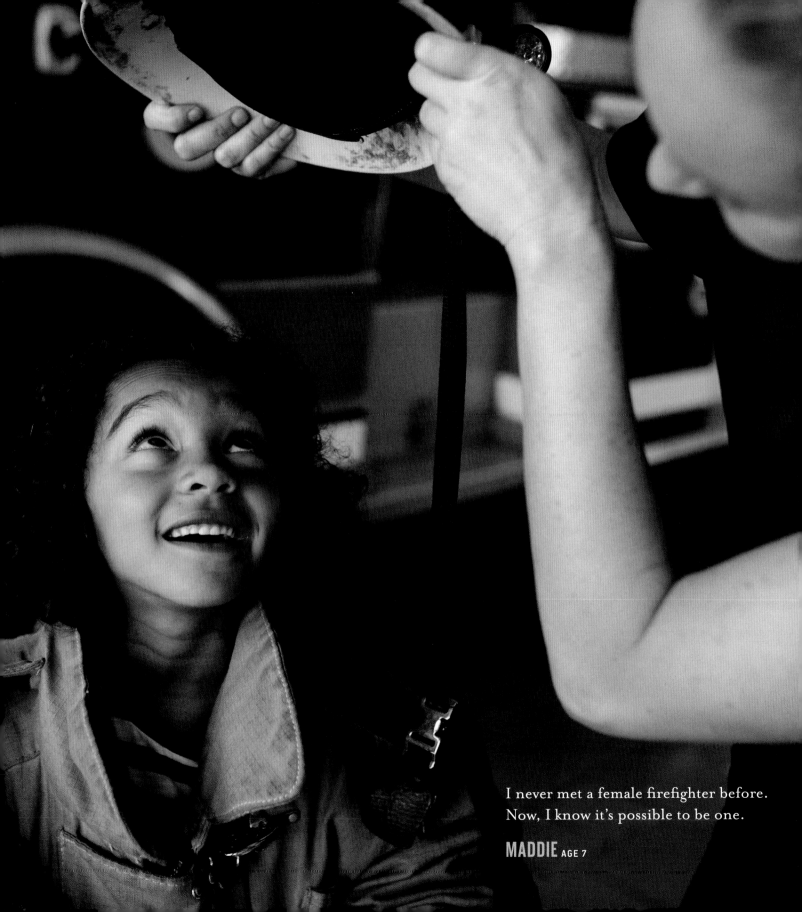

I never met a female firefighter before.
Now, I know it's possible to be one.

MADDIE AGE 7

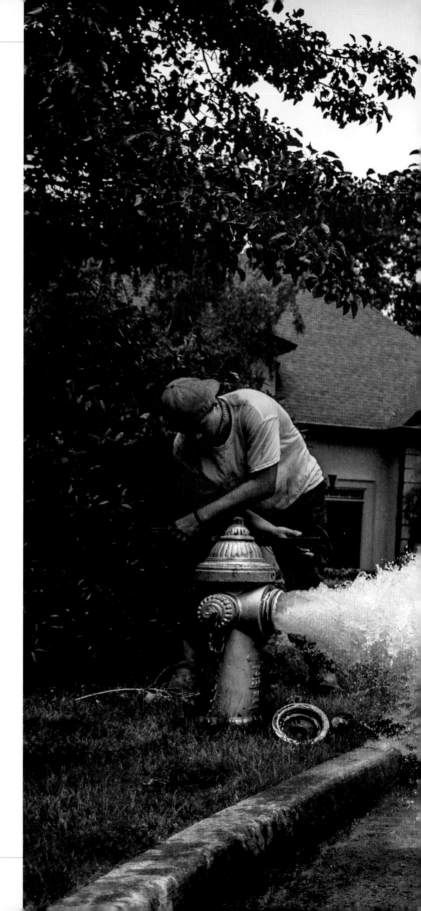

My friends say I'm crazy,
but I'm just me.

ELLA AGE 10

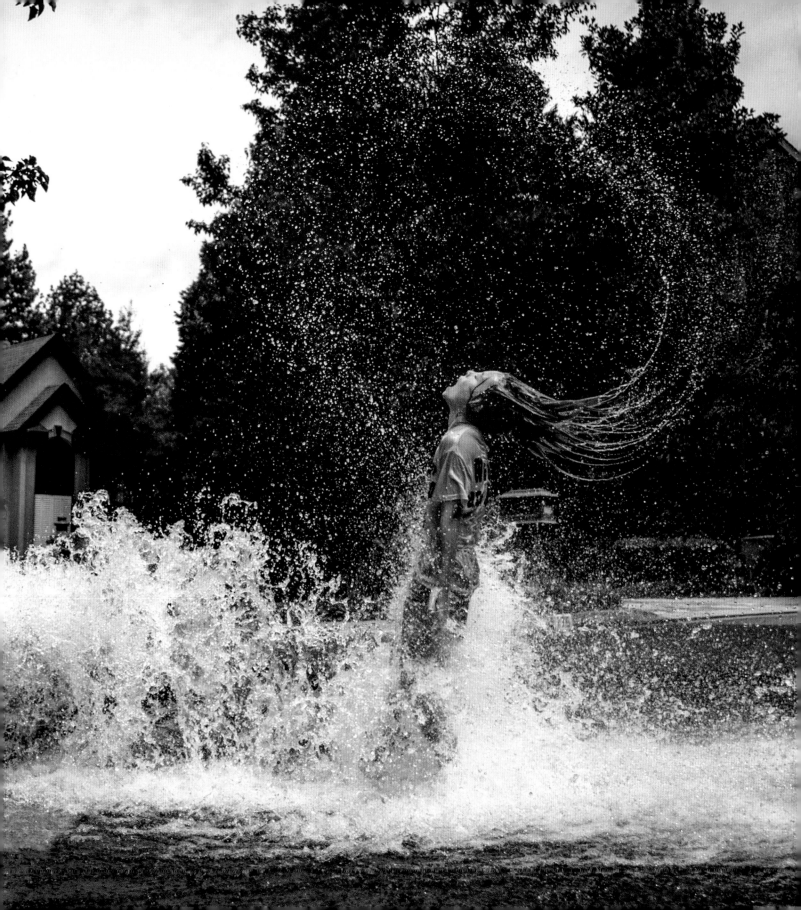

My dream is to be a professional
runner. I'm really good at it, and
I love it.

HANNA AGE 10

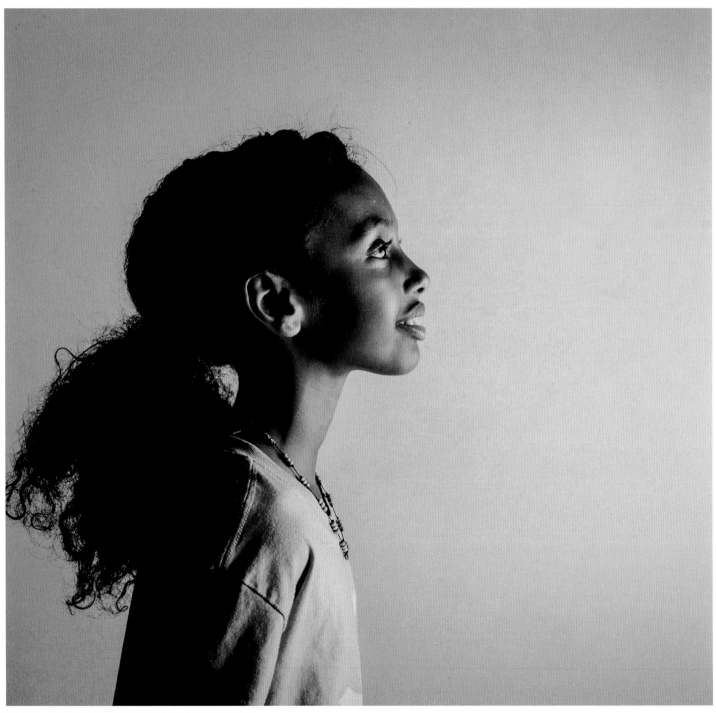

I search deep in the water for sand dollars. The deeper you go, the darker and colder it is, but the reward is worth it!

MADISON AGE 11

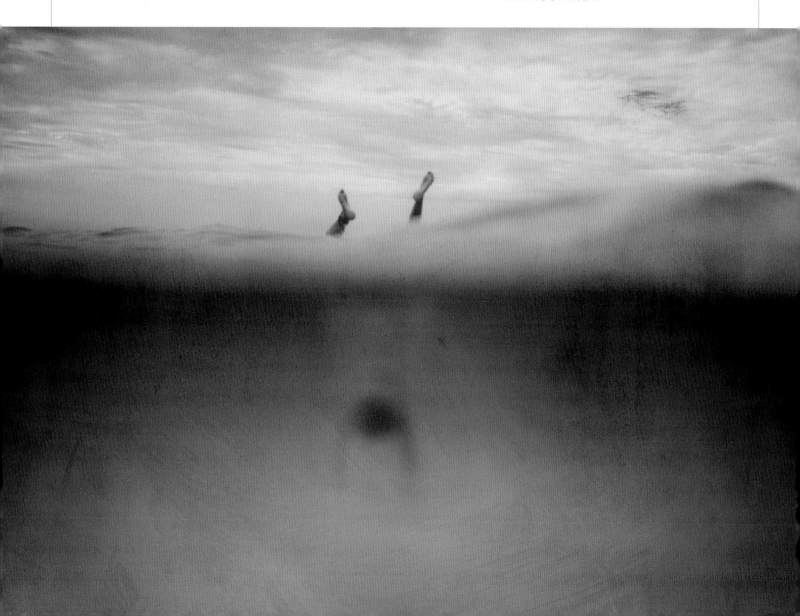

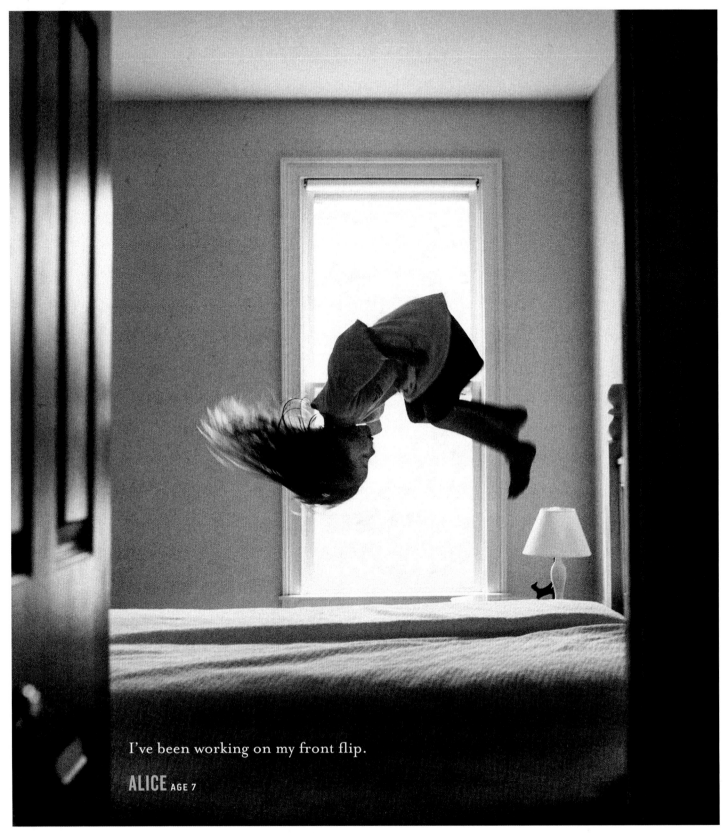

I've been working on my front flip.

ALICE AGE 7

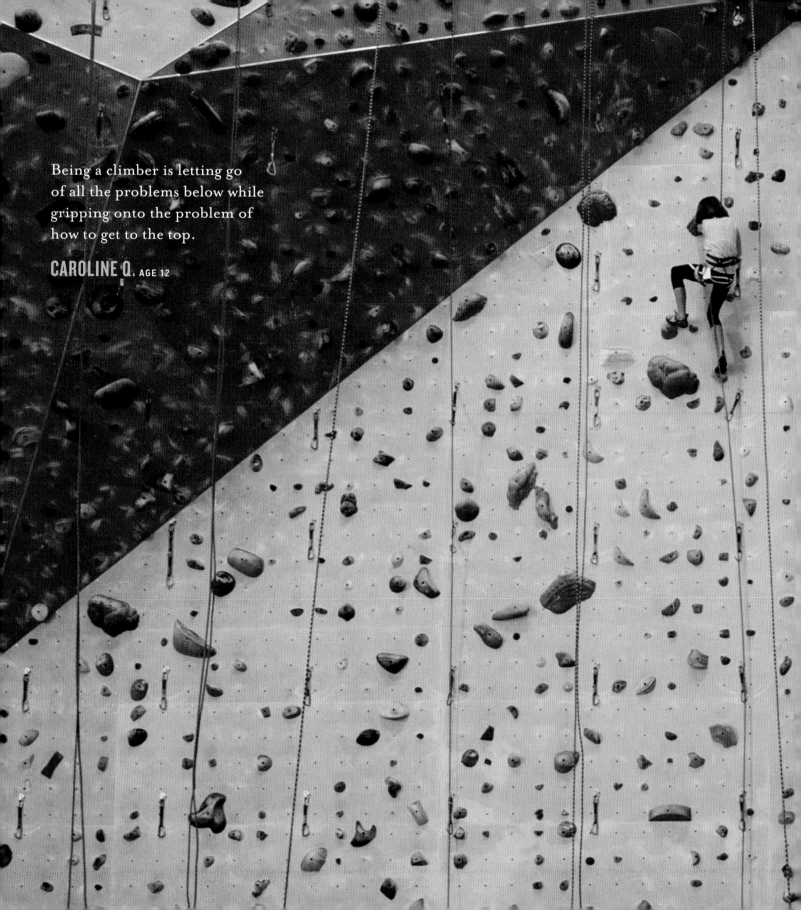

Being a climber is letting go of all the problems below while gripping onto the problem of how to get to the top.

CAROLINE Q. AGE 12

I AM REALLY LOUD, AND WHEN I AM HAPPY, I LIKE TO SCREAM AT THE TOP OF MY LUNGS.

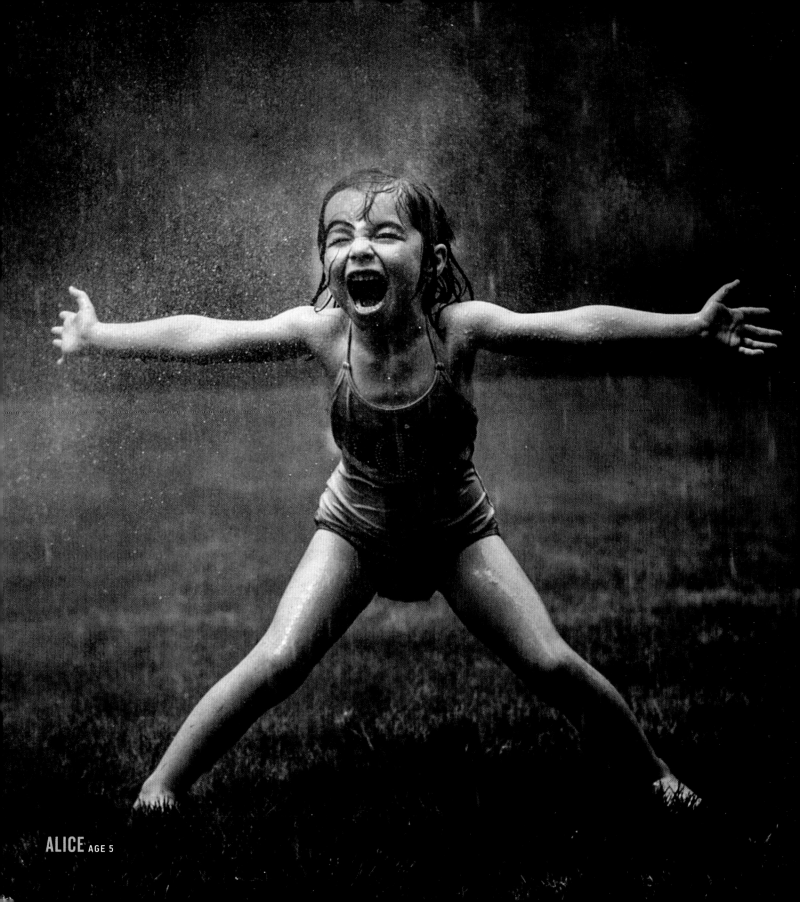

ALICE AGE 5

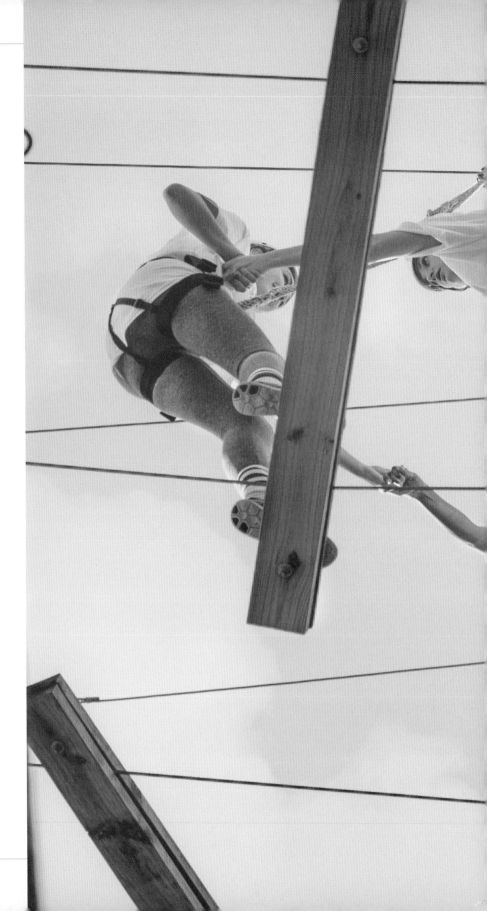

We were dependent on each other—strangers—to make it across the obstacle course. We all definitely had fear of the course, but we were confident, knowing that we could have so much trust in people we had just met.

DAIJA AGE 17

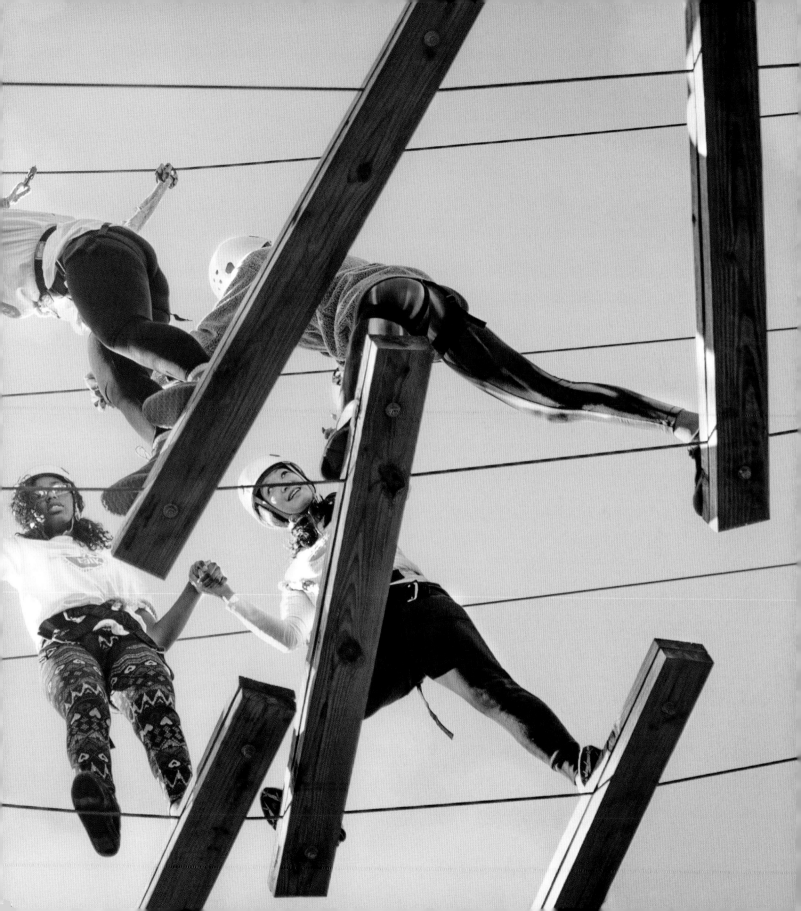

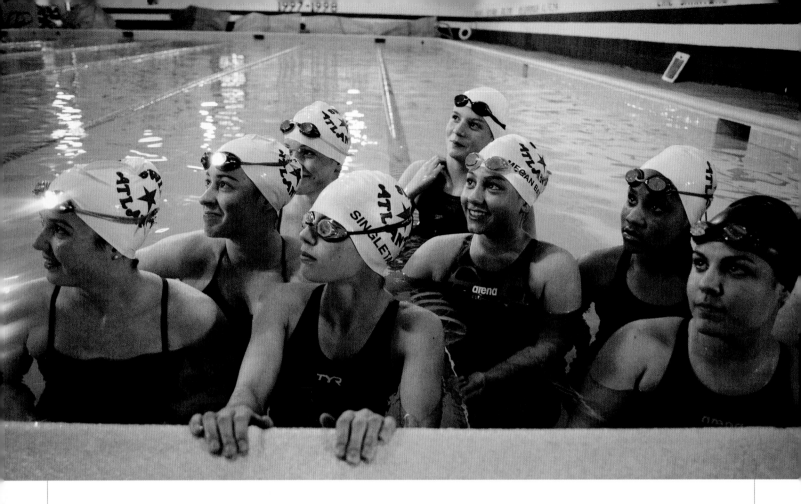

Strong people are not defined
by goals, because goals are just
limitations.

MEGAN S. AGE 17

Dance is a way for people to express themselves, and more than that, it's a way for people to create connections with one another that are deep and meaningful.

TEAGAN AGE 12

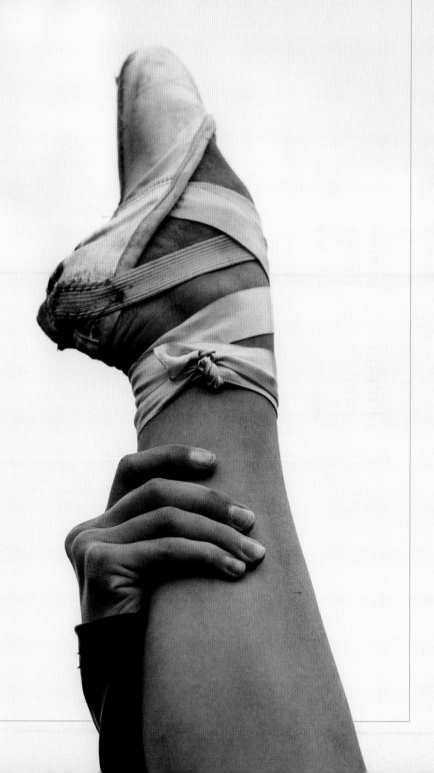

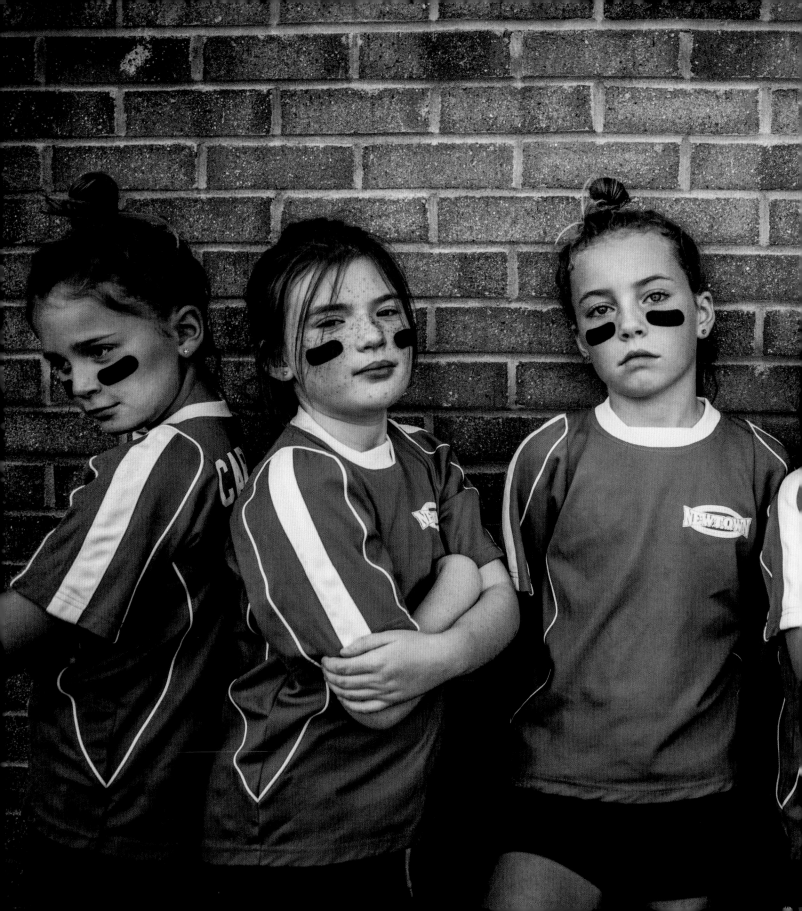

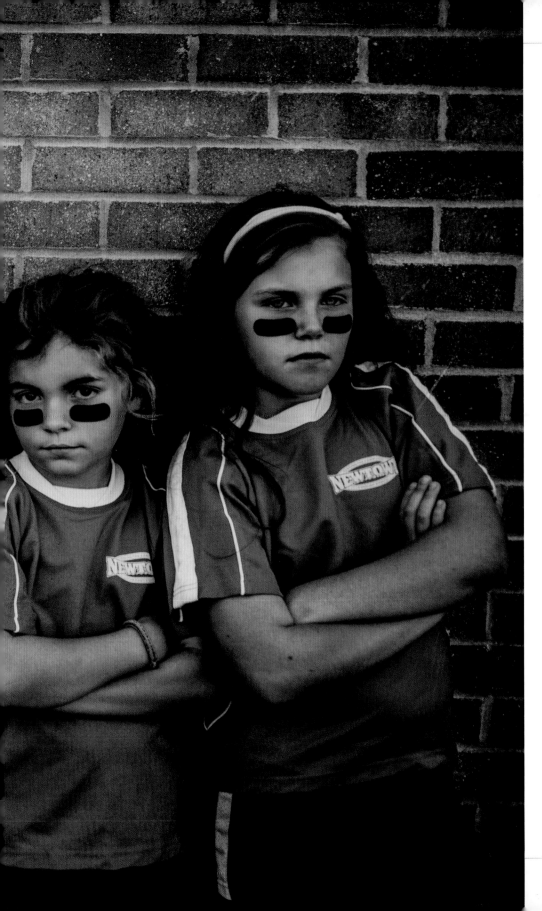

We are undefeated and
plan on staying that way.

OLIVIA J. AGE 9

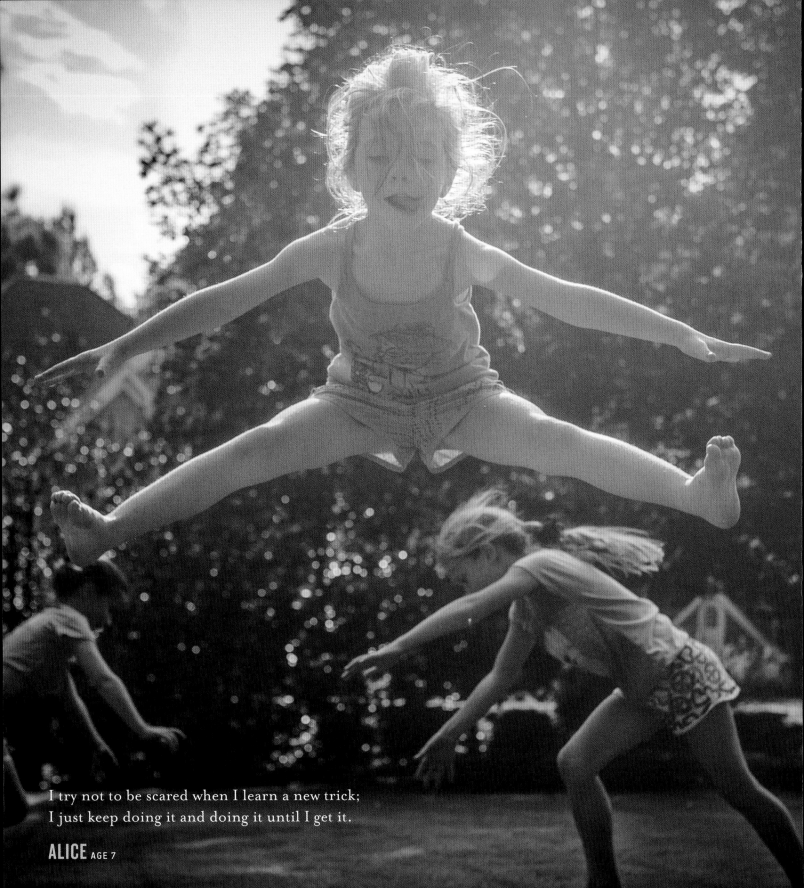

I try not to be scared when I learn a new trick;
I just keep doing it and doing it until I get it.

ALICE AGE 7

I never worry about competing against others. I only care about competing against myself.

JESSICA AGE 18

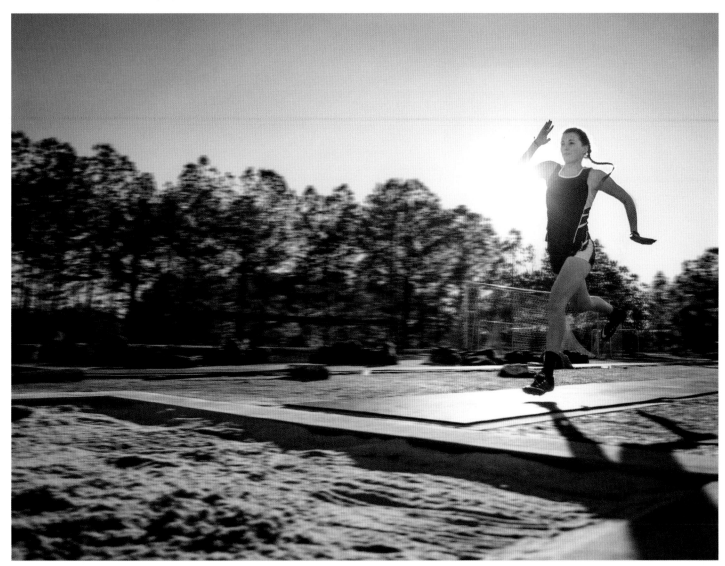

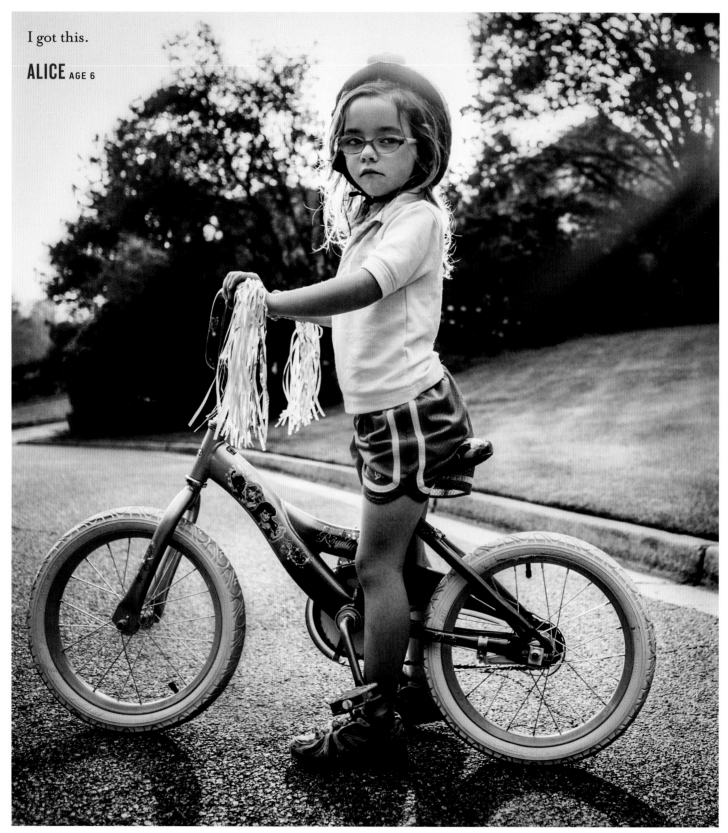

I got this.

ALICE AGE 6

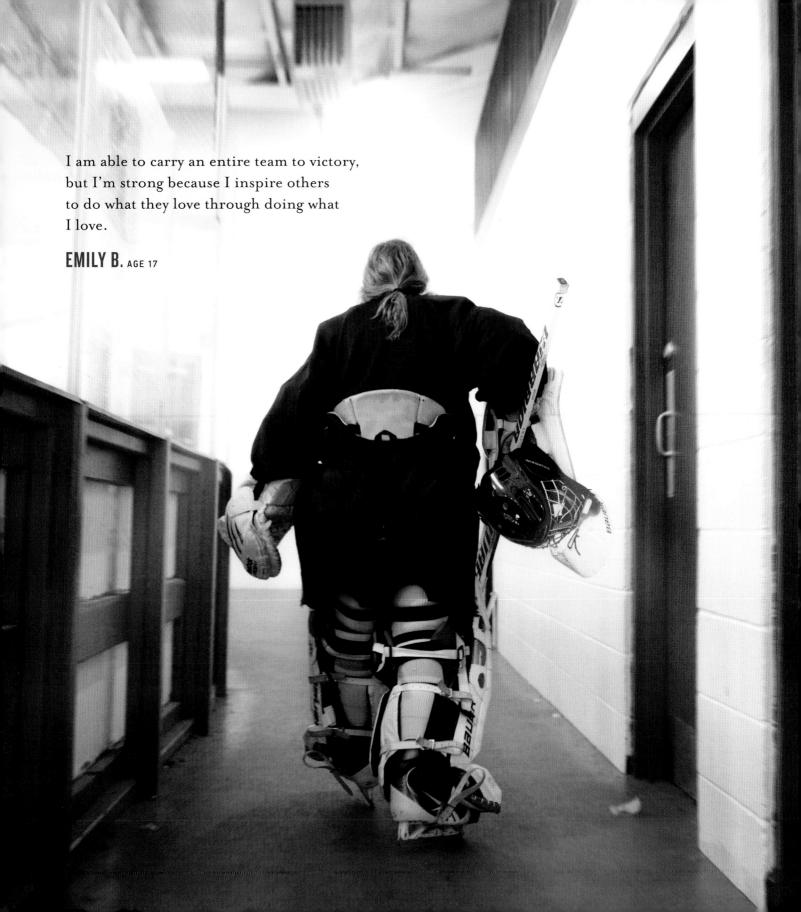

I am able to carry an entire team to victory,
but I'm strong because I inspire others
to do what they love through doing what
I love.

EMILY B. AGE 17

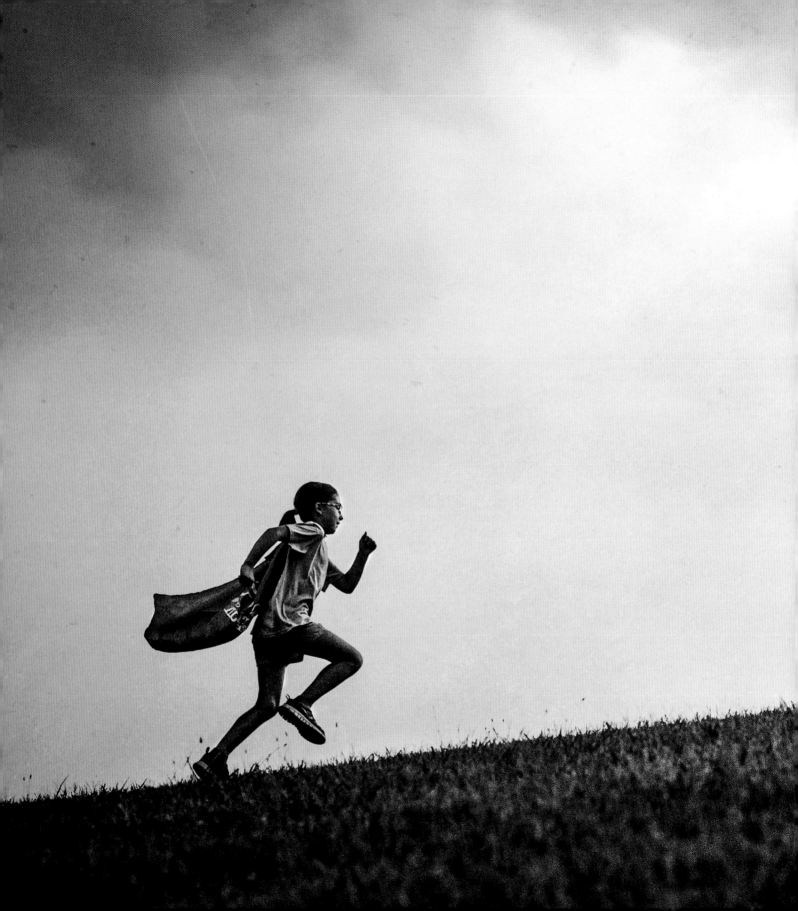

Running equals confidence and confidence equals me.

LAUREN J. AGE 10

"Being **true** to yourself is a really **beautiful** thing."

MEGAN RAPINOE

JOYFUL
IS STRONG

♦

Some days it is so easy. The pool is open. The presentation went well. You won the game. The sun is out. You're laughing with your friends and there's ice cream. It's Friday. It's Saturday. It's Sunday (and it's a three-day weekend). But other days, you failed the test, missed the deadline. You fell down, hard. It's Monday. You're lonely.

Joy is a strength. Because sometimes life is *hard*, for the most unfair reasons and sometimes for no reason at all. The world isn't always slanted in your favor, but the best—the only—thing you can do during those times is look for a glimmer of happiness. Choosing to be happy isn't about what's happening to you. It comes from within. It takes great strength to find the smallest of pleasures, especially when you also have to deal with all the not-so-great stuff at the same time. These girls choose joy again and again—and share it.

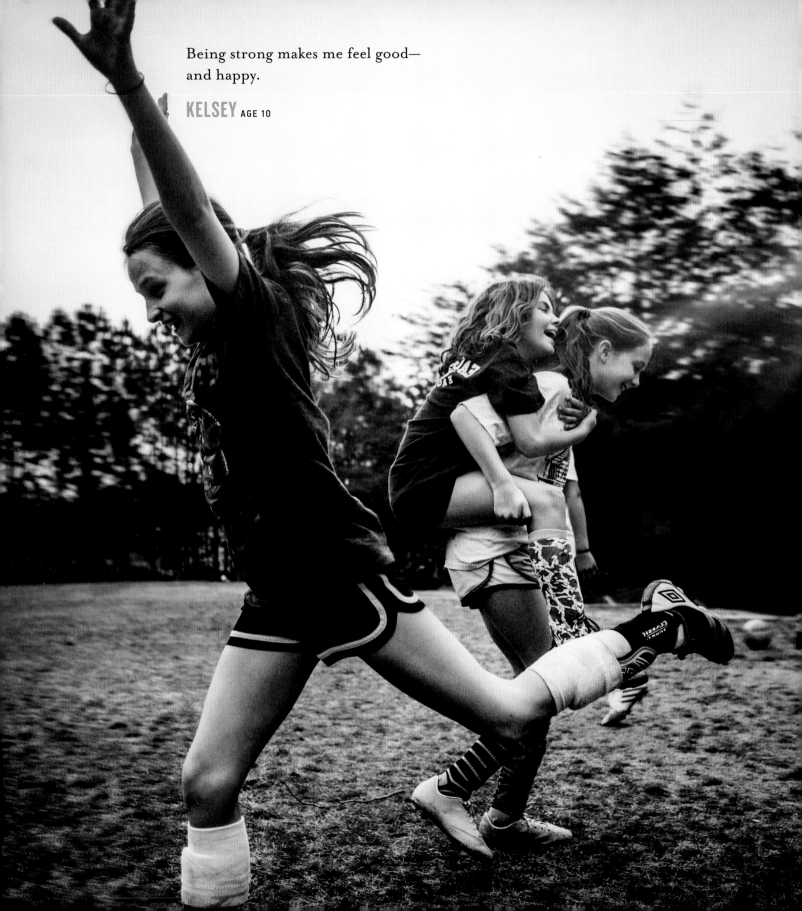

Being strong makes me feel good—
and happy.

KELSEY AGE 10

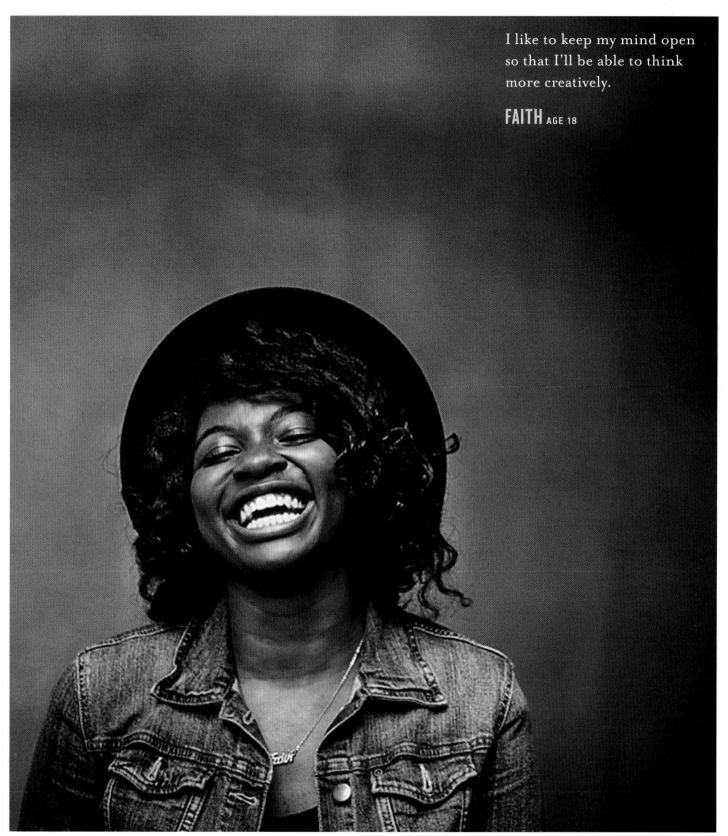

I like to keep my mind open so that I'll be able to think more creatively.

FAITH AGE 18

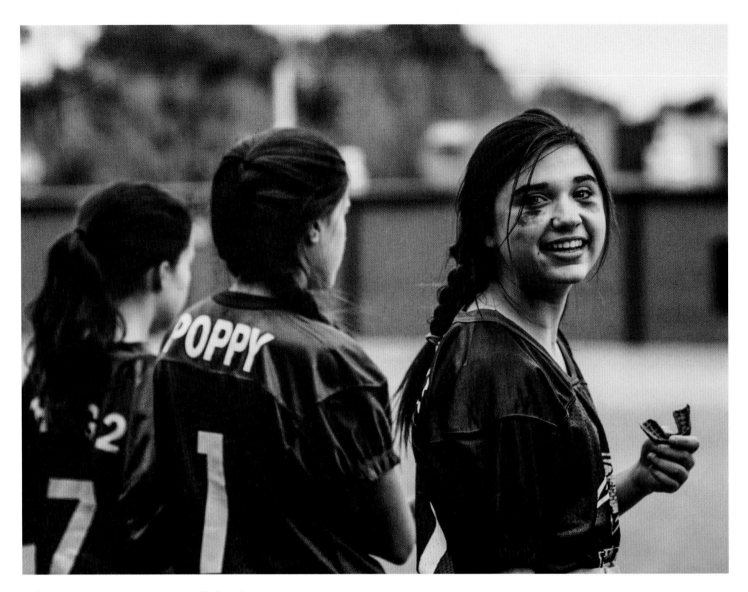

I think everyone is pretty. I think
everyone is strong, all in unique
ways.

LOGAN AGE 13

Dance is as much of a sport as any.

NICOLE AGE 18

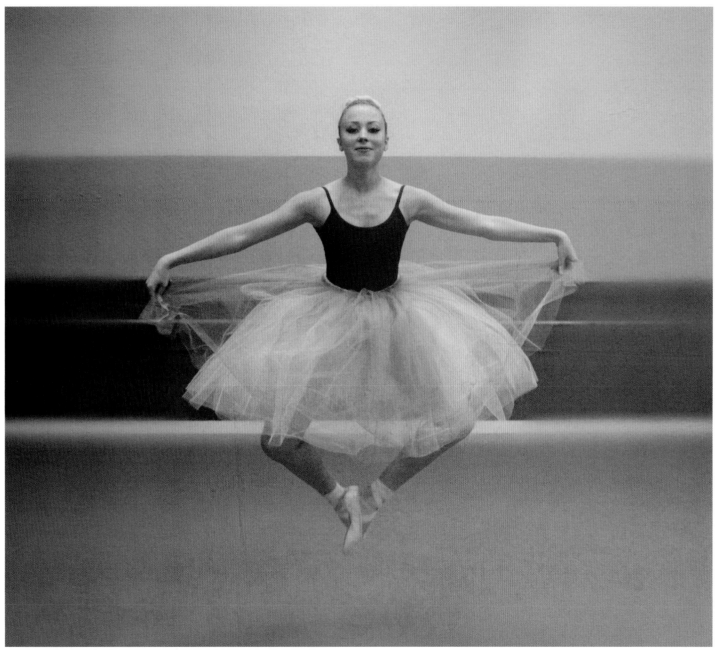

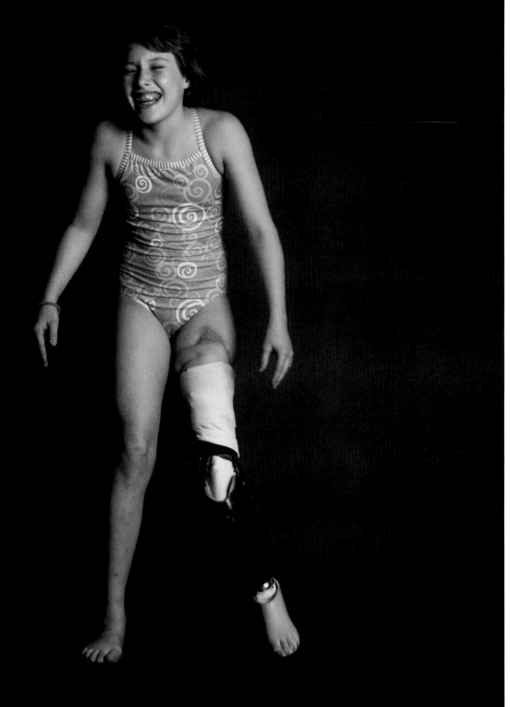

Cancer stole part of my leg but not my joy. I choose happiness. Being happy is my superpower.

GRACE B. AGE 12

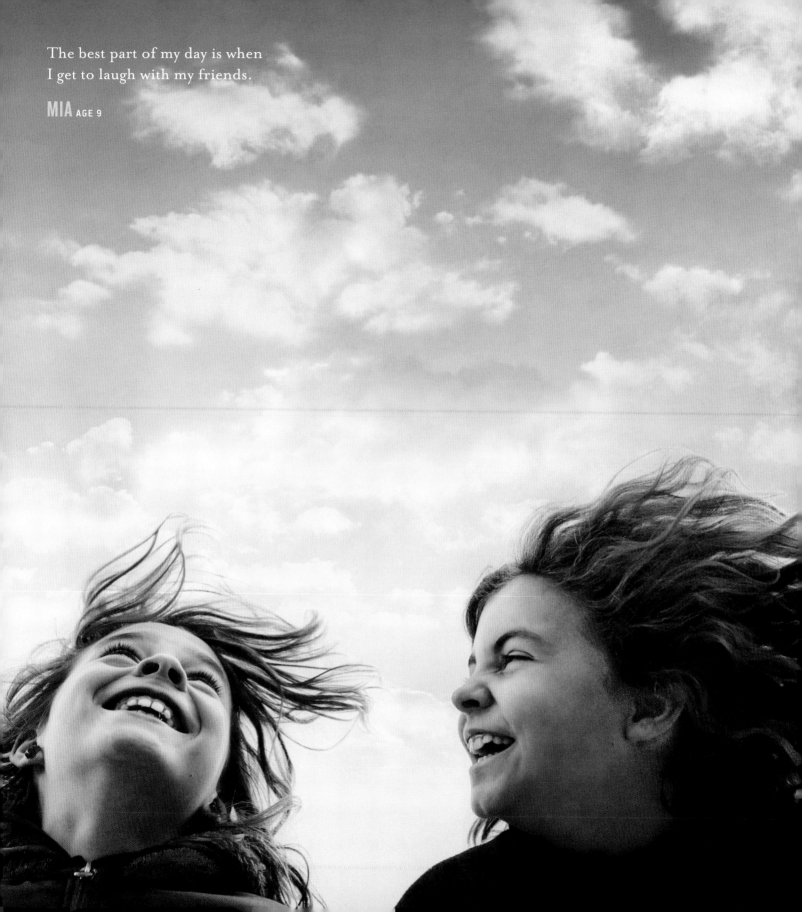

The best part of my day is when
I get to laugh with my friends.

MIA AGE 9

I am magic.

ELLA AGE 8

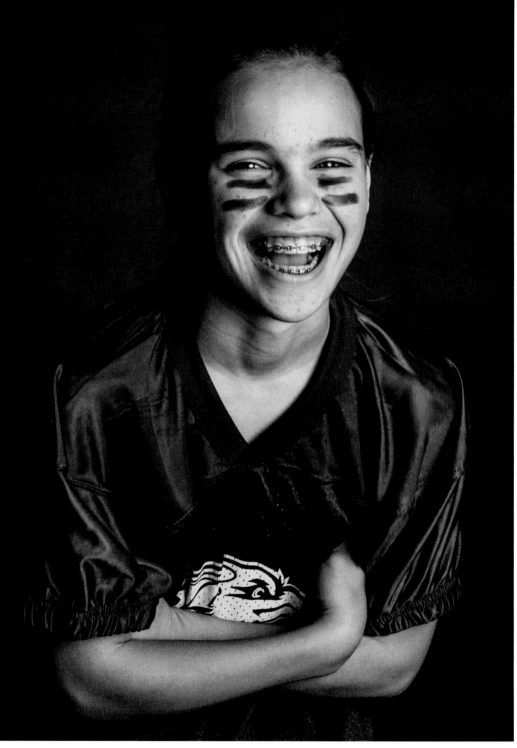

Everyone has strength. It just depends on what they put that strength toward.

GRACE F. AGE 13

I bring joy and happiness
to everyone around me.

SAMMIE AGE 11

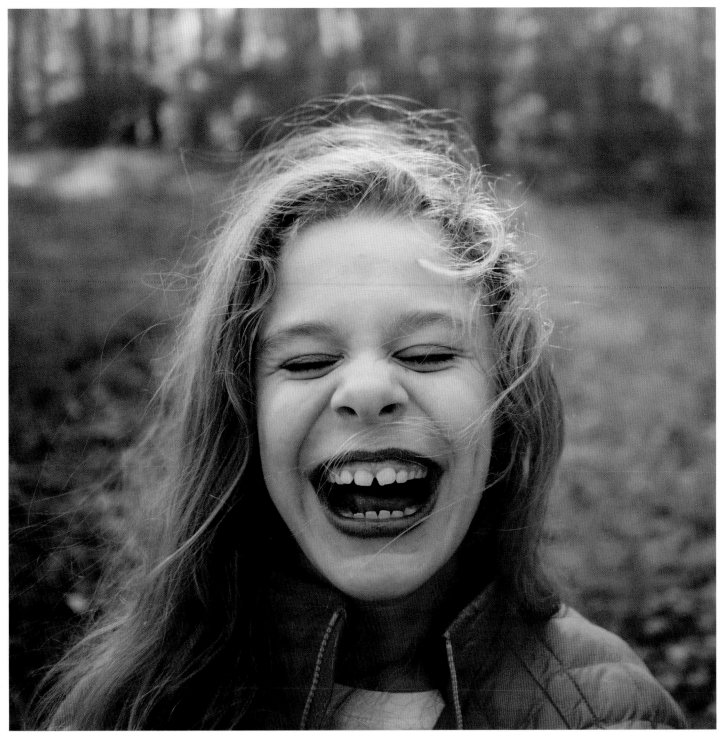

My soccer friends are my best friends.
We see each other through losses, sprints,
practices, injuries—it's why we are so tough
and so close. Like sisters.

CAROLINE C. AGE 9

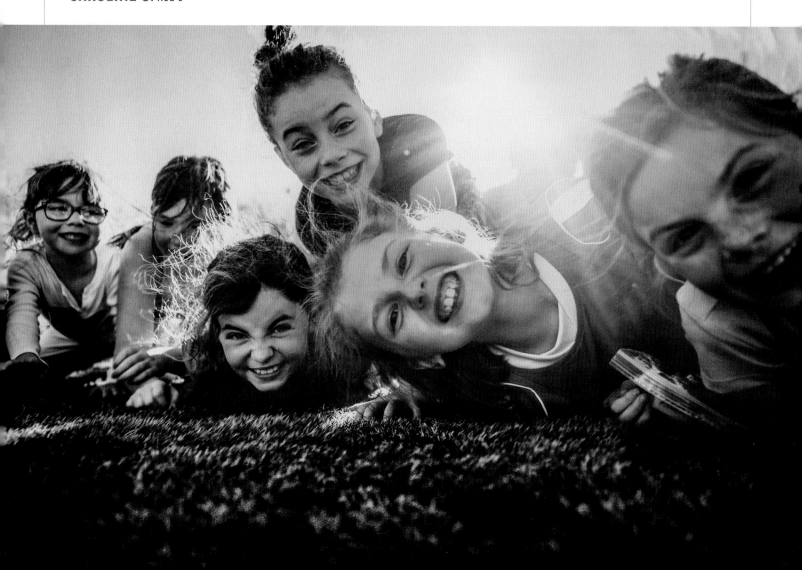

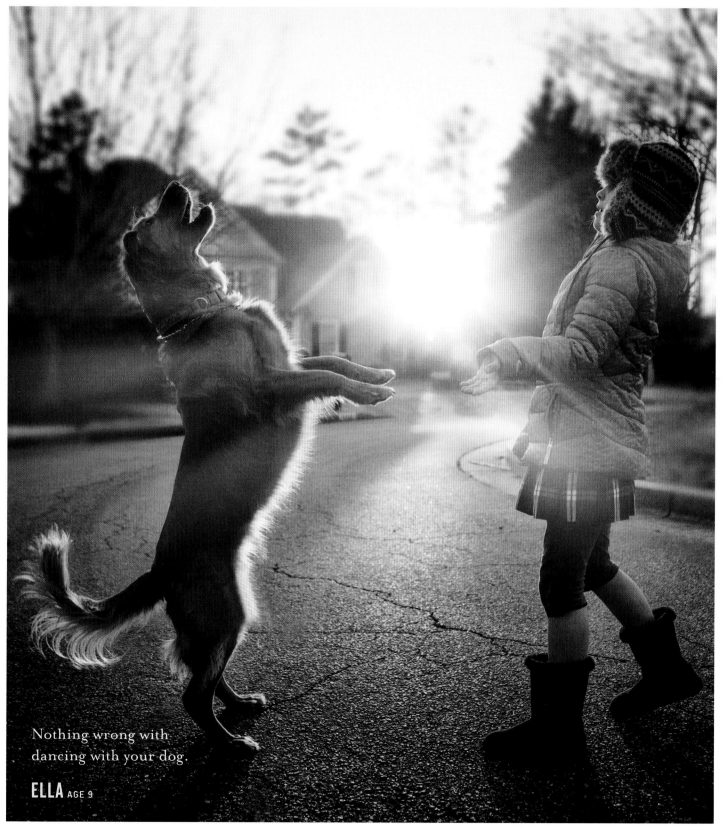

Nothing wrong with
dancing with your dog.

ELLA AGE 9

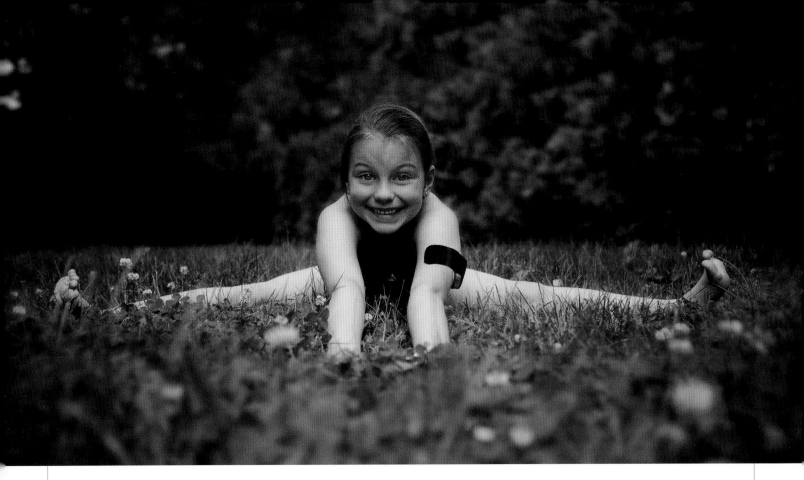

I'm a gymnast with diabetes. I have to eat right and
use insulin so that I can work hard.

HALEY C. AGE 7

I love to sing, but when I was asked to sing a solo in front of my whole school, I was so nervous. My mom told me to just breathe, take deep breaths, and just do it. I nailed it.

JAYDA AGE 11

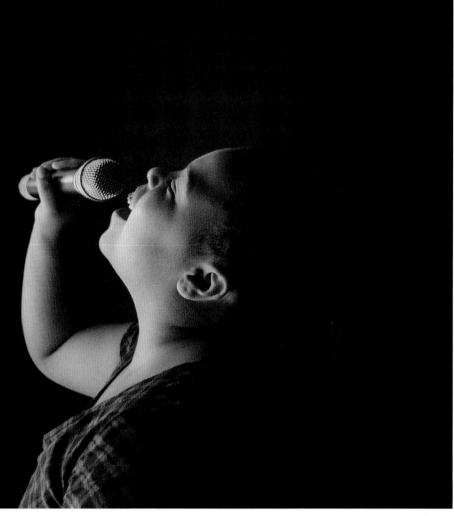

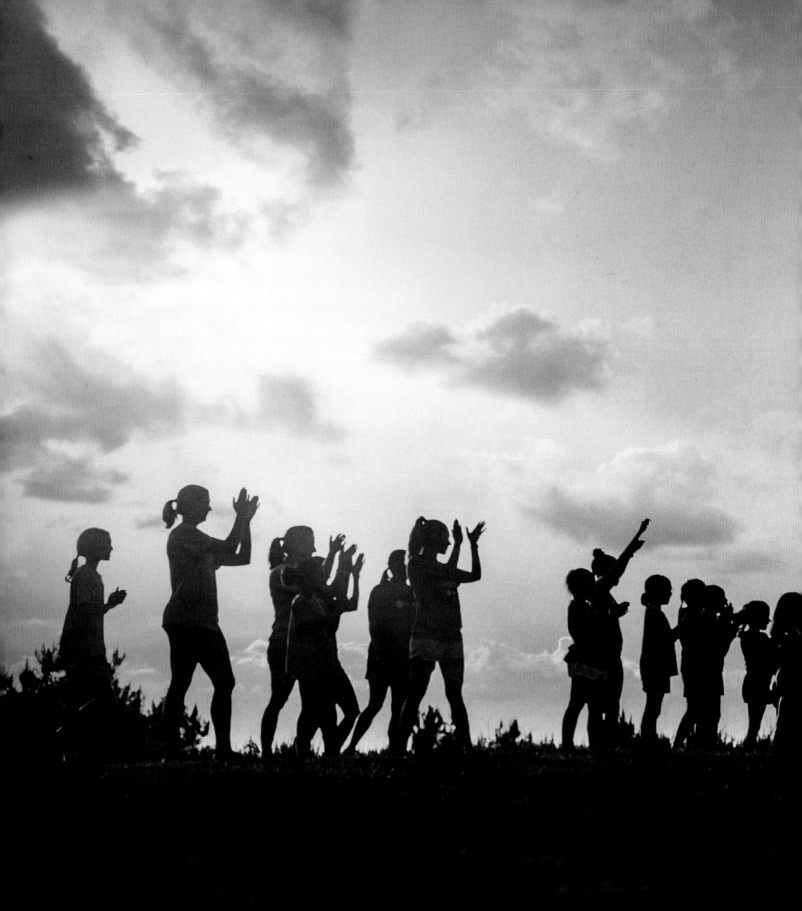

First or last,
everyone claps.

MIA AGE 9

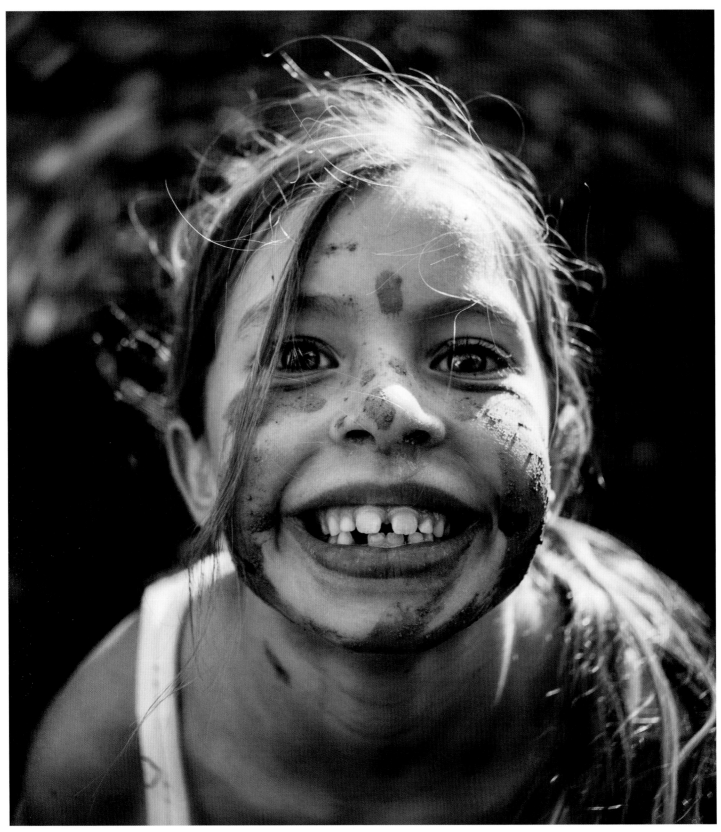

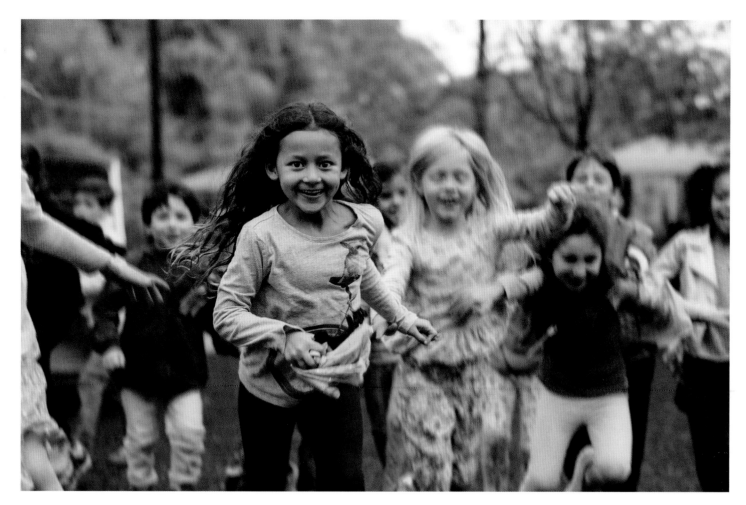

I am happy when no one is
left out or feeling sad.

SOLÈNE AGE 6

Yeah, I am a little muddy.
So what?

TAYLA AGE 6

All the conditioning,
turf burns, and late-night
practices are worth it.

MACKENZIE AGE 13

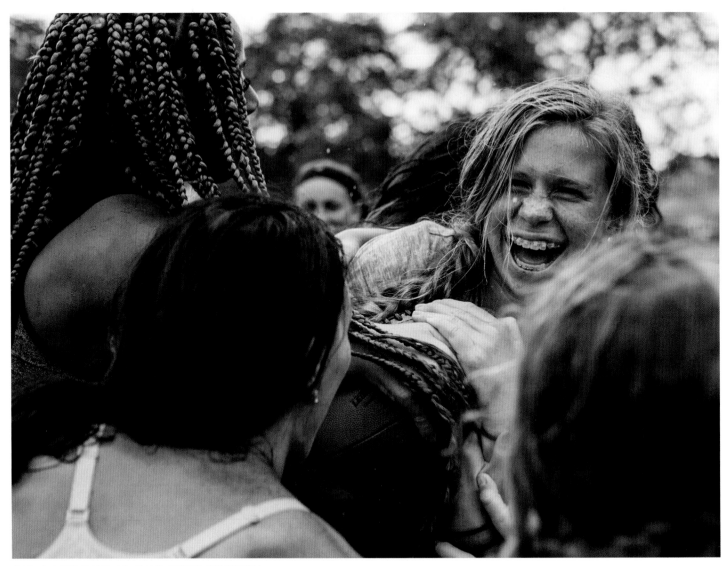

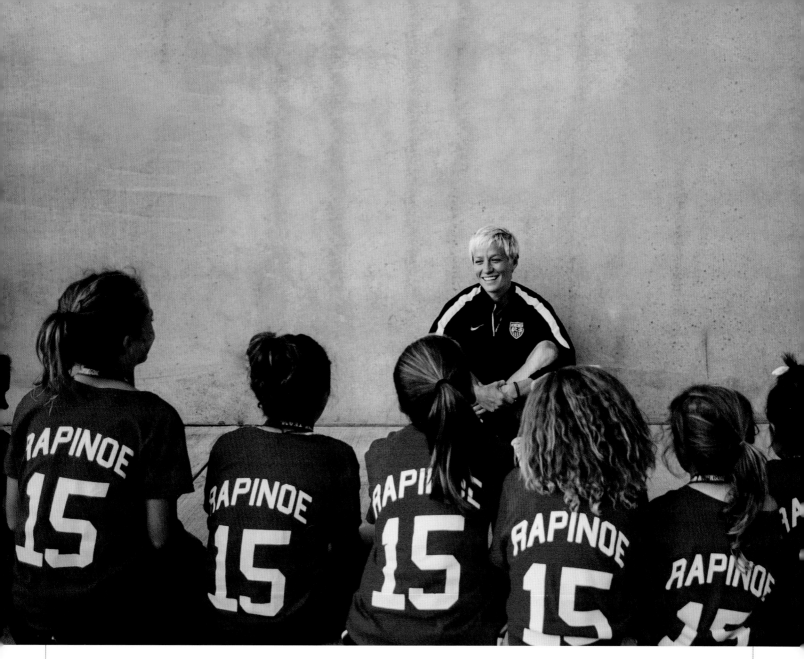

She is one of the best soccer players
in the world. She got hurt and came
back even better. She's my hero.

VIOLET AGE 9

I wanted to stop.
I never did.

MICHELLE AGE 9

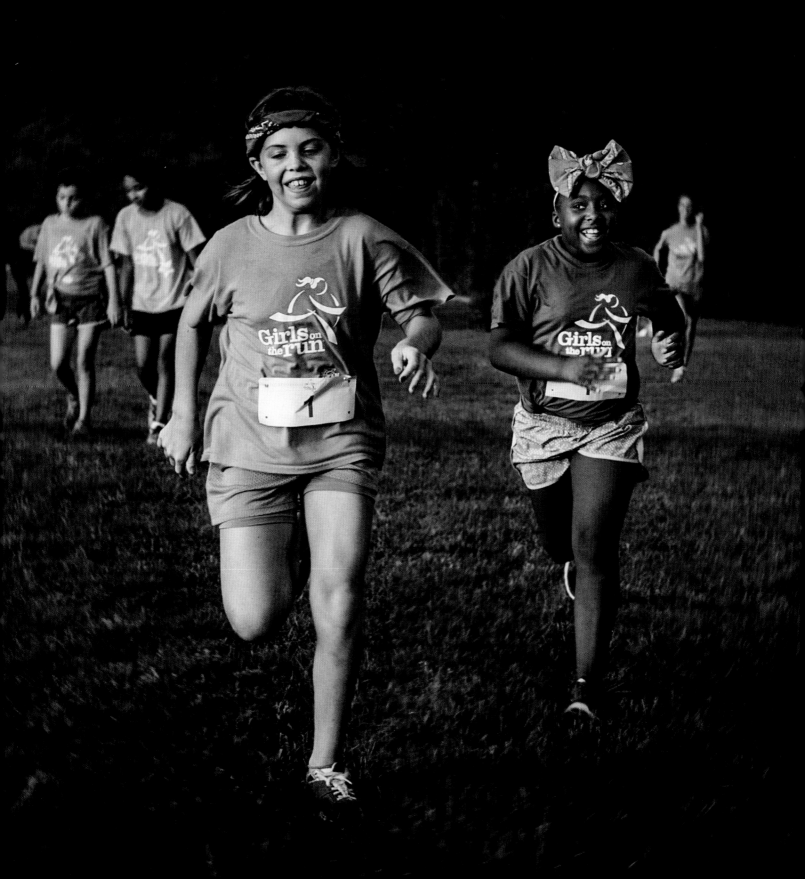

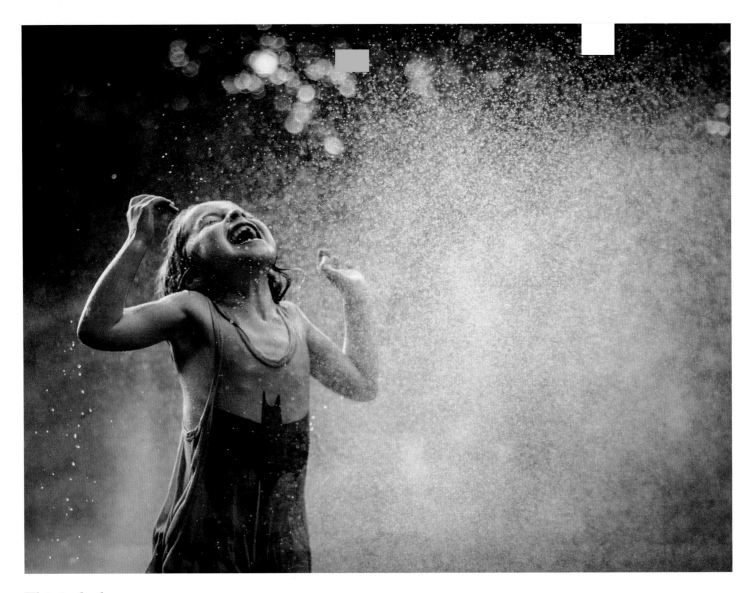

This is the best.

ALICE AGE 6

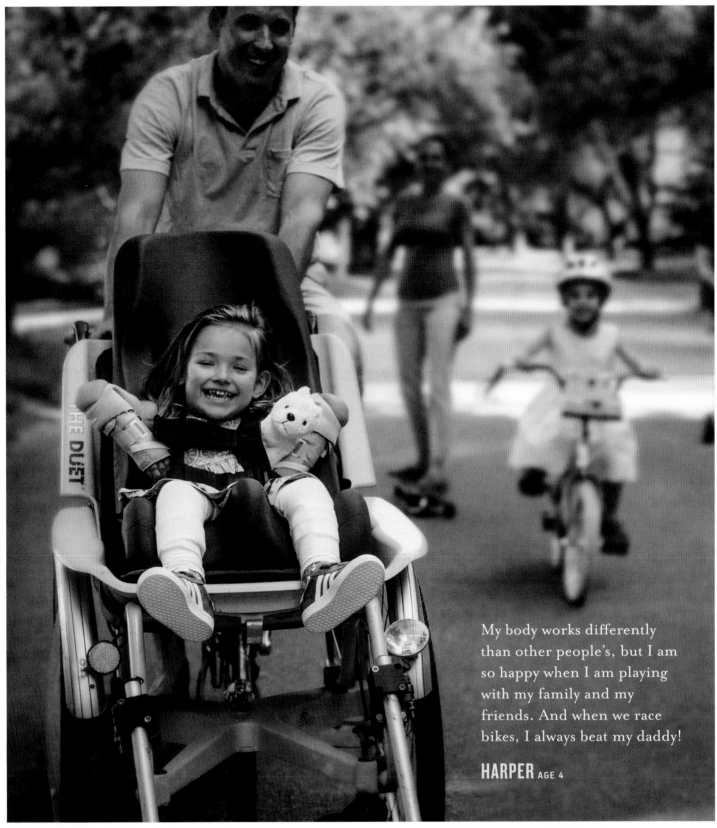

My body works differently than other people's, but I am so happy when I am playing with my family and my friends. And when we race bikes, I always beat my daddy!

HARPER AGE 4

When I am in the air, I feel like I am flying. At the end of a jump, my mind is completely clear.

ABIGAIL AGE 17

"Be uniquely yourself, and when in doubt, listen to your gut, because it already knows what you want to become."

MEREDITH VIEIRA

INDEPENDENT
IS STRONG

There will come a day or even a moment when you will need help, or advice, or a kind word. You will look around for your family, your friends, and your neighbors, but for whatever reason, they won't be there. I like to tell my own girls that at this point, you'll be down, but you won't be out. Going solo is not always a bad thing. You have yourself, and you can lift yourself up. You can pat yourself on your own very capable back and keep moving forward. You can call upon your quirks, your eccentricities, your imperfections—all the qualities that make you different and special—and ignite them.

Mackenzie, with her hand on the tiller of her boat (pages 230–231), is capable of creating her own paradise. Emma has the power to transport herself to another place when she sings (page 235). When Lillian (page 239) snaps a picture, "it feels so good." Their strengths are expressions of who they are.

Whether chasing down their dreams, relishing a quiet moment, kicking off an adventure—or simply feeling comfortable in their own skin—the girls on the following pages know that being independent means that they're on solid footing for most things that life can throw at them. They've *got* this.

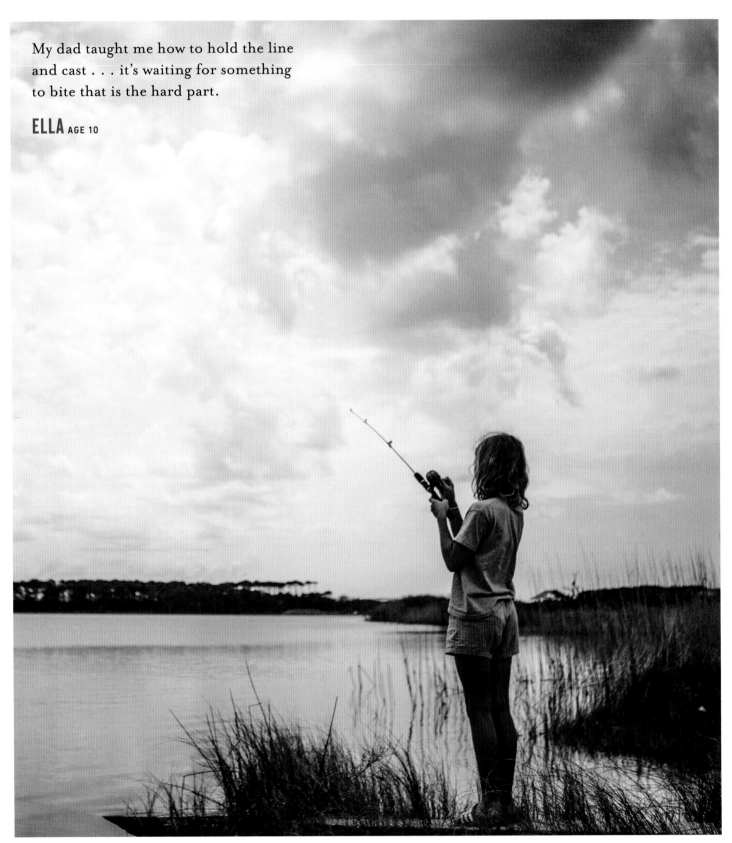

My dad taught me how to hold the line
and cast . . . it's waiting for something
to bite that is the hard part.

ELLA AGE 10

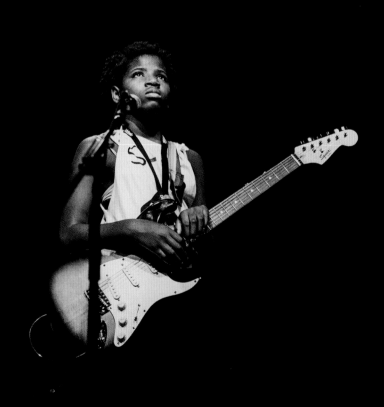

The best part is that
I always enjoy what I
create.

YOLISA AGE 10

The open water out on the lake is my
paradise. I got my boating license to
do just this with my best friend.

MACKENZIE AGE 13

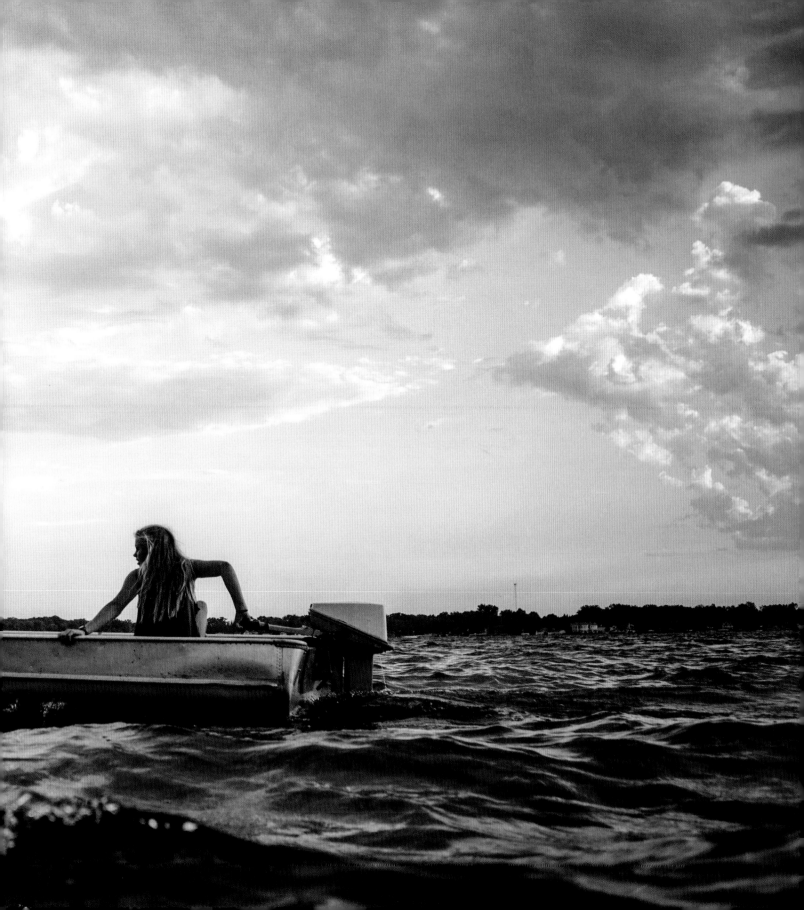

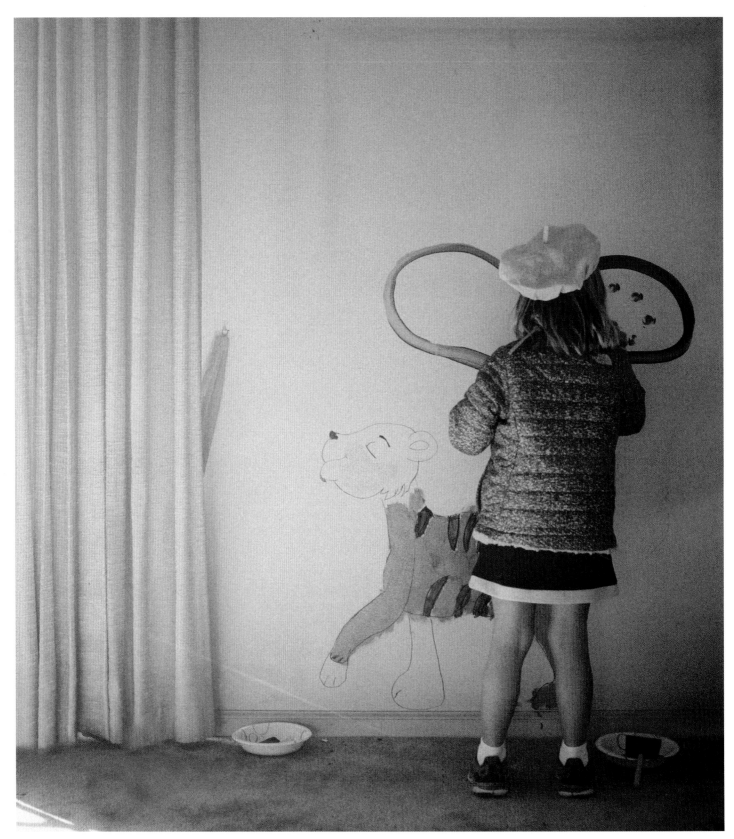

I like to paint and create when there are no rules. I can make anything I see in my mind.

EMME AGE 7

I like to race the waves. Sometimes I win, sometimes they do.

ELLA AGE 10

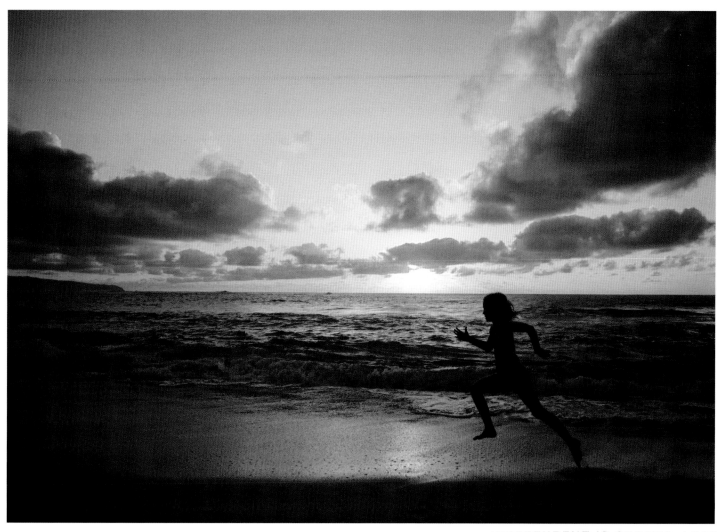

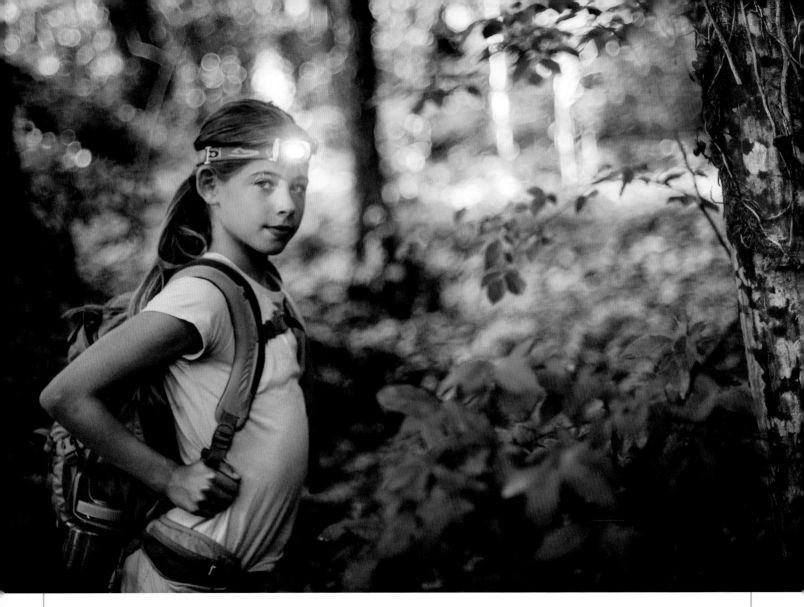

Ever since I was little, Dad has been taking me backpacking. No phones. No one saying, "Be careful!" Just the two of us hiking in the woods, camping, talking about stuff. It's my favorite thing in the world.

EMMA B. AGE 11

When I sing it makes me forget regular life.
I like that it makes me feel that way.

EMMA L. AGE 11

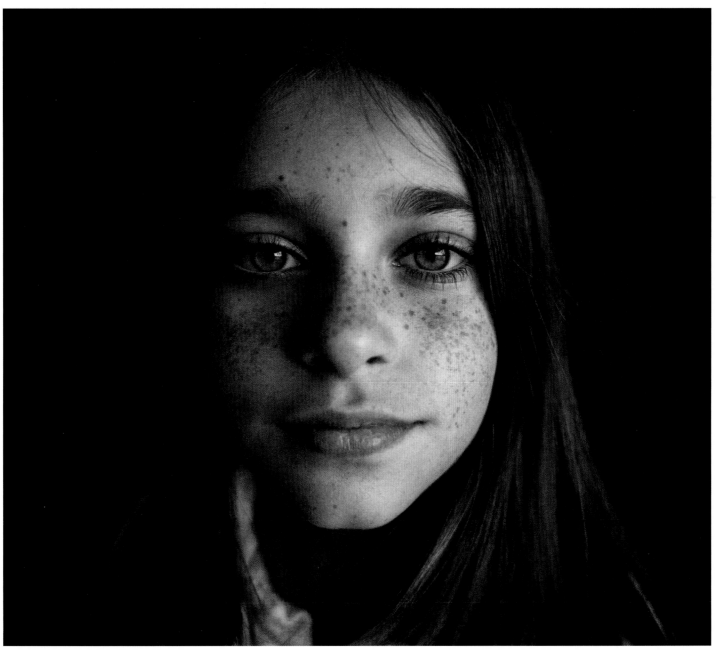

When I do things on my own,
it makes me proud because my own
personality can shine through.

ELLA HART AGE 8

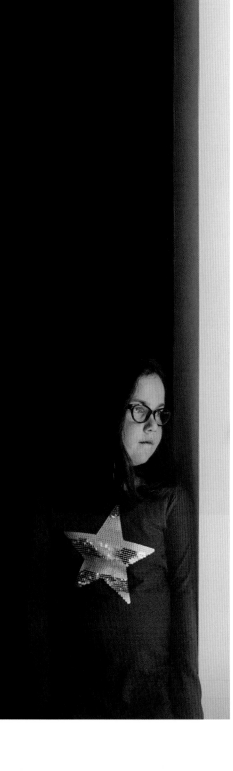

Dance is an outlet I use to express
who I am.

GIANNI AGE 14

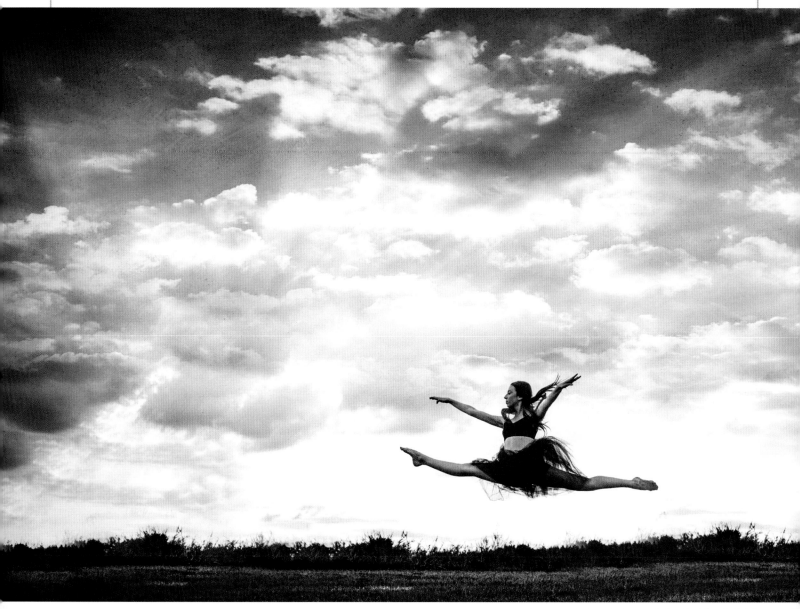

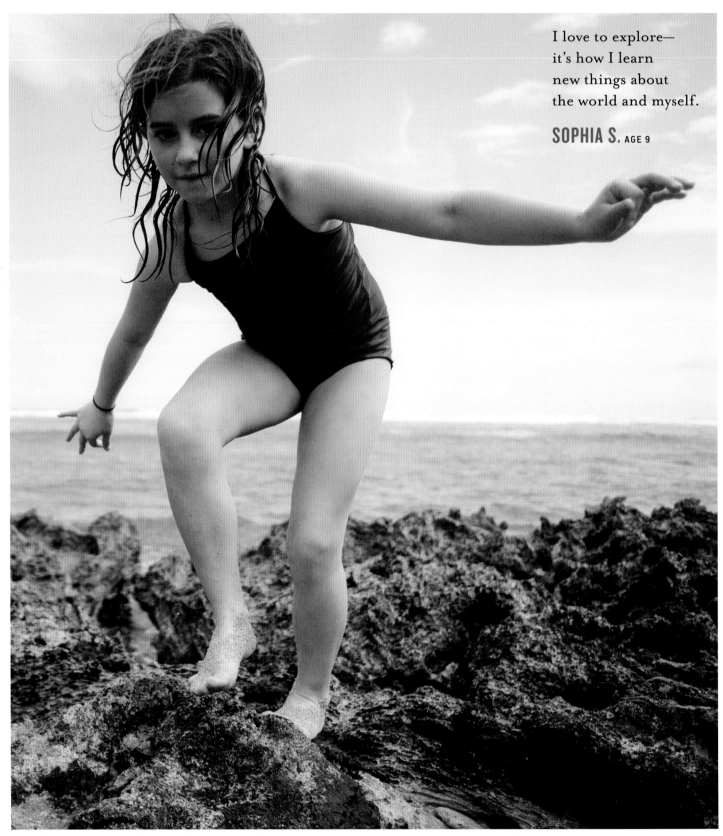

I love to explore—
it's how I learn
new things about
the world and myself.

SOPHIA S. AGE 9

I love photography because it is a kind of art,
and art is fun and exciting. When I get the
perfect picture, it feels so good.

LILLIAN AGE 5

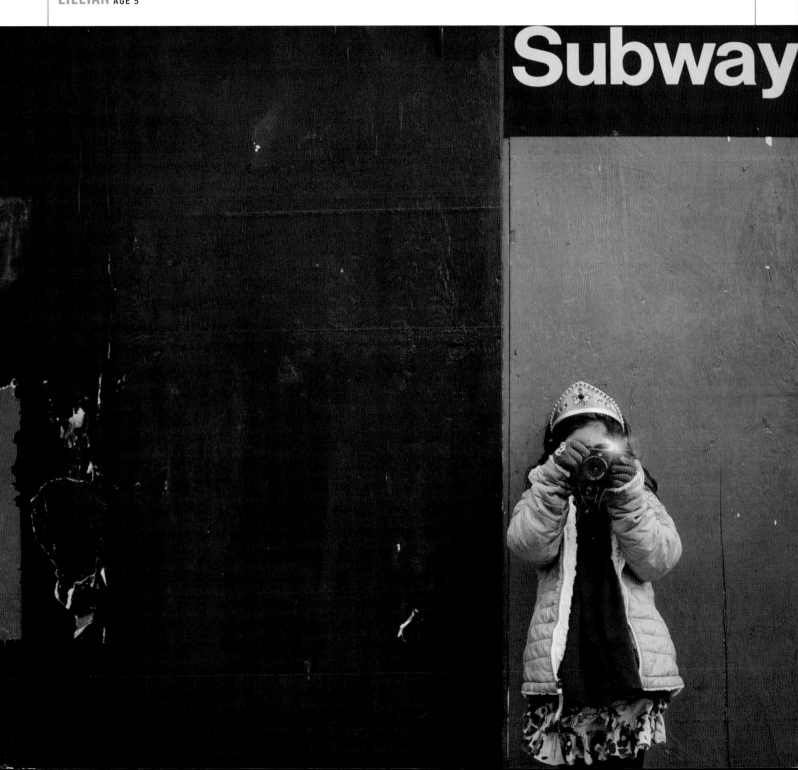

I like to smile and make
other people laugh!

MILLIE AGE 7

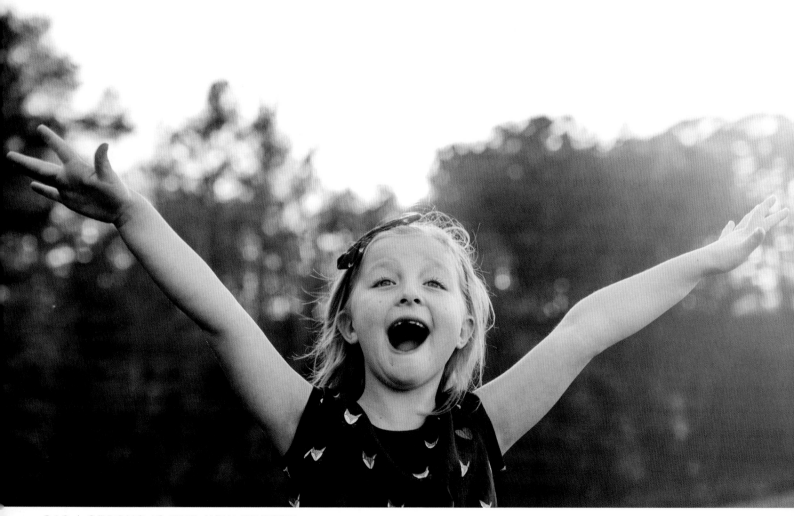

I have juvenile arthritis, and I don't like
when I need to use my wheelchair. But when I do,
I'm in control and don't need anyone to push me.

EMME AGE 7

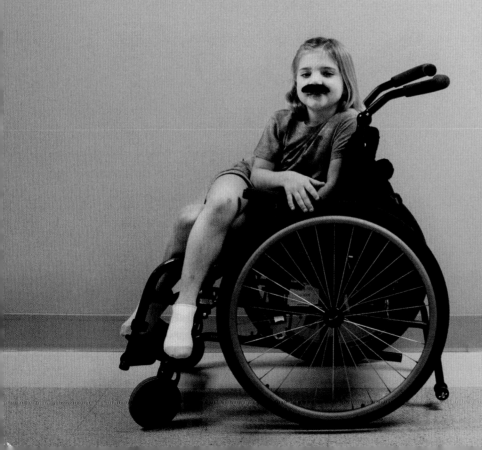

Satisfaction is working
hard, not giving up, and
having heart and will.

RAINAH AGE 12

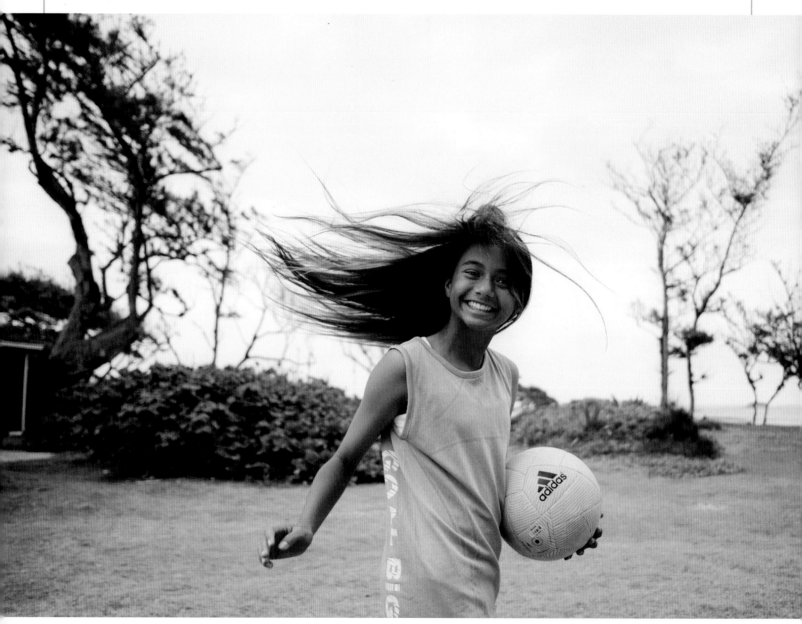

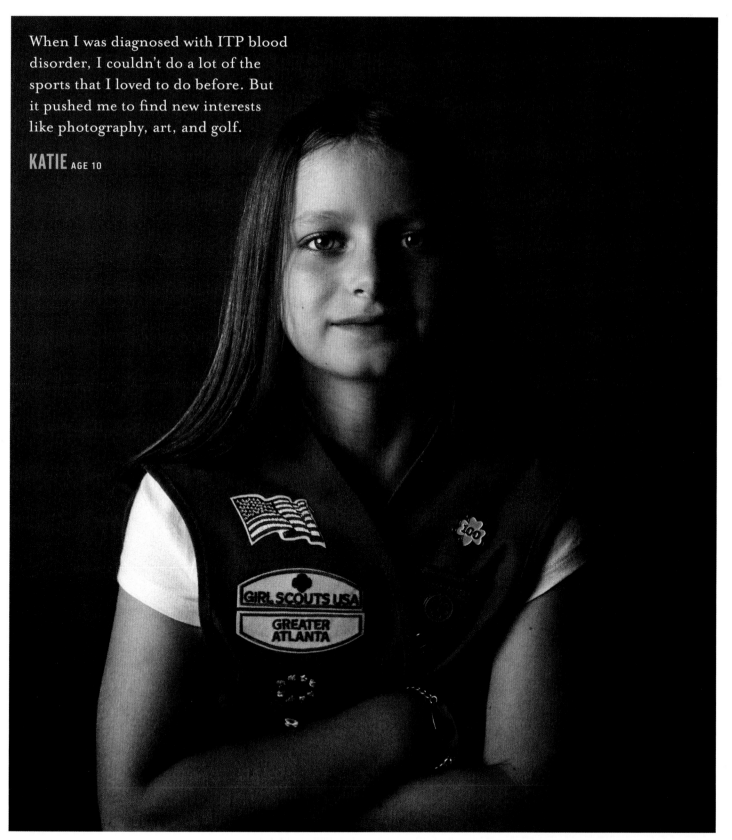

When I was diagnosed with ITP blood disorder, I couldn't do a lot of the sports that I loved to do before. But it pushed me to find new interests like photography, art, and golf.

KATIE AGE 10

I am able to hold on and trust an animal five times my size with my life. Strength is not a physical measure, because no matter how "strong" you are, you cannot out-muscle a horse. *True* strength is a quiet determination.

CARA AGE 16

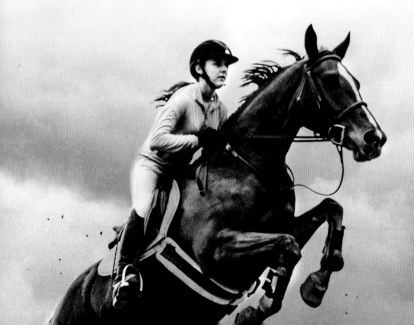

I can be whatever I want,
even a unicorn.

ALICE AGE 6

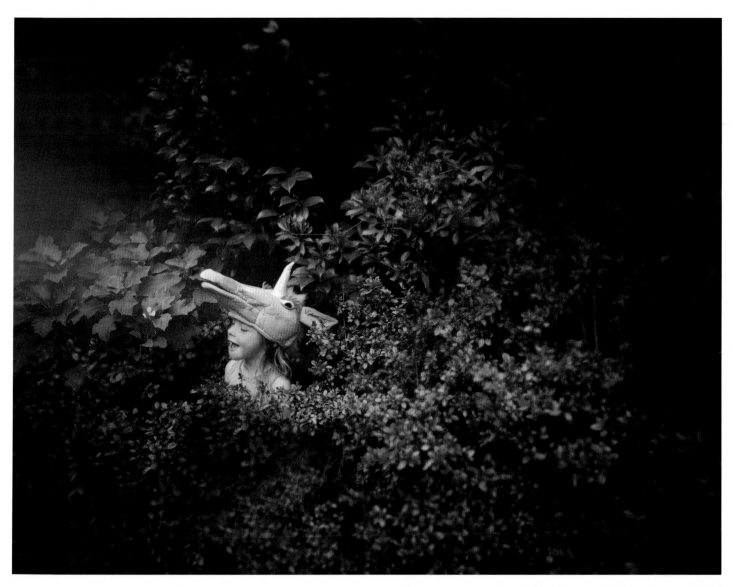

I have always experienced the most immediate sense of strength when claiming my own personal freedom.

FIONA AGE 18

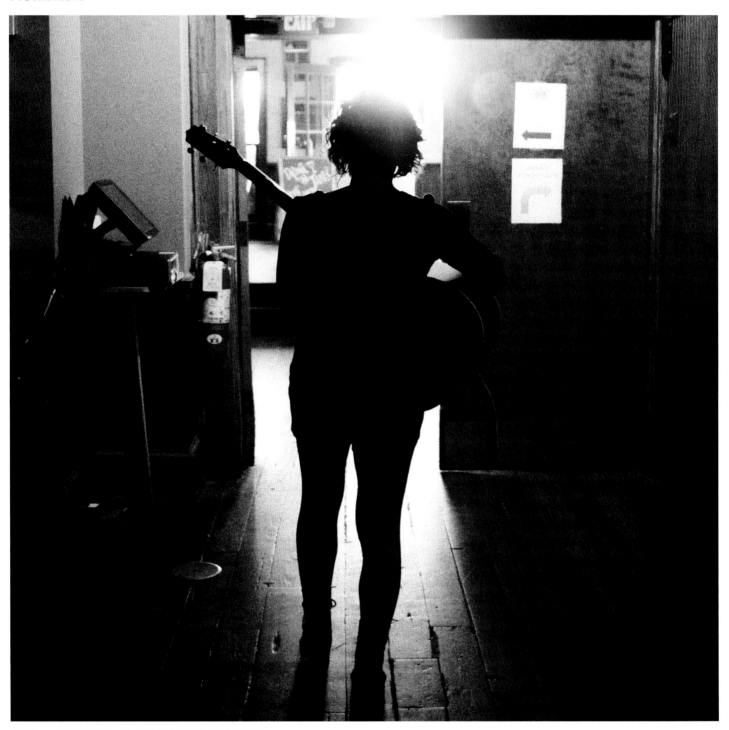

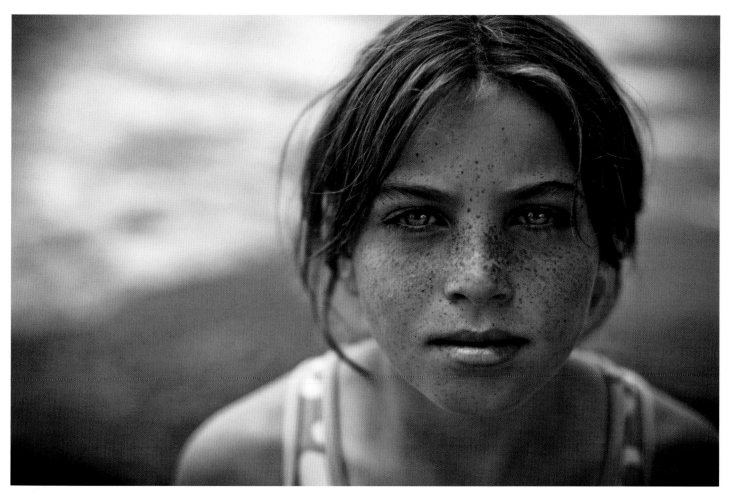

I don't shy away from being myself.
My mom has always told me to say
what's on my mind.

HALEY H. AGE 10

I daydream a lot. My parents call it "Ella World." I think up some really cool things.

ELLA AGE 9

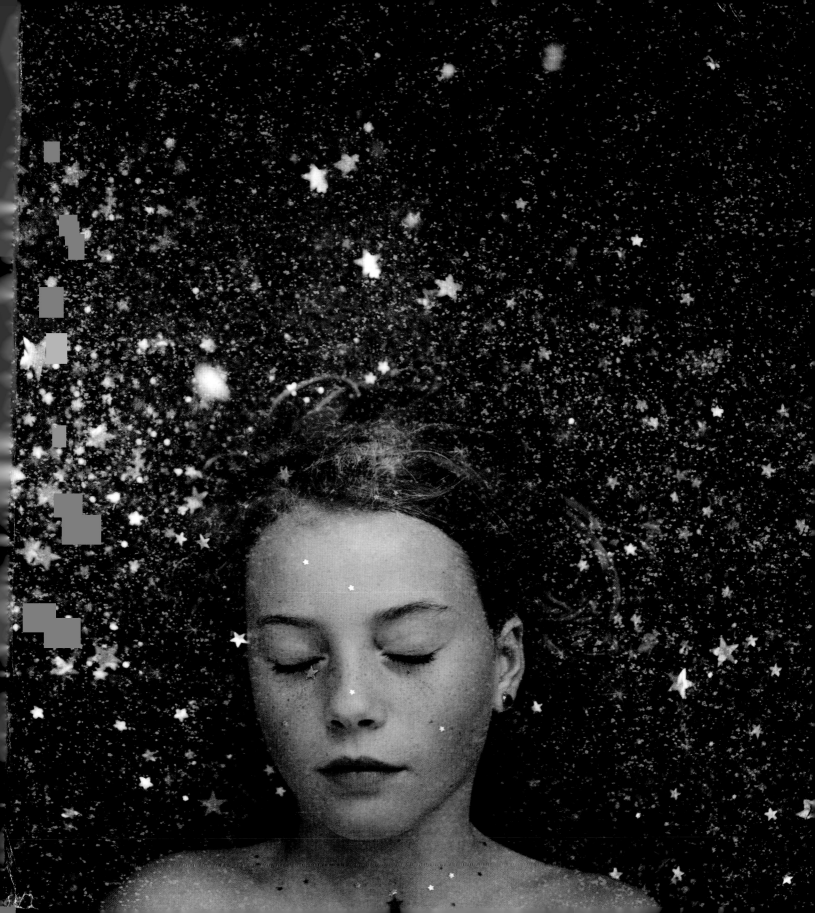

ACKNOWLEDGMENTS

There are so many amazing people who have allowed this book to become the actual thing that you are holding in your hands, and not just a dream in my head. I still can't believe it.

Mike, you were the first to believe in me, there supporting me every step of the way, cracking me up and keeping me sane. I love you. To my parents, thank you for allowing me to be me without question and for being at every game, every event, every everything. You're the best. Meg (and your Stones), you're my lifelong sidekick, my sister, and my friend. Dave, Steve, and the Anthonys, I will always be your little sister, and that is a huge part of who I am. Thanks for letting me tag along, always. Amanda, my "sister wife," and the Riepes—what would I do without you? Thank you to the Parkers, for your constant support and humor. Thanks to Mary Alice Stephenson for asking the question "what do these images mean?" and sparking this entire concept. Megan Nicolay, creating this book has been an amazing experience thanks to your expertise, care, and foresight. Anne, Selina, Chloe, Jessica, Rachael, Beth, Lisa, Julie, and everyone at Workman, thank you. William Callahan, I couldn't have gotten to this point without your wit, knowledge, and calm head. Liz Dilworth, your organization, follow-up, and forward-thinking were invaluable—thank you for all you did to make this book a reality. To everyone at Greenhouse Reps, thanks for believing in me. Coleen and the whole Curry family, you guys rock. Thank you to the Myers, for all your South African hospitality. Much love, too, to my Demon Deacon and Gladiator families.

And finally, a huge and humble thank you to all the girls and their parents for taking the time, trusting me, and allowing me into a little part of your lives. I am honored.